BLACK AVATAR
AND OTHER ESSAYS

BLACK AVATAR

AND OTHER ESSAYS

AMIT MAJMUDAR

ACRE

CINCINNATI 2023

Acre Books is made possible by the support of the Robert and Adele Schiff Foundation
and the Department of English at the University of Cincinnati.

ISBN-13 (pbk) 978-1-946724-61-8
ISBN-13 (e-book) 978-1-946724-62-5

Designed by Barbara Neely Bourgoyne
Cover art: Wooden idols of Lord Krishna, on display at the Handicraft Fair in Kolkata,
West Bengal, India; iStock by Getty Images.

The press is based at the University of Cincinnati, Department of English and Comparative Litera-
ture, A&S Hall, Room 248, PO Box 210069, Cincinnati, OH, 45221–0069.

Acre Books books may be purchased at a discount for educational use. For information
please email business@acre-books.com.

For Ami

... It is enough
My works begin, again, in love
Already waiting where I strive to go:
Love I am grateful I'm alive to know,
Love I am fighting, writing through to,
My love, my guide, my goad, my guru.

CONTENTS

BLACK AVATAR
AND OTHER ESSAYS

BLACK AVATAR

How Colorism Came to India

SOME MEMORIES MY SKIN HAS COLORED

You are what you remember.

Right now, I'm remembering the town where my parents were born, and in that town, the house where my mother grew up. During the two years our family relocated to India, and on every subsequent childhood trip there, we visited Junagadh and stayed in my grandmother's large and almost empty house. A plank of polished wood, suspended from the ceiling on four chains of interlocking brass S's, swung fast and high in the anteroom. My sister and I spent many happy hours on it, since there wasn't much else to do. Black oil stained the hinges, and black dust stained the bottoms of our feet as we shoved off from the stone floor. When the swing really got going, the balls of our feet barely kissed the surface.

The floor started out gritty early in the morning, went briefly smooth and cool after it was cleaned, then built up its layer of grit over the rest of the day. Dust sifted everywhere, instantaneous and inescapable. The layer reasserted itself just moments after the sweep and tap of the dry grass broom, the dunk and swish of the rag. A girl arrived every morning to carry out this task, dark-skinned, no layer of ghee-graced fat to soften the nubs of her spine. A hierarchy was there to see, encoded in more than one way, but we

Regd. Trademark

A tiger and a goat, sipping peacefully from the same teapot. This logo has since been
replaced with a blander, text-only logo, but thankfully the tea is just as tasty.

had never been taught to see it. We stopped the swing and drew our feet up,
crinkling our noses at the whiff of cowdung and slum and murky bucket-
water. Squatting and reaching, spinning in forty-five-degree arcs to smear
darkness across the stone, the girl danced past us. Sometimes we could hear
her singing a film song or garba to herself, her voice lower and rougher than
those of the women in our family. We did speak Gujarati, but the difference
between our careful, American-accented Gujarati and hers—folksy, guttural,
everything slurred together—kept her incomprehensible to us, and us to her.
Was there really a language barrier, though? We never exchanged a word
with her, though she came by every day of our stay. The swept and rag-rinsed
stone felt cool and wet against our feet as we pushed off again.

Breakfast was sometimes Parle-G and Ovaltine, sometimes golden rect-
angular khari biscuits and chai. The brand was always Wagh-bakri, Tiger-
Goat, two mortally opposed species coming together in my imagination to
clink teacups and slurp from saucers, though the logo showed them lapping
from the same teapot. A layer of cream formed on the top, a slimy film I had
never seen on American milk. The processed milk back home seemed the
right kind; this natural separation atop natural milk struck me as a horror,
alien, gagworthy, wrinkling in a spokewheel where I pinched it.

After lunch, I would ask for a few coins and run out to the soda man. On his wooden cart, a block of ice hid from flies under a chequered maroon rag. Corked green bottles—refilled where, and under what hygienic standards, best not to know—held the treasured fizzy drinks. A rusty chisel hacked ice chips. We blew through the straws before sipping because you could see little flecks of dirt if you squinted down the barrel. Black pepper, brown cumin, white rock salt, mint and lemon: I have tried factory-bottled, sell-by-date-on-cap "masala sodas" from Indian food stores in America, bought every brand of jaljeera powder on the market and mixed it with seltzer water and crushed ice from the refrigerator dispenser, but I've never found that taste. No doubt the soda man gave me a few of the fevers and bouts of diarrhea that plagued my boyhood India trips. Maybe *Escherichia coli* was his secret spice.

In that vast house, on the ground floor, lived my grandmother and unmarried uncle. On the upper floor lived a famous, retired politician; she had begun renting it in the 1960s, risen to local power, and now, thanks to both her own clout and the tenant-friendly nature of Indian law, still paid her 1960s rent (a pittance to begin with; adjusted for inflation, less than a pittance) and could not be evicted.

In time, a squatter and his family would arrive on the square of property between the house and the street. He covered the lawn with mud and cow dung, and his two white cows chewed endlessly, flush with our ground floor window-grates, their noses moist and their eyes incurious. My sister and I had staring contests with these sacred animals, who, like the politician upstairs, could not be evicted. When my grandmother's house was eventually sold, the tenant and the squatter had to be bought off. The developer ended up giving them bigger payouts than my grandmother, who owned the place on paper. Part of her deal was a flat in the eventual high-rise, two tight rooms and a bathroom—the final comedown for the widow of the wealthy lawyer, Mr. Ghoda, who died of tuberculosis five years before streptomycin.

But that was years in the future. At the time of my boyhood memories, my mother's unmarried brother was still alive, and he lived with Nani Ma and oversaw the house. They were both very fair-skinned and possessed a ghostly, luminous pallor. Nani Ma had thin white hair that escaped the plum-sized bun and seemed to rise off her skull in a fine steam. Her first name,

which we never used, was Tilottama, and I know now what an incongruous name that was. In the old Sanskrit texts, Tilottama was an apsara, a celestial temptress who set at odds the demonic brothers Sunda and Upasunda. She was the original femme fatale. My Nani Ma—literally, "little mother," fitting, since she stood under five feet—puttered about the ancient mansion in her widow's white saree, offering mango preserves in vain to her American grandchildren. Sometimes she asked us questions through my mother as if through an interpreter, though she knew we spoke some Gujarati.

Her hearing, already diminished with old age, had the added obstacle of earwax. She could have supplied a candle factory. My mother, a physician, used a plastic bulb and a steel bowl full of water to flush brownish-yellow chunks from my grandmother's ear canal. Nani Ma's eyebrows rose high to greet the restored soundscape, and her smile peeled back to show her perfect dentures.

My uncle Rasik still wore the bellbottoms of his happier youth. Most of my memories of him are of my mother's joy at seeing him again after three or four years overseas. He seemed more and more skeletal with every visit, though at the time, he seemed inordinately tall and skinny. He used to love colorful scarves and the finest clothes, and my mother still treasures a faded photograph of him in his dandyfied twenties. An air of regret hung about him when we came to stay there. We wondered, though we never asked: had he suffered an unrequited love? A broken-off engagement? How had the handsome, stylish Uncle Rasik ended up unmarried and living in this crumbling house?

My only memory of an argument between him and my mother involves Uncle Rasik insisting, over my mother's strenuous medical objections, that AIDS could be cured by drinking your own urine. Maybe his death, in his forties, of kidney failure, was not so mysterious as our family makes it out to be. "Kidney failure" only describes a physiological problem; there is always a *why* behind it, and that *why* was never answered with a diagnosis. More than one organ system might have been failing by the end, since our last visit revealed, on his white skin and white sclera, the yellow-gold blush of jaundice. My eyes were still a decade and a half from being trained to detect that. My mother must have known.

* * *

I spent the first eight years of my life in Ohio, which was, at that time, over eighty percent white. I knew what it was to be the dark one. But when my parents relocated our family to India—permanently, or so they planned—I became, abruptly, white-skinned. I was also a foot taller than my classmates in Ahmedabad's English-medium public school, the Gujarat Law Society. When we posed for the class photograph in khaki shorts and white button-down shirts, the photographer had trouble deciding where to put me. I threw off the symmetry and hid the student on the riser behind me. I ended up standing dead center in the top row, slightly stooped, trying to sink to the mean. Eight years of American nutrition—mayonnaise and Oscar Mayer's bologna on (leavened) white bread, french fries, hot dogs on the Fourth of July—had shot me up. America did that to Europeans, too; I read somewhere that Revolution Era Americans stood a foot taller than the ethnically identical British soldiers who sailed west to fight them. In my classroom, I was the white giant. The students did not know I spoke and understood Gujarati, and I never let on. I got to hear what they said about me.

It was all complimentary. This baffled me; I kept expecting to be bullied. I knew how my American classmates treated foreign kids. Maybe my American origin protected me; the country had prestige back then. Maybe it was my height. Maybe it was my skin, which I had always thought of as dark, too dark, but now, miraculously, discovered to be "fair."

The other "fair" girl in our class was Aditi, and over the course of the year, whispers suggested we should be a couple. She was also the fastest sprinter, male or female, and had won the class-wide sprinting competition the year before. At the teacher's whistle, two students had to sprint to a tree and back—across an uneven dirt field, in the dress shoes of our school uniform. The winner advanced to the next round. The finals came down to me and Aditi. She was half my height and could not compete with my stride. I had never been athletic back home in Ohio. Now I had unseated Aditi. Tearful and enraged, she swore to her friends, in rapid Gujarati she thought I couldn't understand, that she and I would never be a couple.

The smartest student in the class was the darkest-skinned girl, Dhrumi. On the first day, our "maths" teacher asked for a student to stand up and review the highest multiplication table learned the previous year. In Ohio,

we first-graders had only gotten as far as subtracting double digits. This Indian second-grader shot up and—her voice booming from deep in her chest, blazingly confident—recited, *Thirteen ones are thirteen! Thirteen twos are twenty-six!* And so on until one hundred and sixty-nine. I got all queasy and sweaty as I stared up at her. She happened to be right next to me, so the intimidation was even more pulse-poundingly intimate. In Ohio, I had always been the odd, unathletic, dark-skinned kid—but I had also been acknowledged as the smartest kid in the class. (In the 1980s, in Ohio at least, stereotypes about Indian-Americans were mostly "positive": we were supposedly math whizzes, science whizzes, good at violin and piano.) Somehow, here in India, my defining qualities had been inverted. Suddenly, I was light-skinned and physically imposing, but I knew less than anyone else.

Besides a math education that lasted me through seventh grade after our family's return to Ohio, that was what I learned during my two years in India. I could not define myself based on how other people saw me. You aren't what others perceive you to be.

You are what you remember.

I went to and from school in a rickshaw packed with eleven other kids. The passenger backrest had been taken out so the students could sit back-to-back, butts jostling for real estate on the seat. The privileged spot was up front, next to the driver, hanging half-out in the noisy, exhaust-rich wind. When I got home, I soaped myself and made a ring with my thumb and forefinger. I drew this ring down my arm. My wrist collected a black cuff of suds. It took three soapings before the grime was gone and the suds at my wrist stayed white.

A can of scented Ponds talcum powder took the place of moisturizer in that humid climate. But was keeping our skin dry its real use? We used it after a bath or before going out in public, whitening our faces like seventeenth-century French courtiers. *Don't play outside too much*, warned the same aunts who praised my sister and me for our "fairness." *You'll turn black!* I learned to fear the stain of the sun, the loss of my precious complexion.

On the other side of the world, of course, pale Americans were paying money to lie in luminous coffins for an hour. Whitening creams in India,

bronzer and tanning lotions in the United States: no one was entirely at ease in their skin. The thinness and sun-darkened skin that signified poverty in Gujarat signified health, vitality, and prowess in Ohio.

Indians come in all colors, though, and the demarcations do not always follow a north-to-south, light-to-dark gradient. I could see the variations for myself in our extended family. My mother's older sister was born with very dark skin, while my mother was born, four years later, with bright white skin and a perpetual blush. Their features to this day are nearly identical, just in different sleeves. The same goes for the two sons of my father's older brother. Their features are so different that it's hard to believe they're related at all.

This isn't an unusual phenomenon. India's epics reveal such contrasts were present thousands of years ago. In the *Mahabharata*, two sets of cousins go to war; the father of one set, Pandu, has a name that means "pale." One of the main figures in that epic has skin so dark, it gives him his name as well. His brother, Balarama, has white skin—but it's the dark-skinned brother who is worshiped in temples to this day: "Krishna," in Sanskrit, means "black."

My parents returned to an India more or less the same as the one they had left. It was they who had changed. They could not revert to a life where relatives showed up at your front door without knocking or calling beforehand, and that was the rest of your day. My parents had forgotten the summer heat, the mosquitoes, the bumper-car roundabouts of Indian traffic, the bureaucrats who wanted a bribe for every minor task. America had trained them out of the reflex to shrug your shoulders when things didn't work right. Indignation at shitty service, in any aspect of life, is the distinctive American trait, and a mere decade there had instilled it in my parents.

My sister and I were adapting to the new life. Reluctance and resentment (and, when a cockroach skittered out of a sneaker, squealing horror) gave way to rhythms of normalcy. Our Gujarati would never be so fluent again, but we still spoke in English to each other, rapid, telegraph-terse snippets strewn with stale school slang our former classmates had left behind. A mixtape, recorded off the radio, preserved Gloria Estefan's "Conga" long after the stations had stopped playing it. Sometimes my sister and I took her sticker album out of storage and admired her collection page by page.

The scratch-'n-sniff root beer and bubblegum and strawberry had faded for good when my dad told us we were going back.

My best friend in Ohio was a white kid named Nick. An asthmatic only child, Nick had the biggest collection of Transformers in our school. I loved sleeping over at his house—classic meal of pepperoni pizza and pop (I was two decades away from going full Brahmin on dietary matters), sleeping bags in front of the late-night Pee Wee Herman movie, and Nick laughing around the plastic hookah of his bronchodilator treatment . . . He and I wrote letters to each other during my time away, keeping up the friendship even though we expected never to see each other again. When I told him we were coming back, he insisted on coming to pick up my family at Johns Hopkins airport.

What was he doing beside a stretch limo? And why was Nick's dad in a chauffeur's uniform and cap? It turned out that Nick's dad had taken up a side job on nights and weekends, and that job was driving a limo. He had worked this out with his boss. Our return to America—our homecoming—took on a dreamlike quality.

The first day of school was just as surreal. I had done second grade and third grade in Ahmedabad; now, for fourth grade, I returned to the same elementary school in the same Cleveland suburb, surrounded by the same classmates. Even the school bus number was the same. My dislocation/relocation might never have happened. If I had never moved to India at all, never learned Gujarati and Hindi, mastered all those multiplication tables, withstood long bouts of diarrhea and vomiting, discovered a love of sitafal and jeera soda, rubbed ice on my forehead in the hundred-Fahrenheit-plus heat, spent afternoon hours trapping flies in medicine bottles, gotten to know and love two dozen cousins, buzzed around Ahmedabad helmetless on the back of a Bajaj scooter—I would have been right here, I thought, watching this exact teacher write *Mrs. Fisler* on the chalkboard, the very same set of school supplies on the very same desk, glossy Transformers folders with Optimus Prime on them, freshly sharpened Ticonderoga Number 2 pencils, and this same bottle of Elmer's School Glue, milk-white, with the cow on the logo.

I stuck out just as much here, I realized, as I had there. My self-perception inverted a second time. A year before, at the Gujarat Law Society, I had been oversized and fair-skinned. Now, at Millridge Elementary, I was scrawny and dark. I felt like a shapeshifter whose shapeshifting was out of his control. Or a reverse chameleon: intent on *not* matching his surroundings.

A deeper, more permanent transformation had taken place in me. Just as ten years in America had changed my parents, two years in India had changed me. Within months, I started showing the signs. Neither country had absorbed me, so I fled to a third country, where no one had a body, where all the people were made of words—the undiscovered country of the library. There I encountered my tribe: literary characters, historical figures, and the writers who brought them forth with words. There I found identity, belonging, truth, religion. There I found myself, at last, at ease in my own skin.

2

THREE KRISHNAS

During those two years when I thought I must make my exile my home, repatriated to a country I never thought my own, a portion of my horror centered around food. No strawberries? No pepperoni pizza? No *Coke*? This was the semi-socialist India of the 1980s, and certain staples were not to be had. ThumbsUp was an unsatisfying knockoff, the color of Coke but not the real thing. I longed for the smushy cloud of enriched white flour that used to swaddle my grade school mayo-lettuce-bologna sandwiches. Alas, India had no lettuce, no mayo, no bologna. I wished I had known before we left! I could have savored all those tastes and textures, said goodbye to hot dogs and cold cuts one last time.

No more Saturday morning cartoons, either. Years later, Ahmedabad's terraces would mushroom with satellite dishes, but back then we had one television channel, Doordarshan, which carried staid ladies in flight-hostess sarees robotically reading the news. Once a week, though, the state-run channel redeemed itself. We happened to have moved to India when the TV versions of our ancestral epics aired for the first time.

We watched them . . . well, religiously, I guess. A mustachioed villain in brassy armor and a foot-high crown would shoot an arrow that paused at

the center of the screen while the background raced past, the arrowhead fountaining like a Diwali sparkler. The hero, in his own chariot, would fire an arrow back, and the two arrows would meet in midair with a thunder-crack. Closeups on the two combatants, outraged and shocked at this outcome. Monologues padded each episode, and, at moments of parting or self-sacrifice, so did elegiac songs. As unwatchable as they seem today (to me, at least), those television series were my first exposure to the epics, and they gave me the first Sanskrit words I ever learned. Characters often said "avashya," which means "certainly," and sages blessed young women with "saubhagyavati bhava," which means, essentially, "may you stay unwidowed"—no doubt an important blessing in the age of heroes.

Nitish Bhardwaj, so iconically Krishna that he reprised the role in a 2016 stage play, almost thirty years after his initial portrayal.

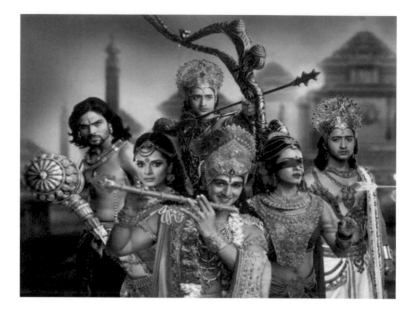

The cast of a 2013 television serial, with Saurabh Raj Jain front and center as Krishna. To the left of him is Pooja Sharma, the actress who portrayed Draupadi.

Whoever did the casting for those series had a major influence on a whole cohort of Indian Hindus, since we saw so many of our civilization's central figures in those physical forms. The impressions went deep; I can still conjure up the faces of the actors who played Rama, Sita, Ravana, Lakshman, Krishna, Arjuna, Duryodhan, Draupadi, and a whole host of other characters. I was too young and too ignorant to assess the casting choices for myself. Only years later did it strike me that Nitish Bhardwaj, a light brown–skinned Maharashtran, might have been a wildly (and tellingly) wrong pick for a character named Black.

Behind that choice, and behind all the consistently coffee-colored Krishnas of the Indian screen, lie three thousand years of history, religion, self-image, and self-loathing.

India and Indians were not always ashamed of the melanin content of their skins. Indian antiquity, like every other civilization of which we have record,

had its fair share of hierarchies, but color rankings don't seem to be one of them. Among the earliest Sanskrit texts are the *Upanishads*, and skin color almost never comes up. When it does, it takes for granted that Indian people (then as now, apparently) come in many shades. The *Brihadaranyaka* ("Great Wilderness") *Upanishad* is one of the earliest we possess, antedating the founding of Buddhism by at least a century. Prospective parents are given a way to pick what color child they would like:

> If one wishes that his son should be born of a fair complexion, that he should study the Veda, that he should attain a full term of life, they should have rice cooked with milk and eat it with clarified butter. . . .
>
> Now if one wishes that his son should be born of a tawny or brown complexion, that he should study the two Vedas, that he should attain a full term of life, they should have rice cooked in curds and eat it with clarified butter. . . .
>
> Now if one wishes that his son should be born of a dark complexion with red eyes, that he should study the three Vedas, that he should attain a full term of life, they should have rice cooked in water and eat it with clarified butter.
>
> *Brihadaranyaka Upanishad*, VI. 4:14–16, in *The Principal Upinshads*, translated by S. Radhakrishnan

If anything, the hierarchy is reversed: the wished-for dark-skinned child studies *three* Vedas instead of just one. (At that early phase of Indian history, there were only three Vedas in existence; a fourth would not be added for centuries.) A learned, long-lived daughter requires the parents to eat rice cooked with sesamum. Modern Brahmins, many of whom have shifted to a lactovegetarian diet, might not expect the recipe two verses later. If parents wish that their son be "learned, famous, a frequenter of assemblies, a speaker of delightful words, that he should study all the Vedas, that he should attain a full term of life," the text advises them to cook rice with "either veal or beef." This seems to be the most glowingly described, most desirable child of the lot, and though that child's gender is specified (male, as you might imagine), the skin color isn't.

In the Hindu tradition, Krishna isn't the first instance of blackness distinguishing the divine in human form. The *Mahabharata*, chronologically, was composed second; the earlier epic is the even more famous *Ramayana*, whose earliest parts likely date back to the seventh century B.C. as well. The poet Valmiki points out Rama's skin color in the first *sarga* of the first book of the epic:

> His proportions are perfect and his limbs well-formed and symmetrical.
> Dark is his complexion, and he is valorous.
> Valmiki, *Ramayana*, v. I: *Balakanda*, sarga 1 verse 11, translated by Robert P. Goldman

This, of course, did not stop Ramanand Sagar from casting the wheat-colored Arun Govil as Rama.

The name "Rama" itself, though most commonly construed to mean "delightful," may be a synonym of Krishna: according to British scholar M. Monier-Williams's Sanskrit-English dictionary, in the Atharva Veda, "Rama" means "dark" or "black." Regardless, Vishnu is the God of whom both Rama and Krishna are avatars. The *Thousand Names of Vishnu* describes Vishnu himself as dark: "megha-shyamam" ("stormcloud-dark"). One of Krishna's epithets, in a millennia-spanning body of devotional poetry, takes up this name: Shyama ("Dark One").

Three Krishnas constellate the *Mahabharata*. The Krishna of temples, kirtans, iconography, ISKCON, and the *Bhagavad Gita* is merely the most famous. Two other characters share his name. Their skin color is not irrelevant. They are named for it, and in the visual language of the epic, their blackness marks them as superior in some trait—literary genius in one case, beauty in another. Together, the three Krishnas warp the epic around them, black holes that originate, drive, and guide the *Mahabharata's* galactic sweep.

The *ka* sound in Krishna comes from Kama, the winged archer whose Greek equivalent is Eros. The name's *ish* sound comes from a Sanskrit word for the divine, the specific meaning of which is "controller." Compare this to "ishwar," a common synonym for "God" in several modern Indian languages,

and to the title of the *Isha Upanishad*. The name itself, considered as a whole, is a near-homonym of the word "kritsna," which means, appropriately, "entirety," "all," or "whole." Krishna uses the word once, in a seemingly deliberate alliterative pun, in the *Bhagavad Gita* (4.18). The context is how a yogi, seeing the paradoxically identical nature of inaction and action, completes his work on earth. Krishna's phrase is *kritsna-karma-krit*, and it means, colloquially rendered, "he does it all"—an excellent descriptor of the all-sustaining Vishnu. A more exact rhyme, though, connects the female form of the name, Krishnaa, and "trishnaa," the Sanskrit word for "thirst" or "desire," and a name of Mahakali (the "Great Black Goddess") in Shaivite theology.

What's in a name? A dense network of mythological and theological connections encoded in a few syllables. This is why a major meditation technique is simply repeating a sacred name. Known as japa, the technique has hypnotic, illuminating power; syllables reveal secrets. (One paragraph is enough to parse the phonetics and etymology of "Krishna." Doing the same for "Rama," the sacred name most often used in japa, would take an entire book.)

The first Krishna, the one at the epic's origin, is more commonly known as Vyasa. Vyasa is a descriptive title; it means "arranger" or "compiler" and refers to his role in Sanskrit literature. Vyasa compiled the Vedas and composed the *Mahabharata,* the world's longest epic. Then, far from retiring to the equivalent of Stratford-upon-Avon, he knocked out the eighteen *Puranas,* or "Ancient Tales," collections of stories about the Gods.

Did he really write all of the works attributed to him? There are three writers so influential, so seemingly superhuman, that learned men dispute whether they ever really existed, or wrote all the works attributed to them. I add Vyasa to a short list with Homer and Shakespeare.

Vyasa, in a metafictional move three millennia in advance of Borges, is both the composer of the *Mahabharata* and the grandfather of the epic's warring factions. Author and ancestor, poet and progenitor, his full name was Krishna Dvaipayana, literally "Island-born Black." The archetype of the Brahmin, he embraced an ascetic lifestyle, sacred wisdom, and poetry. Vyasa's mother was a fisherman's teenaged daughter who had premarital sex on a ferryboat. A randy ascetic (and soon-to-be absentee father) called down a fog to hide the ferryboat and what they did to make it rock. Her secret baby

was "Island-born" because she rowed out to a deserted island to deliver. His skin was so black that no other name suited him but Krishna.

The greatest creative genius in Hindu antiquity has black skin. So does one of its most beautiful women.

The name most commonly used for her is "Draupadi," but that too is a descriptive name, meaning "daughter of Drupada." King Drupada himself gave her a different, more descriptive name. In Sanskrit, the *uh* sound at the end of a word indicates male gender, the *ah* sound, female gender. Draupadi's original name was Krishnaa, and she is the fiery black woman of Hindu mythology.

Fiery, literally: in the epic, she is born from a giant fire. King Drupada had trouble conceiving children, so he arranged for a large-scale sacred ceremony. Vedic rituals center fires, and Drupada's childbearing ceremony required a massive one. The epic describes King Drupada's new daughter, a literal godsend, walking fully grown out of that fire. The darkness of her silhouetted figure only darkens further as she emerges. Vyasa compares her complexion to black beryl. Her appearance is striking to the point of being surreal; "her complexion was dark," writes Vyasa, with

eyes like lotus petals and curly blue hair. . . . her body was redolent with the sweet fragrance of the blue lotus.
 The Mahabharata, Adi Parva, translated by C. V. Narasimhan

Draupadi's blackness, too, has been missing from Indian television screens. Vyasa's poem named her Black and described her complexion, but the television version I watched in the late 1980s imagined Draupadi as a golden-skinned Bengali woman named Roopa Ganguly. A Tamil television series that ran between 2013 and 2016, *Mahabharatham*, cast the similarly light-skinned Nisha Krishnan. A 2013 Hindi adaptation features Pooja Sharma, who matches her predecessors. Indian casting directors have been stubborn on this point. The most absurd casting choice of all, though, was the 2008 television serial, *Kahani Hamaaray Mahabharat Ki*, whose Draupadi was Natasha Hassanandani—a Sindhi actress from the far northwest of the subcon-

tinent. Sindhis are known for their light skin and light eyes; Hassanandani's skin seems, from the available online photographs, almost white.

These casting choices aren't just the result of an ignorance of the source text. They were made with Indian audiences in mind, including those in South India, where complexions tend to be darker than in North India. Fair skin is what Indians imagine to be the pinnacle of beauty now, even though their own, civilization-defining, sacred texts insist otherwise. That profound rupture in the Indian self-image can't be attributed to caste, since Vyasa, Draupadi, and Krishna have been revered, and their dark complexions emphasized, for millennia of Hindu history. Eliding Draupadi's salient and significant blackness has kept dark-skinned Indian women from seeing themselves in the most beautiful woman in Indian epic poetry.

Draupadi's intoxicating melange of black skin and blue hair and lotus scent drives the action of the epic—because it drives the men of the *Mahabharata* mad with desire. Shortly after she is born from the fire, Draupadi goes on to marry five royal brothers, the Pandavas. Vyasa describes this arrangement as exceptional, even scandalous; it wasn't common for the time, and it remains the only example of polyandry in the two Hindu epics.

The eldest Pandava brother wagers and loses her in a foolish dice game with his scheming cousins. The cousins drag Draupadi into the gaming hall and try to strip her. She's wrapped in a single bolt of cloth. At the time all this is happening, she's in seclusion in the palace because she's having her period. The cousins want to humiliate her five husbands and see her mysterious dark body at last, so one of them starts pulling at her garment. He keeps pulling, but there's always more to go. She's an infinitely high kite he can't tug down to earth. At last, he drops his arms. Exhausted, he staggers into the hill of cloth he's piled behind him.

Krishnaa got through that outrage by closing her eyes and communing, in her mind, with a distant friend with the same black skin and the same name. The epic hints at a mysterious connection between them, the connection of siblings, or twins. As she endured that long but mercifully futile stripping, her face, hands, and trembling lips resembled the act of prayer. Hers is probably the first documented prayer to the third Krishna of the *Mahabharata*.

3

DISLOCATED BOYHOODS

The Penguin Classics one-volume edition of the *Mahabharata* stretches to 912 pages and consists of a few arbitrary selections, eleven percent of the actual text, linked by long italicized summaries of the skipped parts. This is a prose translation; a verse translation would have further inflated the page count with white space. Bibek Debroy's complete prose translation, published in 2015, takes ten hefty volumes. The epic contains origin stories, side stories, digressions into statecraft, a full-scale retelling of its own predecessor epic (the *Ramayana*), and even an interlude that has risen to the status of scripture (the *Bhagavad Gita*).

So much material! Yet it doesn't contain stories of Krishna's childhood. In fact, Krishna shows up very late in the epic. Vyasa introduces him in a way that hints at the mystical connection of the epic's "black" characters: we first meet Krishna at the competition where princes compete for Draupadi's hand in marriage. Arjuna is the Pandava brother who wins her with his skill in archery. He manages to shoot a mechanical fish (through the eye, no less) circling over his head, using only its reflection in a pool of water at his feet. Krishna oversees that wife-winning exploit just as he later oversees Arjuna's war-winning exploits on the battlefield.

Minor characters often merit elaborate backstories. Yet Krishna gets no digression in the epic that loves digressions.

It seems Vyasa felt Krishna's boyhood would take a whole separate book. Or even two: legend has it that Vyasa wrote the *Bhagavata-Purana* (*Ancient Tales of the Blessed One*) as well as the *Harivamsha* (*The Lord's Lineage*). These are the books where you can read Krishna's backstory. Yet even in those ancient sources, you don't find one of the most enduring stories about Krishna, which is his love affair, as a teenager, with a married older woman, Radha.

In fact, Krishna's childhood exploits (adventurous and amorous) seem to have captured more minds than his work as a philosophical teacher. Eight hundred sculptural panels related to Krishna survive from before 1500 C.E.; only three concern the Krishna of the *Gita*. Of the Krishna-related iconography Gopinatha Rao identifies in his 1914 *Elements of Hindu Iconography*, almost all feature him as an infant or young boy.

India, like all premodern societies, did not have a high literacy rate; scholarly commentators expanded on the *Gita* in texts accessible to a lucky few. Some of its more abstruse ideas work best to stimulate deep discussions between a guru and a pupil—one on one, as it was originally imparted by Krishna to his friend Arjuna. Krishna knows his teaching has an intimate, esoteric quality:

But since you aren't scoffing,
I'll proclaim to you the utmost secret . . .

A royal wisdom, royal secret . . .
 Bhagavad Gita, 9:1–2, translated by Amit Majmudar

To draw the masses to him, he offers—as gateway drugs to the *Gita*—beauty, danger, love, and laughter. Krishna's boyhood has stayed popular with poets, musicians, artists, and sculptors for thousands of years. (One of his eponyms is Mohan, which means, roughly, "Spellbinder.") This book is just one more example of his knack for transfixing poets. I studied and translated the *Gita* for years before I sat down to write these chapters about Krishna's boyhood. I suspect I went about things in reverse order.

The creativity Krishna inspired among Indian artists wasn't just a drive to rework old material at the level of form, tune, telling. It was generative. Stories like the one about Radha got *added* as time went on. This kind of thing happens wherever you don't have a strict priesthood policing the fanfiction of believers. Hinduism is a multicentric religion, regulated lightly, if at all. Its superabundant poets exercise poetic license even in religious matters.

A near-universal philological consensus claims that the final book of the *Ramayana*—the notorious one where Rama exiles the pregnant Sita— never actually came from Valmiki's quill. The "Uttarakanda," or "Book of Answers," was tacked on a few hundred years later by a lesser poet. Take it from someone who has read the whole epic—the change in authorship there is painfully obvious. But that didn't keep the fanfiction from becoming part of the official account.

Even in a one-founder Indian religion, poetic encrustation starts happening. The Buddha accumulated over five hundred "Jataka tales," which recount his past lives. The phenomenon started happening in the first few centuries after Jesus's death until early church authorities excluded some gospels as "apocryphal" or "heretical." They had good reason to do so. In the *Infancy Gospel of Thomas*, for example, young Jesus kills two boys: the first boy spills some water that Jesus was collecting, so Jesus curses his body to wither; the second boy makes the fatal mistake of bumping into Jesus. When the second boy's grieving parents dare to complain, Jesus strikes them blind. Eventually, after arguing with his teacher, the young and impetuous Jesus comes around, reverses his murders, and restores the sight of the grieving parents. If such apocryphal gospels hadn't been quashed, if they had been allowed to percolate through Christendom unchallenged, they might have damaged the brand a bit. Hinduism never quite developed the idea of apocrypha when it came to texts, much less heresy when it came to beliefs, and so the last book of the *Ramayana* has hitched itself to Valmiki's epic, and Rama's life story, permanently.

Krishna has fared better with latter-day storytellers. Aside from persnickety moralists who dislike how he gallivants with village girls and Radha— though even that promiscuity has its metaphysical interpretation—Krishna's

boyhood stories are pure delight, full of derring-do, romance, dancing, demon-slaying, and high adventure.

That joyful childhood begins, though, in tragedy, injustice, and horror: an emaciated, bearded man kneels between the thighs of a skeletal woman; she writhes in the throes of labor as lightning cracks the night. Krishna's story begins in a prison.

My eight-year-old daughter started wearing a little pendant with an image of baby Krishna this week. His skin is blue-black, his hair is black and curly, and he has a little pot of butter next to him. The pendant is about the size of an almond, and I don't know where it came from. It just sort of appeared in the clutter in her bedroom while she and her mother were cleaning it. She tracked down a chain, and now she even wears it to school. I confess, I am very superstitious. I've taken the pendant's appearance as a sign that I should write this book, and every time I glimpse it on her, a lightweight trinket but shining uncannily, I think, *Write that book already*.

We knew a family whose elderly, widowed grandmother had gone deep into the worship of "Bala Krishna." A murti of the crawling Baby Krishna received all the attentions of a new mother. Knob-knuckled, arthritic hands soaped and rinsed and clothed him, tilted a thimble full of milk to his lips, swaddled him in a tiny sandalwood cradle. The octogenarian widow had regressed not just to a twenty-something mother but to a girl playing with a doll. Her devotion had become extreme. Her grown son explained that she wouldn't take a trip anywhere because she could not forgo the care and feeding of her little one. He wasn't complaining; resignation softened his voice, as though he were describing dementia.

At the time, I remember cringing inside at his story—such silly, superstitious, embarrassing pieties! Yet all these years later, I think it's beautiful. For whom, exactly, was I embarrassed? That brass murti of a baby had passed some of its youth to an old woman. The *Gita* showed Krishna at his wisest, but does everyone need wisdom? Krishna himself, in the *Gita*, explains that bhakti, a direct emotional bond with the divine, is the quickest, easiest, most delightful form of yoga. It's the spiritual ascent that feels downhill all the way. Why should I care if she mothered a statuette? I have come to treasure

the plurality of modes and customs of worship. This religion enjoys the thriving biodiversity of a rainforest.

I had an uncle who, in his kooky old age, became a great devotee of Hanuman. On a later trip to India, a few years after we had resettled in Ohio, we visited his house. I smirked to see him burst in with a giant smile on his face and bright orange goop smeared on his forehead and both earlobes. (Every evening, on his route home from work, the temple beckoned him with its bright bells. He ducked in, said his prayers, dropped a few rupees in the bin, shut his eyes—and got smeared with joy.) The orange goop and the smile on his face came from the same hand. They were a single gift. I had years to grow before I could learn to receive that intellect-transcending gift. Before I became simple and emotionally open enough to be worthy of it.

It took me a long time. Hot summer afternoons in Ahmedabad drove eight-year-old me to strip down to nothing more than an orange stretch of silk left over from one of my mother's sarees. I tied it around myself so I looked like a holy man in a saffron dhoti. I went around the flat muttering fake Sanskrit slokas and bestowing blessings, right palm out, on the houseflies I would later hunt and kill. Every so often, I would fetch a couple steaming ice cubes and rub them over my chest and face until they slid into water and evaporated. What was that masquerade? I was mocking the forms of religion, true ... but what possessed me to mimic the forms of religion in the first place?

After we returned to America, I stayed skeptical. A grainy VHS cassette shows my family attending, or really observing, a kirtan at a West Virginia ISKCON temple. White Hindus with shaven heads had costumed themselves in the garb of my ancestors; I had costumed myself in jeans and T-shirt and enormous gold-rimmed glasses, while my physician father wore a white polo and slacks. In the footage, we watch with detached bemusement as the Americans get into it, swaying their heads and skipping in a circle, one guy banging a dholak, his hairless white head intersecting with my mental stock image of a white supremacist skinhead. *Hare Krishna, Hare Krishna, Krishna Krishna, Hare Hare.* My dad and I start bobbing along with the rhythm. My mom, my sister, and a few relatives keep their distance as he and I launch into the circle with mischievous smiles.

About a year ago, we found that footage and guffawed at it, we two men of the world. We were levelheaded, rational, not the type to get caught up in such excitements—but we had still skipped around and made wild, flapping, jabbing moves with our arms. We had slipped into the dance without our hearts becoming part of the dance. We had maintained our ironic distance; we had adopted the form of religious ecstasy in the spirit of mischief. Why leave the peripheral onlookers at all, though? My irony was halfhearted.

Within a few years, I ventured into the Eastern Philosophy section of the local library. Then, on a trip back to visit Ahmedabad, I begged my most book-ish uncle to brave the traffic and take me to a bookstore downtown, one that sold Sanskrit books in translation. I wrapped hardbacks of Kalidasa and Vyasa in my clothes to keep them safe in our check-in bags. Enough with spy thrillers and detective novels; by age thirteen, I had entered the dance in earnest.

The infant Krishna grew up to dance, but he spilled from a womb's water-tight enclosure into the brick- and bar-bound enclosure of a jail cell.

Krishna's uncle, King Kamsa of Mathura, had given his cousin Devaki a proper Indian wedding, with musicians, long tables of hot food, and el-ephants trumpeting the groom's arrival. Vasudev came from an illustrious family—his sister was Kunti, who would become, years later, the mother of the Pandavas. After the ceremony and reception, King Kamsa himself offered to drive the newlyweds home. On the way, a voice, real or imagined, boomed down from the sky. It mocked him for colluding in his own downfall: the eighth child Devaki bore would be the death of him.

The newlyweds' honeymoon and first home was a dungeon in Mathura. There, Vasudev and Devaki conceived child after child. Vasudev delivered and passed each newborn to Kamsa, who swung it by the ankles so the skull burst against the prison wall. Every infant involved two horrors. The murder was the second; the first was the stubborn, animal compulsion to conceive it under the sign of death.

By the time Devaki became pregnant with Krishna, six bloodstains splotched the bricks: a running tally. There had been a miscarriage, or what Devaki thought was a miscarriage, shortly before this pregnancy. While De-

vaki miscarried in prison, Vasudev's first wife Rohini, hiding at the time in the countryside, conceived Balarama, Krishna's white-skinned elder brother. The tellings don't entirely explain how, but Balarama must have been hardy enough to withstand the transplantation. He would grow up on a farm, preternaturally strong and warlike. A wooden plough, taken up in his powerful hand, swung and spun and smashed as deftly as a bat.

When it was Krishna's night to be born and murdered, mysterious things started happening. An out-of-season, monsoon-heavy storm hid the cries of mother and newborn. In spite of all the thunder, the prison guards snored in their chairs. Cell door after cell door unlocked and swung open. Vasudev knew divine intervention when he saw it. Swaddling baby Krishna in a wicker basket, he set out into the storm, crossed a river, and found his way to the faraway house of the cowherd Nanda.

That night, a daughter had been born to Yashoda, Nanda's wife. Vasudev would be spared the sight of his son brained in the jail cell, but he would have to carry out something just as howlingly unjust, as if, like energy, the sum total of horror and injustice in the world had to be conserved. So he switched out Nanda's child and his own, switched their destinies. The beast had to be fed.

Vasudev and Devaki pleaded with Kamsa to spare this child because she was a daughter. The *Bhagavatam* tells how Devaki clung to the girl, whose hair was still wet with vernix from Yashoda's womb. Kamsa pried away the newborn and dashed her against the stone floor.

The luminous figure of a Goddess rose from the newborn's corpse. Her imperious reproaches humbled Kamsa, who set his cousin and her husband free after his dressing-down, apologizing (as if an apology could cut it) for killing their children.

A few days later, the king regressed to his paranoid brooding. His ministers explained that the real child—a son, a future usurper—must have been smuggled away, if not by Vasudev then by divine intervention. They urged him to

kill all the babies who are ten days old, as well as those who are not yet ten, in all the towns, villages, and pastures.
Krishna: The Beautiful Legend of God (Srimad Bhagavata Purana Book X), part I, ch. 4, translated by Edwin F. Bryant

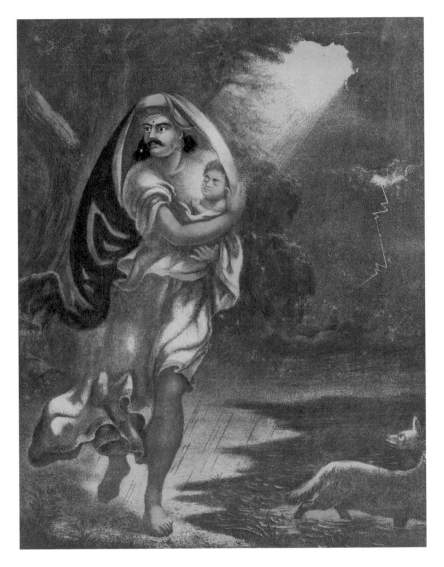

Vasudev braves the elements to smuggle his newborn son to safety.

Kamsa, fearing the power that had snuck into the world and escaped him once already, agreed that a massacre of infants was the only way to stay safe on his throne. Rather than send his own troops to commit the crime, he called on a series of supernatural killers. Krishna the demon-slayer would get an early start out there in the countryside of Vraj. His fight to survive would begin in the cradle.

King Kamsa's decision to kill off the newborns in his kingdom resembles Pharaoh's decision, in the Book of Exodus, to kill all the firstborn sons of his Hebrew slaves. He, too, feared a challenge to his rule. Stories echo stories echo stories: Hera sent two snakes to kill the baby Hercules; in Thebes, as in Vraj, a future hero lay at risk in his cradle. At the end of Krishna's life, a hunter's errant arrow hits him while he's resting, and Krishna dies from it. The arrow pierces a part of the body familiar from the story of Achilles: the heel.

Stories echo stories, yes, but often, whether they're in Aesop or the Arabian Nights, they originated in India. Even lesser-known medieval tales like *Barlaam and Josaphat* end up having an Indian original, in the latter case, a Buddhist one: the Sanskrit word "bodhisattva" became "Josaphat" by morphing its way through Persian, Arabic, Georgian, Greek, and finally Latin.

The ancient Greeks found their way, through invasion and trade, into India. The Indians called them "Yavanas," a mangling of "Ionian." Texts as early as Valmiki's *Ramayana* refer to them, and a statue of Lakshmi was even unearthed in Pompeii, in a room that has been named for the find. Who knows which way these stories traveled—if they traveled at all? Stories may well show up independently in more than one place for the same reason stories travel: the same stories work well on people, time and time again, regardless of where or who they are.

I do notice one all-too-merciful touch in Vyasa's telling of Krishna's birth story, though, and that is the Goddess who reveals herself after Kamsa kills the switched baby girl. The Goddess's appearance mutes the grotesque violence of the moment and absolves Krishna's father, Vasudev, of some of his guilt. With Krishna's six siblings, the imprisoned couple had no choice; they were purely victims. When Vasudev escaped his prison, took someone else's newborn out of the cradle, walked all the way back, and waited for his wife's

psychotic cousin to show up, he collaborated in the killing. What's worse, the deception doesn't even work for long, and even backfires: Kamsa, realizing he must have been duped, decides to target all the newborns in his reach.

In the source texts, the Goddess shows up immediately—above the corpse, above harm. The listener's attention gets diverted from the dead infant girl. I wanted to use my poetic license to delete that detail. (I already used my poetic license once, though, to relocate Krishna's captive parents from house arrest in a palace to a dungeon.) I have since thought better of it; for Vyasa, I suspect, the moral unease of the moment needed some mitigation. He was probably right. In the *Mahabharata*, Vyasa shows no squeamishness toward nihilistic violence and senseless loss of life. After the war ends, Draupadi's five sons are murdered in their sleep. Yet here, dealing with Krishna's youth, Vyasa planned to tell a series of stories very different in nature, tone, and mood from the *Mahabharata*. Young Krishna would face an infancy and boyhood full of assassination attempts, but he would do so with innocence and playfulness and ease. Even when the wetnurse showed up in Vraj with ratsbane smudged on either nipple.

4

ASSASSINATIONS

Her name was Puttana.

Her figure captivated the farmhands when she sashayed out of the woods. They had no notion of where she had been wandering or what she had been doing. The demoness could fly, so she outpaced the news of the dead babies she left behind her. What the farmhands saw were her full breasts, her arms crossed under them, little wet spots over the nipples where letdown had already started. Yashoda's newborn son wasn't crying, but Puttana's predatory ears could hear the merest gurgle. Her nostrils flared at the new baby smell. Her eyes made the plea to the new mother in the doorway, her arms rising slightly to show she was full to bursting, a raincloud with nowhere to rain. Yashoda nodded and allowed her into the house.

Puttana took baby Krishna out of his cradle and sat on the floor with him. Yashoda tugged the curtains across and left Puttana alone with the baby.

Here you go. Aunty has something for you.

The poison-smeared areola glistened. The nipple beaded with a drop of milk, white as krait venom on a fang.

Drink, little boy. There you go.

She leaned forward so the nipple brushed his cheek. His eyes still shut, he rooted toward the touch, his mouth opening reflexively. With his still-soft skull deftly cupped, Puttana guided him so he latched on. For a moment, they looked like mother and child, blissfully connected. She became, as every mother becomes at that moment, the Mother Goddess. Though her love was calculation, though her giving was a way of taking, a contented smile relaxed her face, her eyes hooded with bliss.

It didn't last long. The smile contorted into an indignant grimace, the eyes widened and bulged. With a small cry, she looked down at the baby. He'd bitten her! He was sucking so hard that his tiny mouth pinched her, downright chewed on her, as if she'd stuck a rodent on herself. Her panicked finger jerked back when she tried to stick it between his cheek and her bleeding breast. The tiny chin worked away. Now he was sucking the breath out of her lungs, the pain out of her nerve endings. Puttana screamed and rose to her feet, but baby Krishna stuck to her leech-tight. Her breast swung, and he swung with it, still sucking and tearing the skin, mingling milk and saliva and blood. Contact with those living fluids activated the poison, which heated up and frothed.

The wet nurse streaked shrieking out of Yashoda's house. The poison, turned back on the poisoner, broke down Puttana's ability to manipulate maya. In other words, all her makeup washed off, all at once. Her illusory body gave way to her real body, pitted and pimpled, hairy and oily, large and lumpen, nothing like the slender round-breasted girl who had transfixed the country boys just minutes ago. Trying desperately to shake the thing loose, she rammed her body into everything around her, knocking over trees and wheelbarrows, even chipping a few bricks off a wall. At last she barreled out of the village and disappeared into the forest. Luckily, a trail of blood and squeals led Yashoda and the village women to the spot where Puttana lay dead on the ground. Newborn Krishna rested comfortably in her cleavage between the bitten breast and the whole one. Puttana's broken skin bubbled and oozed. Krishna gave, at that impossibly early age, his first social smile.

When Yashoda felt her son latch on, she wondered how that wound could have appeared on the assassin demoness. Had this little mouth really done that? No doubt, she thought with a shiver, there had been some sort of

suppurating wound there to begin with, and she had tried to feed him not milk but pus. A mysterious fever would have carried him off.

When Krishna finished nursing, he dropped off to sleep. His body became its own weight in iron, then got even heavier. She had to hoist the little one off her thigh before he fell into dreamless sleep. More than once, after a groggy moonlit middle-of-the-night feeding, she had drifted off with him and woken up with pins and needles in a foot gone cold. The only way to get him off of her was to pinch him awake. He unremembered his own nature and returned to his human weight.

On the day he sat up for the first time, Krishna's parents and all the adoring villagers held a small party. Afterward, Yashoda fed him and set him down and returned to chat with her neighbors. They were marveling at how precocious the baby was when a sudden sandstorm filled the air. What was the desert doing here in leafy, lovely Vraj? The villagers squinted into the endless golden whoosh, all points and no needles. Yashoda called Krishna's name in alarm, and her mouth filled with grit. She dead reckoned her way back to her house, but the sandstorm hid the door. *Krishna!*

The sandstorm began to circle itself counterclockwise. As it did so, it dropped the sand and became pure wind. The grains covered everything, but no one noticed. What filled the sky now focused to a dark tower. The top of the tornado flared into a torso and arms and head. His beard was made of whipping vines, ropes, and clotheslines; his flashing teeth were so many tin roofs; his nostrils were wind tunnels straight into the hell of his hunger. Yashoda realized she was looking at another demon, another assassin, just as her baby floated through the sky and spun up the tower into Trinavarta's arms.

The demon torqued and swept a cape of thunder across his escape. The thunder's echoes died out into laughter. Only Krishna had seemed unbothered by the ruckus and whirl. He had been taking his afternoon nap, and this interruption woke him up only briefly. Sleep carried him down even as Trinavarta carried him up, and soon Krishna was dreaming as Vishnu, reclining on the Sea of Milk, supported by a giant serpent. Krishna contained the weight of the cosmos and what buttresses the cosmos. (A black hole, the

speculation goes, is really just a star with all its starstuff packed down to an impossible density.) Krishna darkened in Trinavarta's embrace. The demon tried to dash Krishna to the ground, as tornadoes do everything they pick up, but Krishna was too heavy to lift. The tornado-torso tilted, and now the baby was on top, forcing the assassin down to the earth. Tree trunks ripped skyward, root networks and all. Leaves, rocks, and splinters sprayed aloft as his back grated the earth. Pinned by Krishna's weight, Trinavarta could not move, and a wind that cannot move is a wind that dies. His chest struggled to rise, and the last sound he heard was his ribcage crumpling. The demonic tornado diminished to a dust devil, then to a trivial whish, then to a whisper, then to silence.

Yashoda, Nanda, and the villagers found Krishna sound asleep in a clearing. Yashoda's scream had delight in it, and fear, and finally gave out into a shudder of relief and gratitude. Krishna awoke when he heard it, but before he could let out a cry, she lifted him effortlessly. She spun with him in her arms.

Krishna shows his universal form only three times. The most famous instance is in the eleventh chapter of the *Bhagavad Gita*:

> Look at me, Partha—forms,
> A hundred, more, a thousandfold,
> Divine multiplicities,
> Multiple colors and shapes!
>
> Look now at the cosmos whole, at everything
> That moves and everything that doesn't,
> In my body standing here as one
> With whatever else you wish to see!
> *Bhagavad Gita*, 11:5, 7, translated by Amit Majmudar

Krishna shows that form to Arjuna ("Partha" in the passage above) out of love and affection, but also to persuade him of the transcendence of his cause and the triviality of his own life and death on the battlefield.

Immediately before the war, though, Krishna heads over to Hastinapur on a mission to avert it. When the Kaurava prince Duryodhan, insisting on conflict, tries to capture Krishna, the negotiator reveals himself as an intimidation tactic.

There's only one time that he shows his universal form playfully, and it's to Yashoda. Krishna is a little older when he does it, walking, talking, playing on his own with the other village boys in Vraj. They like to wrestle the calves and hang on to their tails. One day, Balaram and the other boys shout to get Yashoda's attention—Krishna's been eating dirt! Yashoda rushes over to reprimand her boy, but he denies the charge, even though he has flecks of mud on his mouth. If she doesn't believe him, he says, she's welcome to look in his mouth.

Yashoda calls his bluff, and Krishna opens wide—wider than any mouth has opened before.

> Yaśodā [Yashoda] saw there the universe of moving and non-moving things; space; the cardinal directions; the sphere of earth with its oceans, islands and mountains; air and fire; and the moon and the stars. She saw the circle of the constellations, water, light, the wind, the sky, the evolved senses, the mind, the elements . . .
>
> She saw this universe with all of its variety differentiated into bodies. . . . She saw the time factor, nature, and karma. Seeing Vraj as well as herself in the gaping mouth in the body of her son, she was struck with bewilderment. . . .
>
> *Krishna: The Beautiful Legend of God (Srimad Bhagavata Purana Book X)*, part I, ch. 8, translated by Edwin F. Bryant

Immediately after showing her the vision—and the nested, infinitely recursive detail of herself looking in his mouth—Krishna wipes her memory.

In the *Gita*, the vision lasts longer. The longer Arjuna looks, the more terror he feels. The blackness of the black hole, the void, annihilation: that, too, is the blackness of Krishna. If the form had lingered any longer, Yashoda would have seen those aspects of it.

So Krishna cuts the vision short and restores the merciful illusion that he

is her son. It's a double illusion, since even in Vraj, he is really Devaki's son. Taking Krishna into her lap, her anger forgotten along with that synoptic snapshot of the absolute, Yashoda returns "to her previous state of mind, with her heart full of intense love." Krishna is the child. Yashoda is the innocent.

Our flat in Ahmedabad contained only one set of children's books. None had to do with Krishna, Puttana, or Trinavarta. The stories I read during my two years in India were all Russian fairy tales translated into English. Immense, glossy hardcover books rested on my bare brown knees, and I swear they were always cool to the touch.

Baba Yaga's house hopped up onto its chicken legs and ran off into a wintry illustrated forest. The firebird flickered and swooped through my imagination before I had ever heard, or even heard of, Igor Stravinsky. A pale, yellow-haired prince in a doublet of intricate green braved a dragon. A rescued princess had a face whose mournful beauty I would see again, years later, among the Jewish refugees who ended up in Cleveland after the breakup of the Soviet Union.

In the decade or so before its collapse, the USSR ran a cultural outreach campaign in India—or a propaganda campaign, depending on your per-spective—that handed out tens of thousands of Russian children's books to Indian students. I was one of those students, and I can report that the campaign worked. To this day, I love a Russian fairy tale even more than a Russian novel, a love that has since extended to vintage Soviet animation. Those board books are long gone (how I wish I'd saved them!), but I own Alexander Afanasyev's compendium and keep it on my top bookshelf. The board books I was gifted had no proselytizing content, probably because the fairy tales draw from a deep, pagan past. (That house on chicken legs didn't walk out of the Bible.) Fairy tales and folktales emerge among unlettered commoners, who have considerably less interest in religion than the priests and intellectuals behind most "textual sources." Those Soviet illustrators often used iconography as the inspiration for their work, and the imagery of Orthodox churches evokes more than admiration in me. I feel a sense of nostalgia and fondness. It's part of my personal history, even though I'm not an Orthodox Christian.

What about children's books that retell the stories of young Krishna? They exist in abundance, and my wife and I have made sure to get them for our three children. We want to lodge these stories and images early so a sense of identity crystallizes around them. I reason that if early exposure worked on me for Russian stories and Orthodox Christian aesthetics, two traditions far removed from my life, the effect must be even more powerful if it's their "own" culture. A little timely indoctrination goes a long way, and with any religion or culture, the stories *are* the doctrines, just in an emotionally stirring, memory-friendly form. Theological concepts matter to intellectuals. The rest of us just want to know what happened next.

Illustrated books from India don't imagine their Krishnas as light brown or nut-brown, as casting directors do. Sanskrit-English dictionaries usually give "blue-black" as one of the meanings of "krishna," though never just "blue," which is "neela." Both terms have overlapping senses of darkness; today, in Hindi, "neela" has an almost exclusive claim to blue. Yet it's blue, often a very light blue, that illustrators choose for Krishna, whether it's *Classic Tales from India,* or *My First Mythology Tale,* or *Sri Krishna Leela for Children.* Blue paint is a purely pictorial signal that says, "This figure is Krishna." Blues of various shades can be found in miniatures and manuscript illustrations that go back hundreds of years and derive, stylistically, from the Persian tradition. Many were made for Mughal emperors and subordinate Rajputs, after the conquest of India by lighter-skinned Central Asians and Turks.

With the advent of British rule, Indian artists began to imitate European realism. In the late 1800s, Raja Ravi Varma painted both Yashoda and Krishna as white. Varma had trouble throughout his career deciding how to color Krishna: his *Krishna,* seated with a flute, is black; his *Radha and Krishna* shows a Krishna colored electric blue. His indecision reflects his divided cultural and artistic allegiances. If you include the paintings he made of Krishna meeting his parents, Yashoda adorning Krishna, and Yashoda posing with Krishna (an obvious attempt at Europe's Madonna-with-Child genre), Varma painted Krishna as white, or extremely light-skinned, more often than not. Yet extant photographs show the artist as a dark-skinned man from Travancore, which is part of modern-day Kerala.

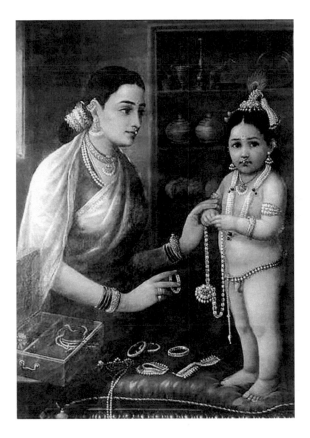

Raja Ravi Varma painted his Krishnas in a variety of colors, and this is one of his lighter-skinned versions; the European influence was not just stylistic.

Are there earlier, precolonial images of Krishna? Most images from extreme antiquity that survive are necessarily sculptures of bronze and sandstone. Paintings don't survive well in India's climate as it is, and when it came to Hindu India's libraries and temples, either a monsoon or a jihad was always storming through. With the murtis that have managed to survive from antiquity, you can tell you're looking at Krishna because of his flute, or a Radha at his side listening to him play, or other iconographic signals. We have no colors to judge.

There is one iconographic set that dates back to 1300 C.E. Located in the state today called Odisha, the Jagganath trio preserves a living tradition that antedates European and Islamic imperialism in that part of the subcontinent. Three neem wood sculptures receive a coat of deliberately chosen paint. Subhadra, the younger sister, is flanked by her brothers. Balaram (here called "Balabhadra") is white. Krishna, the Jagganath ("Master of the World"), is—with his planet-sized round eyes, under his elaborate silks and garlands—unequivocally black.

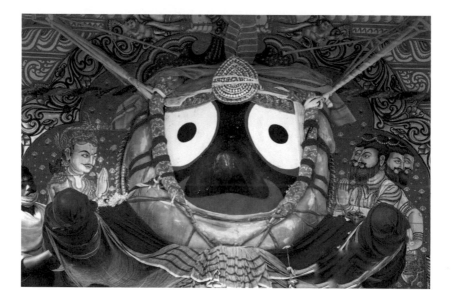

Odisha's striking Jagganath murti, an example of pre-colonial Indian art. Note the unequivocally black color of one of India's oldest, continuously repainted Krishnas.

5

A MENACING MENAGERIE

You are what you remember.

The Somnath Express to Junagadh, its cars a deep, dusty maroon, sped up and settled into sway and clack. This was an overnight train, and we slept on hard beds that folded down from the cabin wall. Short chains held them in place, and the hand that gripped them came away with a rancid metal stink on the palm. I hadn't known metal could rot. Sometimes a train going the other way would pass close enough that an arm, dangled out the window, would have been sheared off. Crossing from our car to the stained, ill-lit toilet exposed me to the swift night. I squatted to spurt loose stool onto the naked tracks.And yet I feel I never slept more deeply than in that rocking cradle of that train car, its two metal-barred windows open to the night air and the occasional cluster of distant lights. Come morning, we would be one or two stations away from Junagadh, and the paused train would attract a boy with a beige thermos full of chai and a chipped cup and saucer.

Indians struck me as weirdly addicted to tea, and my parents were no exception. Back then, it seemed an Indian obsession to me, not an imported British one. Junagadh was one stop short of Porbandar, the birthplace of Mahatma Gandhi; I was a few years away from learning the history that let

me see those ubiquitous chaiwallahs as the result of a foreign empire. Yet even with that book knowledge, the taste—Tiger-Goat with ginger, cardamom, clove, and cinnamon—stayed stubbornly self-assertive, simply what it was, and sure of what it was. Its unlikely hybridity had become original: foreignative, homeperial. No one could take a sip from that chipped cup and think, *Britain*. The East India Company established Assamese tea plantations in the 1830s, but a hundred years later, Indians became the biggest consumers of the tea they used to export to Europe. My tongue remembers the taste of that steaming dawn chai more vividly than my mind remembers what it's read. Something hijacks your history, and you hijack it right back.

It was the British, too, who laid the train tracks, neat as stitches down a cut. A Muslim nawab ruled Junagadh's Hindu majority until Independence in 1947. A second century B.C.E. Buddhist emperor, Ashoka, inscribed an enormous rock in Junagadh with a list of public works. That text mentions his "Yavana" governor, a Greek who ruled that part of India on the emperor's behalf; two of Ashoka's Rock Edicts are in Greek.

Religions and languages, mingled in the region where my parents grew up, make me wonder how many seemingly "foreign" peoples may have swirled together to make me and my family. No wonder Junagadh saw one daughter born dark-skinned and the next one white, but no one thought it odd. It's just like the dark Krishna and his white brother Balarama. South of the often-penetrated Khyber Pass and blessed with a long coastline and businesspeople ready to exploit it, Gujarat is a palimpsest, and Gujaratis are a palimpsest-people. I still remember the time I was reading, out of curiosity, a Greek-speaking Egyptian merchant's log of sea voyages in the first century C.E. That anonymous trader bought, among other things, materials my Gujarati Brahmin ancestors must have used in their Vedic rituals and Ayurvedic medicines:

> Beyond the gulf of Baraca is that of Barygaza. . . . It is a fertile country, yielding wheat and rice and sesame oil and clarified butter, cotton and the Indian cloths made therefrom, of the coarser sorts. Very many cattle are pastured there, and the men are of great stature and black in color.
> *The Periplus of the Erythraean Sea*, section 41, translated by Wilfred H. Schoff

"Barygaza" is modern-day Bharuch, three hours south of Ahmedabad, and "clarified butter" is that common ingredient of Vedic sacrifices and my mother's home cooking: ghee.

I preferred butter to ghee (and still do), especially on a hot roti my mother's dexterous fingers snatched off the flame just as steam ballooned it. She crushed it flat with the char-flecked, softening butter stick that gave it a glisten. I would fold it twice and squeeze the wet butter to the point. Though I loved the dyed-yellow Amul butter well enough, it could not compare to the fluffy off-white butter that came from farmyard milk churned with a stick.

That was the butter of Krishna's childhood stories, and upon my first taste of it, I could see why Krishna spent his free time finding ways to steal it. A spoonful of cloud melted into a thick, buttery oil that seemed to coat my lips no matter how often I licked them. "Buttery" is the wrong word, though. Conventional butter deserves the term "buttery." This stuff *was* butter. It possessed the butterhood to which all factory-packed, storebought butters aspired.

I have tried to suss out the metaphysical significance of Krishna's butter obsession. Some of the stories do have an overt, parablelike aspect: there's one in which Yashoda, angry at Krishna for breaking a clay pot full of butter, tries to bind him with a rope, but no matter how many lengths she ties together, she's always three fingers short—until Krishna, out of mercy, allows her to bind him. That story has philosophical content, amenable to paraphrase: the divine, though beyond our ken, condescends, out of love, to be known. Why butter, then? No symbolic "meaning" seems to fit. My tongue and my memory override logic and invention. My tongue and my memory know better: the kid just knew what tasted good.

Krishna's butter obsession (and, later, his love of women) contrasts him with Rama, the avatar who came before him. Rama was a downright ascetic from the start. The book about his boyhood doesn't recount a single instance of mischief or flirtation. No one knows his favorite food, or if he even had one. Rama's princely boyhood was spent learning to use weapons; shortly after scoring his first demon-kills, the teenaged Rama visited Mithila, won Princess Sita, and never touched another woman or took another wife, though such behavior was common among kings at the time.

Rama grew up not knowing he was what he was. Krishna, the self-aware avatar, decided to have fun. Why take birth in a body if you aren't going to test out your senses? Test out how you can move? The Krishna who binged on butter grew up to dance all night with the girls in Vrindavan. In the meantime, though, he still had a few demons to slay.

After the murderous wet nurse and the would-be kidnapper tornado, assassination attempts come from demons in animal form. A crane with a razor-edged beak swallows Krishna, but he struggles free and breaks the beak with his bare hands. The pieces become stakes to gore his adversary. Later, he and his friends explore a cave together, until the cave mouth shuts behind them—they have been tricked into entering the maw of a giant python, Aghasura. A python's body conforms to its prey, digesting away the contour of the mouse. Cavernous Aghasura, filled with Krishna and his friends, starts to swell *after* he closes his mouth. His body stretches to accommodate the rise of a new moon, that dark celestial body, Krishna's darkness too expansive for any throat to contain—not a poet's, no, not even a snake's, all one throat from head to tail. The bloated python bursts, and daylight reveals the forked tarmac of the tongue, the ribless vaulting of the gullet. Shimmery black-green scales confetti down from the sky.

Animals wander the streets in India. Cows mostly. Only visitors notice them. After you have lived there a while, you forget their presence. They become mere background, as unremarkable as pigeons and sparrows.

Junagadh didn't have much for us to do. During the rainy season, mosquitoes smoked off the ground, homeless and hungry. Come nightfall, we anointed our bodies with Odomos and lit slow-burning insect repellent coils. We scanned the mosquito netting for moth holes and tried to tape any we found. A single mosquito lurking inside the translucent tent could prompt a hunt.

One day, when the rains had stopped, our parents walked us to a small shrine several blocks away. Two stray dogs, I remember, shot down a flat's stairwell and across my path, so close I felt the shiver of their wake on the skin of my shins. Soon the rains would start up again, flood the train tracks, and delay the Somnath Express by a week. Here, at least, was an outing.

The shrine was dedicated to a poet. I wasn't interested in poetry yet and had never imagined myself as a poet. Our extended family had no examples of anyone in the field of the humanities, or literature, or fiscally disinterested fields of learning in general. Imagine my surprise, then, when my parents explained that I was a descendant of this poet.

I have no memory of the shrine itself, other than the image of a small shikara of stained gray stone. All I really remember is climbing a wet road up a hill. The pictures and videos I have found online show a blotchy, weather-beaten edifice, gray and beige, giving way onto a cleanly courtyard with a prayer nook. These resources substitute for my memory. A plastic-looking, dead-eyed statue of Narsinh Mehta, in garlands gaudier than anything he wore while he lived, has a light peach skin color, what used to be called "flesh tone." Most of my relatives are light-skinned, and that may well have been what he looked like. The nearby murti of Krishna, though, refuses to imitate the realist conventions of European statuary. This is an older school of Hindu religious art, abstract but not crude. It has the mystery of a Bran-cusi head, but with bright, white, alarmingly circular eyes. The small murti is almost totally muffled with silks and garlands, but what I can see of the body is absolute black.

Our official family history tells how Narsinh Mehta, nicknamed "Nar saiyo," was a great devotee of Krishna. Mute until the age of eight, he went on to write the most famous and enduring poems in the Gujarati language. My relatives shared his devotional songs, or bhajans. Everyone knew a few stanzas by heart. Mahatma Gandhi's most cherished bhajan was written by Narsinh Mehta. The poem described the ideal Vaishnav, or devotee of Vishnu: someone who knows the pain of others, and who treats women as if each one were his mother. It turned out that the last name "Majmudar" was a title bestowed by the Maharajah of Baroda on an ancestor of ours. Once upon a time, our last name had been "Vaishnav." Narsinh Mehta's bhajan guided Gandhi's choice of last words. A Vaishnav, according to the penulti-mate stanza, is someone who has Rama's name on his lips.

That was all I knew about Narsinh's life for a long time. I spent time with his songs instead. Fifteenth-century Gujarati was familiar enough to understand, except for the occasional humdinger of an archaic line. When

I did my own research, years later, his story turned out to have all sorts of subversive and suppressed details.

Narsinh Mehta had cross-dressed as a gopi when he sang Krishna's praises through the streets of Junagadh. That would have been scandalous even for a man of no repute. Narsinh came not just from a Brahmin family, but from an elite *subtype* of Brahmin, the Nagirs, an elite who looked down on the other elites. (Nagir is pronounced *naah-grr*.) Narsinh cared nothing about his caste or anyone else's. Untouchables wished he would sing for them, too, so he visited their homes in his silks and makeup, and he performed for them. The members of his caste—my family's caste, on both sides—scorned him for his holy antics. His sister-in-law was a shrew who relished reproaching Narsinh for being incapable of holding down a real job. All that good-for-nothing could do was write poetry! Even his poetic devotion to Krishna marked a break with the caste, which focused its worship on another dark-skinned God of the pantheon, Shiva.

My own family has inherited Narsinh's devotion to Krishna. Yet we haven't inherited anything else from him. Some genealogical snooping revealed that we aren't actually descended from Narsinh himself, though he did have a son and a daughter. We Majmudars are descended from Manekbhai, Narsinh's brother—and from that sister-in-law who scolded him for writing poetry.

One of Narsinh's most famous poems is about Krishna besting a demon. Kalinaag isn't one of King Kamsa's assassins, though. He's the dangerous snake who lives in a local lotus pond. Narsinh's poetic account of Krishna going after Kalinaag is playful, singsong, balladlike, the style matching the story.

The poem begins with play: Krishna and his friends are playing a game with a bat and ball, some classical Indian cousin of cricket or baseball, and Krishna hits the ball into a pond. It's the pond where a giant black snake with many hoods is known to live. Krishna dives in. The snake's wives plead with him to go away, but Krishna wants his ball, so he has them wake up the snake. The snake, enraged at this interruption of his nap, fights Krishna, but Krishna takes some vines and fits them in Kalinaag's many mouths like so many bridles. Kalinaag, no doubt a symbol of submerged passions of anger

and lust and violence, has to submit. His wives plead for his freedom, and Krishna agrees—and leaves with his ball.

Narsinh's poem refers to Krishna's color twice. The first time, one of Kalinaag's wives mentions how lovely Krishna's color is. No doubt she has a fondness for that color, since her husband shares it: Kalinaag means "Blacksnake." The second time, Krishna stresses his own color when he introduces himself. "Krishna kanudo" double-stresses his color, since "kanudo" also means "black." In Pali (and in Hindi to this day), the word is "kanha," a corruption of the Sanskrit "krishna." Kanudo is a Gujarati derivation from the Pali: Krishna's own name, two languages transformed.

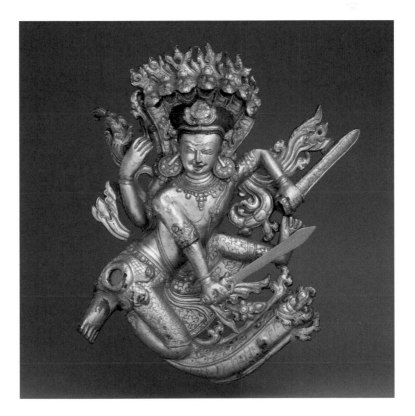

A 17th-century gilt copper Krishna statue from Nepal.
It portrays the triumph over the snake, Kaliya—the subject of
one of Narsinh Mehta's most famous poems.

What follows is my translation of Narsinh Mehta's poem about Krishna. It takes the form of a dialogue between Kalinaag's wives and young Krishna, with some narration toward the end:

THE SNAKEWIVES
 Little boy, get you gone
 from this lotus-strewn pond.
Our master's about to awaken, and when
he awakens, he'll hit you, and we'll
be stained with the sin of the kill.
 Little boy, get you gone
 from this lotus-strewn pond.
Little boy, did you wander away?
Did your enemy point you astray?
Oh, why you come here? No doubt
Your time, my boy, is running out.
 Little boy, get you gone
 from this lotus-strewn pond.

KRISHNA
Not at all, Mrs. Snake—
I haven't forgotten my way,
no enemy's led me astray.
At a dice-game in Mathura, ma'am, I staked
and lost the head of your Snake.

THE SNAKEWIVES
 Little boy, get you gone
 from this lotus-strewn pond.
Your color is lovely, so cute, your face,
you marvelous boy, with your beauty and grace—
how many sons did your mother bear
that she is abandoning one of them here?

KRISHNA

She's a mother of two, and between her sons,
I am the younger and naughtier one.
Now wake up your Snake, and tell him from me,
Krishna's my name, I'm as black as can be.

THE SNAKEWIVES

 Little boy, get you gone
 from this lotus-strewn pond.
I'll give you my chain, worth a lakh, give or take.
I'll give you this belt—just let him lie!
I'll keep it hush-hush from our husband the Snake,
And slip you the goods on the sly.

KRISHNA

What would I do with your necklace?
What would I do with your belt?
You're in your own house, Mrs. Snake.
Why steal things from yourself?

THE SNAKEWIVES

 Little boy, get you gone
 from this lotus-strewn pond. . . .

 Twisting his whiskers, massaging his feet,
 the Snakewives awaken the Snake from his sleep.

THE SNAKEWIVES

Mighty husband, wake . . .
there's a child at the door. . . .

 The two of them tussle and wrestle away:
 In the end, it is Krishna who masters the Snake.

His hoods by the hundred are snorting as loud
as elephants rumbling high in the clouds.
　　　"Little boy, get you gone
　　　from this lotus-strewn pond,"
the snakewives start to weep.
"You'll hurt him, you'll drag him, you'll get him
to Mathura for his beheading!"
Joining their hands to the Master, they sob,
"Let go of him, please, it's us at fault,
we didn't understand at all,
we didn't recognize the Blessed God."

All of the snakewives appeased
Shri Krishna with pearls on a platter—
and so from Narsaiyo's Master
the Snake by the Snakewives was freed.

6

THE GODDESS NAMED BLACK
IS THE GODDESS NAMED WHITE

My mother's sister and her kids used to join us in Junagadh. Hansa maasi, though her name means "Swan," is darker skinned. My mother's skin is white, her cheeks a perpetual pink. Ignore the color scheme, though, and the two are uncanny mirror-images.

My aunt, like my mother, has two children—the elder child a daughter, the second a son, born just four days before me. My mom and her sister have the same hand gestures when they talk, too, inherited from my grandmother. Seen through the mosquito netting, through the slow-burning citronella coil that left a hazy tingle in our eyes and noses, in the darkness of that high-ceilinged front room where we were sent to sleep, the sisters could have been the same woman facing a mirror, one light, one dark. They chatted in whispers that gave way, with increasing and unselfconscious animation, to full-throated laughter and gossip as they assumed we had fallen asleep.

Black is not just our color of supreme beauty (Draupadi), genius (Vyasa), and divinity (Krishna). Black is also the color of time and all time does; the color, too, of female ferocity. The Goddess in her necklace of skulls goes by the name of Kali because Sanskrit has more than one word for many things,

and "Kali" and "Krishnaa" are feminine forms for "black." Kali's alternate meanings are different, in this case, "time" and "death"—an association encapsulated in Shakespeare's "dark backward and abysm of time." Kali is downright terrifying, but she's no less divine for that. She embodies the same aspect of the divine that terrified Arjuna when Krishna showed him his universal form:

> Your mighty form—its many mouths and many eyes,
> Its many mighty arms, many thighs and many feet,
> Many bellies, many harrowing tusks—seeing this,
> The worlds are shaking—so am I!
>
> Seeing these harrowing tusks of yours
> In mouths that resemble the fires of time,
> I have lost my direction, I can't get to shelter!
>
> Swiftly [the warriors] enter your mouths
> With those fearsome, those harrowing tusks!
> Some of them I see with mashed heads
> Stuck between your teeth!
> *Bhagavad Gita*, 11:23–27, translated by Amit Majmudar

Kali's iconography shows her mouth open and her red tongue thrust out. She wants to taste you, to devour you as Time does everyone. Whether it's fire's or earth's or a scavenging vulture's, it's always a belly that digests a corpse.

Kali, though, is only one form of Shakti, the Goddess whose name means "Power." Every God has his corresponding Goddess. Vishnu has Lakshmi; in time, as we will see, Krishna got Radha. Goddess worship on the Indian subcontinent seems to have incorporated hundreds of local traditions over time. Goddesses worshipped in various places, by various groups of people, have coalesced under a single concept of the Devi, or feminine divine. So the ferocious Kali is also the demon-slaying Durga and the gentle, maternal deity Bhawani, whose name means "lifegiver." Another gentle form of the

Goddess, at the opposite end of the spectrum from black Kali, is Gauri—literally, "White."

I have emphasized the centrality of black skin to ancient Indian portrayals of beauty, but I don't want to overstate the case. A deity could have white skin, like Gauri; so could a king, like Pandu, the putative father of the Pandavas in the *Mahabharata*. Yet it does seem a rarer choice. In the seventh century C. E., a Sanskrit romance-writer, Bana, recounted his hero's encounter with a beautiful white-skinned woman in a temple. The woman even has auburn hair, which Bana compares to "russet lightning." Bana's purple passage about this woman's whiteness, like Melville's meditation on the whiteness of the whale, goes on for pages. (Later Sanskrit prose liked to pile up the imagery.) Bana's portrait takes the form of questions because he wants to evoke the rasa, or aesthetic emotion, of ascharya, wonderment. Bana may have been expanding his audience's notion of beauty to include his heroine:

> Seated on the southern side of the idol in the yogic posture and facing it was a strangely beautiful woman. . . .
>
> Had the shining purity of Gauri's heart taken a human form? . . .
>
> Had all the swans of the world shared their whiteness with her? Had she been carved out of seashells? Did she rise out of a mother of pearl? . . . Was she stroked with a brush made of moon rays? Was she painted white, or plated with silver, or bathed in mercury, or carved out of the moon?
>
> She was the epitome of whiteness.
>
> BANA, *Kadambari,* ch. 23, translated by Padmini Rajappa

Her name turns out, appropriately enough, to be Mahashveta, which literally means "Greatwhite."

As late as the 1980s, when we lived there, India still had a plethora of local Mother Goddesses. My aunt's mother-in-law spent most of her days flush with the television screen to watch the Gujarati equivalent of soap operas, but she was known to have channeled the Goddess on more than

one occasion. My mother spoke of it in an awed whisper—this benign bespectacled old lady would work herself up with chants, then shake, whip her white hair, froth at the mouth, and shriek prophecies. . . .

Maa Amba had a nationwide following, but there were small-scale Goddesses, too, whom no one outside of a few Gujarati villages had heard of, like Bavishi Ma or Khodiyar Ma; Goddesses, too, of a single roadside shrine sprinkled with fresh petals by a Tata truck driver with a red smudge on his brow, or an image pasted to the dashboard by a rickshaw driver new to the big city. I wonder whether their worship survives today. In the eastern states of India, tribal Goddesses that antedate the Vedas have been exterminated in the past century, most of them in the past fifty years. They lasted millennia, tucked away in rainy hill country, the comfort of obscure hunters. They were "Hindu" in the loosest sense; no Vedas, no *Upanishads*, no *Gita* for them. Their way of worship was probably something as hoar as Harappa. Today, thanks to evangelical dollars collected in places like Ohio, India's converted east is Christian. The first conversion is from US dollars to Indian rupees; other conversions follow from that. Missionaries have recast the Devi as the Devil, and the Holy Father has supplanted the Eternal Feminine. Nagaland has a higher percentage of Baptists than Mississippi.

Kali, Gauri, and those local village Goddesses are all forms of Shakti. Shakti's husband, like Krishna, is dark—but nothing like the charming cowherd of Gokula.

Millennia of meditation in the sun have darkened him. So do the ashes from cremation ghats, which he smears on his body, darkness darkening darkness. He wasn't born this way—he wasn't born at all. Swayambhu is one of his names, Sanskrit for "Selfbecome." Mohenjo-Daro knew what he looked like: a three-and-a-half-centimeter steatite seal emerged from the archaeological dig, and it shows Shiva in the classic pose, legs crossed in the lotus position, wrists on his knees. A water buffalo, a rhino, a tiger, and an elephant surround him—fittingly, since one of Shiva's names is Pashupati, Sanskrit for "Beastmaster." Animals came before people, and Shiva came before animals. Snakes bracelet his arms and interlace his wild hair. Shiva's

dark skin retains the darkness of a time before light, the darkness of an emptiness before space.

Krishna, particularly young Krishna, embodies love, joy in the senses, beauty, dancing, music. In his manhood, as recounted in Vyasa's epic poem, he is a diplomat, a strategist, a teacher. He is so thoroughly a man of the world that he picks a battlefield to sing his metaphysics. Shiva lives in detachment from the world, his senses restrained, high on a mountaintop humankind has yet to scale. Shiva, too, knows how to dance—his eponym Nataraja means "Danceking." Yet that dance will happen only when our species has done dirt beyond redeeming and it's time to pack up the carnival. Shiva will dance in a sphere of fire, a demon named Ignorance underfoot. Under his foot, too, is where our species will be, or whatever is left of it.

Mount Kailash remains unscaled as of this writing, even though its height is 7,195 feet lower than Mount Everest's. Shiva's meditation seat has a broad, angular peak, and depending on how the light strikes its faces, sometimes Kailash seems a ziggurat with its steps effaced, or a half-buried, colossal stone arrowhead. The snow on its horizontal ridges may have inspired the three white lines that Shiva's devotees draw on their foreheads. Mount Kailash, at dusk's end, its snow still luminous in the last light: that is the lingam awash with milk, the round-topped, cylindrical pillar that symbolizes Shiva. Its color, almost always, is black.

Every autumn, the Goddess commands nine nights of dancing in Gujarat.

I attended my first garba as an eight-year-old American transplant with no rhythm in my haggard, keepsake Reeboks. Live folk songs through massive speakers made my bones hum wherever I went on that vast field. Electric lights flashed off the flaring dresses of the girls and women, some sequined and hemmed with gold thread, some with coin-sized mirror discs worked into the weave. The boys and men wore sashes over their shoulders and white shirts that flared at the waist, only with bright embroidery down the front, and gold slippers that curved to a point, and saffron turbans. It was a flashy take on the costume of the cowherd—a nod, that is, to Krishna.

Their bodies spoke a language my body could not. They spun, skipped,

backtracked, lunged again, yet somehow always continued in a circle around the field's centerpiece. A brilliantly floodlit statue of the many-armed, tiger-mounted Goddess oversaw the festival from a magnificent platform of marigolds and silk.

After everyone danced in the circle, they took up small wooden sticks and faced each other in rows. This was dandiya raas, and even I could pick up the simple *tap, tap; pause; tap* rhythm that sucked me into the joyful machine of this dance. Hundreds of us matched the beat from the dholak and tablas onstage. The more skilled boys, hopping energetically, shut their eyes and twirled their sticks between sharp, reckless downstrokes. More than one fingernail got crushed that night, but never mine. I kept a lookout for the wilder worshippers and adjusted accordingly.

By the end of the night, I, too, had channeled the avatar. My Reeboks forgot first-grade touch football games on playground blacktop and the freshly mowed lawns of that Cleveland suburb. Dholaks drummed, incense smoked the foreigner out of me. My own sweat rinsed me clean, for one night at least, of America.

Some of the garba songs were dedicated to the Goddess. At least as many sang of Krishna. (A wise rule barred the Hindi film songs that dominated radios for the rest of the year.) A devotional song came at the end, after midnight. The crowd, pleasantly exhausted from the night's workout, sang in unison to the Goddess. Families brought steel plates that bore flowers and small cups of flame on ghee-soaked wicks. Everyone in the family took a turn moving the plate in reverent circles during the song. I always imagined spilling everything, and everyone looking at the sacrilege in horror. Handoffs were particularly fraught. The grace of the Goddess kept my clumsiness in check when it mattered.

Years later I would see Charlton Heston in *The Ten Commandments* come down from Mount Sinai to find his people dancing around a golden calf. I knew the appeal of pagan dancing. For nine nights every year, our most sacred commandment is dance.

Narsinh Mehta, before he became a devotee of Krishna, meditated on Shiva. (Junagadh's Nagirs, remember, used to focus their worship on Shiva.) Shiva gave Narsinh the vision that determined the rest of the poet's religious

and literary life. In this vision, Shiva led Narsinh into antiquity, and into the forest of Vrindavan. Narsinh heard music and drums as they approached. In a clearing lit by a moon and stars brighter than any Narsinh had known, Krishna had divided himself into countless Krishnas, each with his own peacock-feather panache. All of these Krishnas danced past in whirls of yellow silk. Diffracting his darkness through the prism of night, Krishna danced with all the girls in Vraj at the same time. Gone was Krishna the mischievous little boy. This was Krishna the mischievous teenager, the lover, the practical joker, the fluteplayer, the dancer. Because while I've been telling you about Kali, Gauri, and Shiva, Krishna has grown up.

7

PERMISSIBLY LASCIVIOUS LITERATURE

Alone with the Trident-bearer
and her clothes removed,
she covered his eyes with her palms,
but she was distressed
to find her effort in vain—
the eye in his forehead
was still looking.

> KALIDASA, *The Birth of Kumara*, canto 8, stanza 7, translated by
> David Smith

At the end of the *The Birth of Kumara,* a fifth century C.E. poem by the Sanskrit poet Kalidasa, Shiva and the Goddess make love. Taking birth as Parvati, the daughter of the Himalayas, she entices the meditating Shiva into marriage. The description of their consummation goes on for ninety stanzas—marathon lovemaking worthy of the God of Tantra.

Kalidasa, like so many Sanskrit poets, came from an India still centuries away from Islam's introduction of veiling, and over a millennium before the introduction of Victorian prudery. This was the India that carved topless,

dancing apsaras in its temple statuary, wrote the *Kama Sutra*, and created an erotic poetry at once divine and earthy:

Secretly becoming the pupil of Beneficent Shiva
when he taught her how to copulate,
she taught him what a young woman is skilled in,
which indeed was her pupil's fee for her guru.

. . . .

His vicious lovemaking with Parvati—
dishevelling her hair,
rubbing off her sandalwood paste,
scratching her in the wrong places,
breaking her girdle string—
did not satiate him.

 KALIDASA, *The Birth of Kumara*, canto 8, stanzas 17 and 18, translated by David Smith

The sacred relationship of guru and pupil becomes a metaphor for Shiva teaching the Goddess's virgin incarnation how to make love. The ascetic, centuries pent-up, makes love violently—he is, after all, the future destroyer of the universe.

It's not that Kalidasa's art ignores or collapses the distinction between sacred and profane. Rather, he came from a civilization that did not regard sex as inherently evil, "beastly," sinful, or shameful. In any case, Kalidasa's poem portrays a wedding just before that steamy eighth canto. His Shiva and Parvati engage in intramarital sex.

This openness shocked the imperialists that invaded India over the next thousand years. The Virupaksha Temple of Karnataka was built just a couple of centuries after Kalidasa's death, and its erotic sculptures lasted until Muslim iconoclasts invaded with swords and hammers in the fifteenth century. When Richard Burton translated the *Kama Sutra* into English, he wrote out the word "yoni" for fear of offending his Victorian readers. In these cultures, sex was evil, dirty, base—something to be hidden away. The bare breasts and hooded eyes of blissed-out apsaras were forbidden the chisel, forbidden the quill.

The lingam, the symbol central to the worship of Shiva, is most commonly black.

When my uncle took me to an Ahmedabad bookstore, I came back with the complete works of Kalidasa. My relatives praised me for taking an interest in the heritage, as if Kalidasa were no different than scripture. I, too, knew Kalidasa mostly by reputation alone.

Back in America, settling down in the upstairs recliner with my haul, I discovered his descriptions of sandalwood-smeared breasts, love-bites, and girdles slipping from buttocks. Clearly, most Indians, even "cultured" Brahmins like my relatives, had little idea how gloriously raunchy their Sanskrit heritage was. Sanskrit literature wasn't just Gods and metaphysics. There was sex in it, too. Both kinds of enlightenment! I was hooked.

It may seem like all I read back then was old classical stuff, but my first stops, after losing interest in children's literature, were Sherlock Holmes and Jules Verne... and then, obsessively, James Bond novels and espionage thrillers. I was so precocious about this that I recall having conversations about Robert Ludlum and John LeCarre with a baffled sixth-grade teacher. When I mentioned I liked Ken Follett's *Eye of the Needle,* she flushed and expressed shock—she knew about the sex scenes in that one. Little did she know that American potboilers had nothing on Kalidasa, or even the ribald and erotic literature of the West's own past. On summer vacation, under a hormonal monsoon but lacking a gopi to grope, I read translations of Boccaccio and Jayadeva, Bhartrihari and Tibullus, the *Upanishads* and the *Ars Amatoria*, and my superheated mind could scarcely distinguish between spiritual questing, literary exploration, and historically inflected, girl-obsessed fantasy.

Those hardcover books I brought back from India did their part, years later, to bring about my own long-awaited consummation. The first time she hung out at my house, my future wife sized up my room. Though her literary tastes tended toward Wodehouse and Jane Austen, she shared my fierce love of Indian antiquity, both its arts and its ideas. "When I saw Kalidasa and the *Upanishads* on your bookshelf," she tells me, "I knew you were the one for me."

They cooed and coddled him when he was a baby, and they chided him halfheartedly, often giving in to their own delight, when he grew up into

a mischievous boy. They never stayed mad at Krishna for long. More is permitted beauty, and beautiful he was. From the beginning, women loved him naturally and deeply. In the bhakti tradition, the way of devotion, love *is* understanding. Years later, in the *Bhagavad Gita*, Krishna would say how that was the easiest, fastest, sweetest, dearest way to uniting yourself with what transcends you.

As he knew from his childhood, women had an innate advantage in that form of spiritual yoga. Carrying and caring for another human body weakened the sense of self. Ascetics sitting for years with their legs crossed atop a mountain, emulating Shiva, would envy it. The oneness of unborn child and expecting mother serves as practice for nirvana, the oneness of self and Brahman. The sexual act itself, for the male, is only a transient "union." Something of the male stays in the female. Her body is where the genetic union takes place, and an umbilical cord joins the new body to hers. "Yoke" is the root of "yoga."

These yogas—the way conception, gestation, and breastfeeding "yoke" child to mother—are a woman's birthright. Yashoda's religious devotion took the form of motherhood. The girls growing up in Vraj attained all the goals of yoga, too: transcendence, a sense of oneness, "heightened consciousness," devotion, bliss. Love of the arts (not literature, in their case, but music and dance), the self's yearning for self-transcendence, and adolescent sexuality bloomed, all three at once, inside them. Pulse-quickening Krishna grew them up in every way.

The gopis celebrated a Goddess festival on the banks of the Kalindi river. It was a festival just for girls, and they fashioned a murti of wet sand and prayed for good husbands. The form of the Goddess they prayed to, according to the texts: Bhadrakali, "Kindly Kali," the Goddess Black in her sweet and wish-fulfilling form. None of them made any secret of naming Krishna aloud, but none felt any rivalry with the others. Pause this moment: they prayed to a Goddess named Black for a husband named Black. The divine object of desire and the divine power that could grant it had, in their religion, the same skin color.

The girls focused on Krishna so intently under the hot late morning sun that they started stripping off their clothes. They cooled down in the river together, splashing and singing songs. When they turned to shore, the rumpled pools of purple and red and green were gone. Krishna, having climbed a tree, hugged their clothes to his chest and breathed the strange rich scent of girl.

If anyone less beautiful, less beloved had done this, the gopis would have felt violated. More is permitted beauty, and all is forgiven love. The butter-thieving boy had become a thief of maidenly modesty, and it was all still, mysteriously, mischief. They could not stay angry because they weren't angry to begin with. Why play coy before the one they wanted? Open secret: he could have any one of them. They liked his eyes on them. They liked knowing he had taken an interest. How long had he been watching? His gaze felt better than sunlight. Krishna had them come out one by one to get their clothes. Their hands and arms could barely cover everything at the same time. When each gopi stood on tiptoe and reached up with both hands for what Krishna dangled, she bared what she had nearly failed to hide. While she got dressed in front of him, slowly, glancing up sometimes to make sure he was still looking, her friends waited in the water. They did not want to come out all together and divide his attention. They wanted to be seen the way prayers want to be heard.

Love and religion make marriages and societies cohere, but their stickiness is the stickiness of napalm: up the intensity enough, and they catch fire. Ignited, love and religion explode marriages and societies, burn the old bonds away. Such is the plot of many a novel, many a revolution. Someone's spouse is drawn to a newcomer. The masses, ruled by a foreign elite who hold their religion in contempt, overthrow their oppressors. Love and religion disrupt and unsettle, too.

You get a sense of that in the work of the Tamil saint-poet, Andal, who wrote in the eighth century C.E. Andal was herself as old as the gopis when she wrote poems from their perspective; she died when she was sixteen years old. Her poem of love for Krishna—and anger at being slighted by him—draws its imagery from self-harm and mutilation:

If I see that thief who's savaged me I'll savage

my breasts. Uproot their round mounds from

my body's earth, uproot my love to throw at him.

If he won't caress me, what use is this howling tenderness?

ANDAL, translated by Priya Sarukkai Chabria; quoted in *Finding Radha*, edited by Lal and Gokhale

These violent and changeful emotions—yearning, jealousy, playing coy, the thrill of reunion, downright rage—are the stuff of teenaged love. They would fuel the next thousand years of poetry, art, and music devoted to Krishna's love life with the gopis. These emotions track, metaphorically, to the ups and downs of the spiritual life. Seekers have days when they feel distant from their aspiration, only to experience some sudden, all-redeeming exhilaration of insight. Agape and personal despair can alternate in their hearts. Celibate ascetics may have been grateful for the permitted, literally sanctified sexual license of such poems and songs. *It's all metaphorical, so it's okay....* The leela was the world's most sensual means to sense-transcendence.

Krishna's love life, because it inspired so much Indian creativity, made him more and more popular over time. Love songs to, about, and in the voice of Krishna, like the eleventh-century *Gitagovindam* of Jayadeva, became popular classics, their lyrics sung in court, temple, and countryside. Austere theologians wrote commentaries on these same verses, treating them just as seriously as that other song of Krishna's, the *Bhagavad Gita*.

Krishna bound the gopis of Vrindavan in a common devotion. His enchantment called to married women, too, especially in a society where marriages were not made for love. Young women entered their (often much older) husband's house to work. The flute in the forest must have distracted them from sifting the flour, sweeping the rooms, churning the butter. Theirs was the generation that suffered a twinge of confused attraction: they loved him for his mischief, but they could sense the desirability to come. In time, they got to witness his transformation into a man. *Just my luck*, they must have

thought. *Born a few years too late. Married off just before he grew old enough to make love.*

And so, one night—the *Bhagavata Purana* makes sure to note that night's full moon, coaxing love to its highest tide, to holy lunacy—the gopis, married and unmarried alike, abandoned everything for the flute in the forest:

> Some, who were milking cows, abandoned the milking and approached eagerly. Others had put milk on the fire, but then came without even removing [the milk or] the cakes [from the oven].
>
> Others interrupted serving food, feeding their babies milk, and attending to their husbands. Still others were eating, but left their food. Others were putting on makeup, washing, or applying mascara to their eyes. They all went to be near Krishna, their clothes and ornaments in disarray. . . .
>
> Some gopis, not being able to find a way to leave, remained at home and thought of Krishna with eyes closed, completely absorbed in meditation. . . .
>
> *Krishna: The Beautiful Legend of God, (Srimad Bhagavata Purana Book X)*, part I, ch. 29, translated by Edwin F. Bryant

In the *Bacchae*, a play by Euripides dated 405 B.C.E., Bacchus lures women out of their daily lives and into his secret rites. It's the only comparable scene in literature. Yet on Mount Cithaeron, the Bacchae are driven to murderous abandon. In the forest of Vrindavan, the gopis dance in a state of spiritual exaltation. The meditative stillness of the homebound women matches the exuberant dance of the liberated ones. It's the same inner state showing up differently on the outside.

The point of devotion is to become one with the object of devotion. One of the Sanskrit words for lovemaking is "samprayoga," which contains the words for "together" and "yoga." The word's other meaning has to do with astrological conjunction, and "conjunction," even in English, has an etymological relationship to "conjugal." The old books describe how the leela, or divine play, is a play of mirrors:

With their eyes fixed on Krishna, they mimicked Krishna. The young maidens imitated Krishna's gait.

 Harivamsha, ch. 63, translated by Bibek Debroy

The *Bhagavata Purana* is even more elaborate about the mystical union. Over several verses in its thirtieth chapter, the gopis roleplay and reenact the whole series of Krishna's adventures to that point. The Vedantic dictum is "Aham brahmasmi": "I am Brahman." The self, or atman, unites with its divine origin. At the heart of mimesis is *me*:

[Their] bodies imitated their darling in the way they moved, smiled, glanced, spoke. . . . With their hearts [dedicated] to him, the women declared: "I am he!"

 Krishna: The Beautiful Legend of God, (*Srimad Bhagavata Purana Book X*), part I, ch. 29, translated by Edwin F. Bryant

I am he. Sexual union is spiritual union. Love reshapes the lover, with the patience of flowing water, in the image of the beloved.

This I have witnessed in my own life. Eighteen years of marriage and counting. . . . My wife, who never had any literary ambitions, has become a novelist. Her sense of humor has coarsened. Before me, she was strictly a Jeeves and Wooster kind of girl, but after me, she laughs at Harry Flashman, too. Our bawdy inside jokes are unthinkable to anyone who knew her when she was prim, religious, and single. She even deadlifts.

The influence isn't just one-way. If anything, I've come to resemble her more than she has come to resemble me. My changes, physical and spiritual, have been deeper. Why am I a vegetarian now? The very composition of my flesh has come to match hers. Her rule became my rule, and I experienced it as my own will. In my teens and even into my married twenties, my religiosity took the forms of writings in the Biblical, Qur'anic, and Buddhist traditions, in addition to my ancestral Hindu one. Over time, all those fascinations have largely fallen away, and I find myself quoting lesser-known Sanskrit tomes like the *Harivamsha*. Were it not for my partial

transformation into my wife, I would not have written this book. She has not coauthored my works. She simply made the author co-her. I am grateful for her revisions of me; she has greatly improved the original.

Krishna's lovers in Vrindavan were nameless gopis in the beginning. They have been nameless in this book, too, until now. Over centuries, though, one gopi differentiated, took on a name and a back story, and, in time, became a manifestation of the Goddess, worshipped next to Krishna.

Radha does not appear in the early sources. Neither the *Bhagavata Purana* nor the *Harivamsha* make any mention of her. Over time, the details of her story gather: she is Krishna's favorite; she is an adulteress, though the name of her husband varies depending on the account; she gets jealous when Krishna spends time with other girls and has to be appeased.

The earliest written mention of Radha is not in Sanskrit at all, but in the vernacular language, Prakrit. The *Gatha Saptasati,* like so many Indian texts, has a controversial date of composition, but some time before the seventh century C.E., it announced the primacy of Radha:

> O Krishna, by the puff of breath from your mouth, as you blow the dust from Radha's face, you take away the glories of other milkmaids.
> *Gatha Saptasati* (attributed to King Hala), ch. 1, pada 225, translated by Sumanta Banerjee; quoted by Jawhar Sircar in *Finding Radha,* edited by Lal and Gokhale

According to the American translator and scholar Andrew Schelling, the next earliest written mention of Radha shows up in the work of a seventh-century poet named Vidya:

> And what of those
> arbors of vines
> that grow where the river
> drops away from Kalinda Mountain?
> They conspired in the love

A dark blue, 17th-century Krishna dances with gopis in the forest.
This image originally illustrated an edition of Jayadeva's *Gita Govinda*.

games of herding girls
and watched over the veiled
affairs of Radha.

> VIDYA, "And What of Those Arbors," translated by Andrew Schelling;
> collected in *Bright as an Autumn Moon: Fifty Poems from the Sanskrit*

This poem, like Andal's, is written in a gopi's voice, even though Vidya was a man. Several centuries later, Jayadeva, like so many subsequent poets (including my ancestor Narsinh Mehta in his saree and bracelets), sang from a female perspective. The mystery of Vrindavan Forest is not some male sexual fantasy. At times, it transforms the poet into the gopi.

> . . . Krishna is sporting
> With other gopis now, deserting me.
> Yet I desire him.
> I forgive his guilt. . . .
> Seeing only the good in him
> I am blissful thinking of him.
> My mind seems not under my control.

> JAYADEVA, *Gitagovindam*, canto II, song 5, translated by Durgadas Mukhopadhyay

Radha, through Jayadeva's art, focuses the numberless gopis into a single woman. Yet Jayadeva's Sanskrit poetry—late in that language's history—marks an enshrinement. Her fame, her story, and her following were almost certainly growing among the masses over the preceding centuries, though we don't possess the work of folk singers and village storytellers. Before Jayadeva came "Anonymous." After Jayadeva, countless poets—Vidyapati, Chandidas, Rupa Goswami, Narsinh Mehta, Rabindranath Tagore—constellated India in time and geography. They worked in its regional languages to elevate Radha to the status of Goddess-hood. The lover, eventually, came to resemble her beloved.

In the metaphor of the soul yearning for the God, Radha equals the soul, and Krishna equals the God. Radha suffers separation from Krishna,

her distant lover. Yet Radha–Krishna poems, across the centuries, have felt free to invert the metaphor. As early as Jayadeva's work, Krishna strays from Radha, and Radha becomes the fixed point waiting for him to return. She is the patient and generous Goddess, and he is the wayward soul. In time, he finds his way back from sensual pleasures to the higher love:

> He . . . was followed by the yearning smile[s]
> and wistful glances of the gopis
> as they want only to raise their arms
> pretending to tuck back a loose strand of hair
> so as to reveal the lower curve of their breasts.
> This Krishna was reminded of the magnanimity
> of his beloved Radha and fell into sweet reverie
> dwelling on her charms.
> JAYADEVA, *Gitagovindam,* canto II, song 6, translated by Durgadas Mukhopadhyay

Radha, in every portrayal of her I can find, is consistently fair-skinned. Almost all of the portraits of Radha are "late" in the history of Hinduism. No painted depictions from Andal's eighth-century Tamil Nadu or Jayadeva's eleventh-century Odisha survive. Nihal Chand's imaginary portrait of Radha from eighteenth-century Rajasthan, currently housed in the Metropolitan Museum of Art, shows an extremely light-skinned woman. Ravi Varma, of course, depicts Radha as light-skinned as well—though he never painted Krishna darker than in the canvas Krishna shares with Radha. Instinctively, he understood the need for complementarity and polarity. Visually, their figures cover the spectrum from blue to red, from dark to light.

When we moved to India, my paternal grandmother came to live with us. She used to pray to the young lovers. Whenever she eased her bones into a couch, she used to sigh, *Radhe Krishn, Radhe Krishn, Radhe Krishn....* It served, in her personal vocabulary, as the equivalent of *ah,* an expression of grateful relief. Radha's name comes first everywhere. In many places—including modern-day Vrindavan—it can serve as a greeting, only replacing lover's name with lover's, interchangeable because indistinguishable: *Radhe Radhe.*

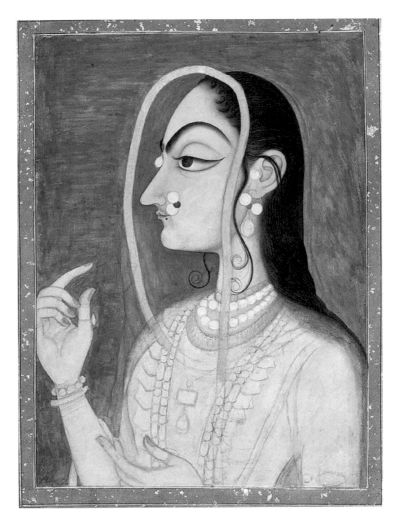

Portrait of Radha by the 18th-century Rajasthani painter Nihal Chand.

8

VERSIONS OF SUBVERSION

Radha left her husband for the forest and the flute. Religious devotion became holy passion and subverted the institution of marriage. The prison doors of her life unlocked mysteriously and swung open. The tinkle of her anklets echoed, and that echo intensified over time. Radha's echo, her double, was born over a thousand years later.

Mirabai was a near-contemporary of Narsinh Mehta. Narsinh was born into an elite subgroup of Brahmins; Mirabai was Rajput royalty, married off to the heir to the throne of Mewar. She wanted nothing to do with that mortal, earthly man, powerful though he was. She believed openly, defiantly, that Krishna was her husband, and she composed the love songs to prove it:

> In my dreams the Great One married me.
> Four thousand people came to the wedding.
> My bridegroom was the Lord Brajanath, and in the
> dream all the doorways were made royal, and he
> held my hand.
>> MIRABAI, "A Dream of Marriage," in *Mirabai: Ecstatic Poems*, translated by Robert Bly and Jane Hirshfield

After her husband's death from war wounds, Mirabai grew even more removed from her life in the palace. Like Narsinh Mehta, she spent more and more time outside the enclave of social status. She spent time among the people, among holy wanderers, and she composed her songs to Shyama, the Dark One.

> The colors of the Dark One have penetrated Mira's
> body; all the other colors washed out.
> Making love with the Dark One and eating little,
> those are my pearls and my carnelians.
> MIRABAI, "Why Mira Can't Come Back to Her Old House," in *Mirabai:*
> *Ecstatic Poems*, translated by Robert Bly and Jane Hirshfield

Mirabai's life began by emulating Radha's. Her love for Krishna made her ignore the proprieties, obligations, and expectations of marriage. Inevitably, given the growing unity of devotee and divine, her life began to emulate Krishna's. The holy widow's estrangement from the royal family led them to scheme against her. Just like the young Krishna, she evaded assassination attempts. A glass of nectar was really poison (compare to the story of Puttana). A flower basket hid a snake (compare to the story of Aghasura). Many believe she emigrated to Vrindavan in her last years, a reborn Radha drawn to the geography of her ancient happiness. How she died remains unknown. She may have met neither a natural nor an unnatural end but rather a supernatural one: legend has it that Mirabai merged into a murti of Krishna. It's an apt metaphor for the merging, at nirvana, of the self into the divine.

In a newly built flat in Ahmedabad—A-9, Super Society, Ramdevnagar—my sister and I saw our first monsoon. No Ohio thunderstorm we had ever witnessed, even the ones with tornado watches and warnings, matched this thing. It deserved its own name; it was not a rainstorm so much as a solid block of water with thunder trapped inside. Sticking an arm beyond the balcony seemed as foolhardy as sticking an arm out of the Somnath Express while another train was rushing past the other way. What happened to pedestrians? Were they knocked flat? Did they come home with bruised

backs and rain-cracked ribs? How did those peppy, beeping Bajaj and Vespa scooters, caught off guard in a roundabout, survive this downslaught? This was the most violent we had ever seen nature in real life. The universe had such extremes in it, and those extremes could find us, threaten us. My sister and I, intimidated, drifted back until we stood flush with the wall.

Our parents sensed our fear, and they encouraged us to overcome it. On the terrace, under that monsoon cloudburst, we welcomed those thousands of small hot fists on our heads and backs. It didn't hurt; it turned out to be a massage. Never before and never since have I been so drubbed and drenched. Heat from earlier in the morning made the terrace steam under our flipflops. We learned to fear no lightning, to laugh at thunder. We breathed the rainwater. Years later, when I read about those Russian saunas where people get beaten with bundles of twigs, I recognized their delight in hot water and a healthy battering.

All it took was a little bravery for the awe, the fear, the sense of smallness to wash away. Yet I have not forgotten my first reaction to the monsoon—the scolding thunder, the ongoing, openmouthed roar of the rain, the way downspouts became waterfalls. Gujarat, far from the wettest part of India, didn't even get the *serious* rain.

Vraj, in the myth as on the map, lay further east, closer to the Himalayas. The mountains trapped northward-floating water-freighter clouds, which emptied their holds to crest the peaks. Villagers had no whitewashed flats, no sheltered balconies from which to watch the storm. I imagine their huts were made of the same organic stuff as the bowing trees and the suddenly rivering earth.

Only natural that they directed their prayers at the sky. The ancient Vedic God Indra sat in the remote vastness of the sky. Fear fathered their reverence, not love. No rain would mean no roti, just mealworms at the bottom of the dusty grain bin. No rain would mean no milk, cows with their ribs showing, calves suckling on shriveled burlap udders. So they dedicated their humble rites to Indra. Ghee and rice sprinkled a fire. A coconut struck a stone and dribbled water in honor of the distant, fearsome skylord, more imperious than any landlord. His cowherd winds drove the cloud herd through, and every year the monsoon grazed a few roofs off the village.

Young Krishna was puzzled by the yearly to-do over Indra. The leading men of Gokula all participated in the prayers, including Krishna's father, Nanda. "Where is Indra?" the naive boy asked. "Has he ever visited Vrindavan? Does he know the names of our cows? Does he know *our* names?" And so, with a mix of innocence and irreverence, he made his case to the grownups that Indra might not be the best place to send their worship. Why not keep it local? This was where they lived their lives, made their homes, grazed their cows. The grass here grew in soil swirled together with the ashes of grandparents and great-grandparents. That's what gave the soil of Vrindavan its richness. If they wanted something grand and imposing, they didn't need to fetch a Himalaya. "That hill right there," said the country boy, "will do. I say we all drive our cattle clockwise around Mount Govardhan. That can be our temple, our place of pilgrimage. That right there is home."

The gopis were on his side, and so were the children, but the matter was settled when the men looked to their wives. The women of the village, as you might expect, were on Krishna's side, too. Nanda had forebodings, and so did the village priest, but they went along with it.

By the time the vast brow of the sky darkened and Indra gave a bitter grumble of thunder, it was too late. The gopis were dancing and singing as they circled the mountain, and half their songs were in praise of Krishna. Sacrilege after sacrilege! It turned out that Indra, like a distant emperor, was capable of noticing a minor province—when it stopped paying tribute.

The rain switched on. This was no ordinary monsoon. This was vengeance. Spiteful winds stripped jasmines off braids and flames off wicks. The villagers, dressed up and dancing a clockwise garba just moments before, buckled to the rain-pummeled earth.

Indra's storm bulldozed the butterflies. The morning had been a hot one, and much of the rain soon steamed off. Everyone struggled onto all fours and crawled through the hot fog. Gusts used the trees to beat their backs with branches. The rain changed temperature and turned to icy needles. Though they shouted in pain, they could not hear their own voices over the noise. This was why the storm Gods were called Rudras, roarers. A few more minutes of this, and the musicians would end up deaf, a raindrop-sized fist

punched through every eardrum, earlobes rubied with blood earrings. The dancers would end up breathing cautiously to spare their broken ribs.

Luckily, miraculously—*shelter*. Mount Govardhan floated off the ground and made itself an awning. They had crawled under it before they realized it. If it had been a sunny day, no one would have been so foolhardy as to take shelter under a hovering mountain. But now they were under it, and as they wiped the rain and tears from their eyes, they saw that it wasn't hovering on its own. Someone was holding it up, on one hand, his body a solitary pillar. They crawled to his feet and recognized them the way they might a rare species of blue lotus. Only these blue lotuses were black.

Krishna held this pose, this mountain, for hours. Days. The villagers gawked at the monstrous monsoon, safe, as if on a balcony flush with a sky-wide Niagara. Humble Mount Govardhan was no Mount Kailasa, but its earthen girth served the purpose. Indra, looking down from on high, focused his storm on that upstart hillock, but it calmly absorbed cloudburst after buckshot cloudburst. The weight of all that water flowed over the edge in a shimmering curtain. Krishna's other hand was free, but he kept it at his side while the gopis, who had retrieved the offerings, fed him the sweets consecrated to Mount Govardhan. This was just as sacred an act as any priest feeding ghee and rice into the fire at the mandala's center—loving spontaneity and reverent ritual in one. Sometimes the calves nuzzled his legs, and he let them lick his free hand.

Indra did not run out of water, wind, or patience. He ran out of will. The mortal at the bottom of this uprising was no mortal at all, he realized. The tonnage of rain he had dumped on Mount Govardhan should have pulverized it. Lightning strikes and pointblank Vajra blasts had failed to make it so much as wobble. Indra sensed he had come into contact with the foundation where foundations rest. The mountain only seemed to be propped on a boy's hand. Really it had moved to a firmer base than mere earth, a base that Indra shared. Indra's aerial bombardment was useless because a foot can't stomp itself.

The winds unraveled into hisses and whistles. Trees stood up again and took stock of how many leaves they had left. The circle of water pouring noisily off the mountain thinned to a few scattered chords. Through the

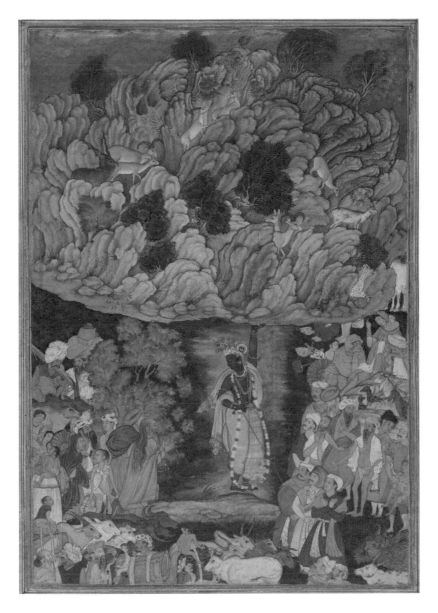

A dark Krishna holds up Mount Govardhan to offer shelter
to his fellow villagers from the dark storm overhead. A common
poetic trope likens Krishna's skin to storm clouds.

clearings, the villagers could see that the rain had let up. Puddle surfaces lay glassy, untroubled, and rainwater raced to the Yamuna. They had gotten used to the roar of the storm, so this new trickle-speckled, birdsong-spangled almost-silence thrilled them. Such intricately textured noise! They broke it only with their cheering, their jumps, their arms high in victory. They all celebrated at their full and natural height, even the grownups, and no one wondered, in the moment, how the little boy under the mountain had raised the mountain so high that they never bumped their heads.

Krishna sent everyone out and, very carefully, tilted one end of the mountain to the ground, then walked his hands out to the periphery. A few pushes with his pinky finger returned Mount Govardhan to its original position. The deliriously joyful cowherds sat Nanda's son on their shoulders and danced him home to Gokula. The last of the clouds swirled away just then, and sunlight spotlit the dark boy. Indra took a good look and nodded, his pride broken, rejoicing in his own defeat. The storm winds had torn hundreds of wildflowers. Rather than offer the lotuses of heaven, Indra sent soft winds to gather those local petals, swirl them aloft, and shower them on Krishna and the ones he loved.

So it isn't just the worldly social order that Krishna, drawing wives away from husbands, subverts. He also subverts the religious structures and strictures of his day. Sacrifices and offerings to the ancient Vedic God were obsolete. Indra, to this day, goes without a temple. Remoteness, in Krishna's code, deserves permanent exile. He is interested only in love, immediate love—bhakti, which comes from a Sanskrit root word with many meanings, among them sharing, possession, loyalty, enjoyment. These emotional intensities belong to the lover, not the vassal. Mirabai loved this kind of love. "Devotion" falls short, though I, too, have used it. The English translation of bhakti is bhakti. Its dictionary definition is Radha.

Krishna kills the demons sent to kill him, dances with the pretty girls, and even upends the traditional sacrifices to Indra—but it's all a game, it's all in the spirit of fun. His ease makes all his youthful adventures, literally and figuratively, *child's play*. More than once, as when he kills the two snakes (Kalinaag and Aghasura), he encounters the danger while playing with his friends.

This is a far cry from other kinds of demon-slaying, even in the Hindu tradition. Rama's demon-slaying has a grim, at times morally ambiguous quality, beginning with his first kill when he's still in his teens. An immediate quandary makes him second-guess what he has done: the Rakshasa he shot was a female one, Tataka. Did he break the kshatriya code forbidding violence against women? Does this qualify as a violation of the rule? Beowulf slaying Grendel and then Grendel's mother, or St. George slaying the dragon—even when morally unambiguous, these killings are serious work.

Conversely, Krishna's demon-slaying has the feel of play. The hero is in danger, and the way he gets out of danger is thrilling, but his life is never really at risk. Modern action-adventure movies honor this convention, too. There's an implicit contract with the moviegoer that Indiana Jones isn't going to die at the end of the movie. Similarly, James Bond is always playing at love with the Bond girl. He is never in danger of falling into a grand passion, much less a marriage. (Bond aficionados will point out that he *did* marry a Bond girl, Tracy Draco, at the end of *On Her Majesty's Secret Service*, but Ian Fleming made sure to kill her off within a few pages.) All this keeps the movies and novels from getting too serious.

Krishna's many loves, too, retain this air of dalliance. Are the gopis in on the game? In the songs of Jayadeva, Radha experiences the thrills, despairs, jealousies of love. But this, too, is role playing in a mortal body. Radha is also the Goddess-half of Krishna, Lakshmi to his Vishnu, his wife on the celestial plane. She has been playing along the whole time.

There will always be something juvenile about stories that don't take sex and killing seriously. Young Krishna stories preserve that quality, I think, on purpose. At once playful and sublimely serious, they remain popular among children, readymade for picture books and cartoons, which is how many of us first encounter them.

Yet stories like the leela in Vrindavan forest, or the raising of Mount Govardhan in defiance of Indra, lure the mature mind toward metaphysical interpretation. They thrill and deepen, and, as their student ages, thrill in proportion to their depth.

That spirit of play may well be the secret of their depth. Play delights, but it is not always a light thing. Consider the quatrains of Emily Dickinson,

or the couplets of Rumi and Ghalib. High seriousness can deploy a poetic device, rhyme, familiar from nursery rhymes. Wordplay asserts itself at dark, bloody moments in Shakespeare. "Ask me tomorrow," says Mercutio while bleeding out, "and you shall find me a grave man." After *Homo sapiens,* the wise man, comes the evolutionary next step—*Homo ludens,* the playful man:

> Play consecrated to the Deity, the highest goal of man's endeavor—such was Plato's conception of religion. In following him we in no way abandon the holy mystery, or cease to rate it as the highest attainable expression of that which escapes logical understanding.
> JOHAN HUIZINGA, *Homo Ludens,* translated by R. F. C. Hull, ch. 1

And so Krishna, the most playful figure in Hinduism, is also the wisest; he is the wisest *because* he is the most playful. Think how the word *holiday* comes from *holy day.* Come Halloween, kids put on costumes: the zombie, the monster, the superhero. An avatar is a costume put on by a God. Rama doesn't know who he is, in Valmiki's *Ramayana,* until the end of the epic, after he has slain Ravana. "I think of myself only as a man," says Rama to Brahma,

> the son of Dasharatha. May the Blessed Lord please tell me who I really am, to whom I belong, and why I am here.
> VALMIKI, *Ramayana,* Yuddhakanda, sarga 105, sloka 10, translated by Robert P. Goldman

The God Brahma reveals to Rama his true nature. In the *Bhagavata Purana,* by contrast, Krishna doesn't need anyone to tell him who he is. There is no equivalent recognition scene.

The playful boy Krishna, in the magical woods of Vraj, is not so far removed from the grownup Krishna on the battlefield. The two are continuous. The playground game escalates into the playground fight. War has rules of engagement. The chivalric joust was a martial duel and a sports match in one; today's sports commentators frequently, and naturally, deploy war metaphors.

The *Mahabharata's* "great war" results from a catastrophic game of dice. The Pandavas lose everything and have to go into exile. Even the terms of

their exile contain a game. For the last year, they have to live in public, but they have to stay in disguise. If they're discovered, they will have to do their exile all over again. So the famous warriors put on the costumes of a horse-tamer, a cook, a priest, a cowherd. The finest warrior of them all, Arjuna, dons a saree and teaches dance and music to a princess.

In Krishna's childhood, dance is holy, and play is holy. Hybridize these, and you get war; Huizinga, in a chapter titled "Play and War," speaks of a "sphere of archaic thought in which chance, fate, judgement, contest, and play lie side by side as so many holy things. It is only natural that war too should fall under this head." What Huizinga says next is equally profound, and the novelist Cormac McCarthy followed Huizinga closely when having the Judge reflect on war in *Blood Meridian*. "Men are born for games," writes the American novelist:

> But trial of chance or trial of worth all games aspire to the condition of war for here that which is wagered swallows up game, player, all. . . .
>
> This is the nature of war, whose stake is at once the game and the authority and the justification. Seen so, war is the truest form of divination. It is the testing of one's will and the will of another within that larger will which because it binds them is therefore forced to select. War Is the ultimate game because war is at last a forcing of the unity of existence. War is god.
>
> CORMAC MCCARTHY, *Blood Meridian*

Krishna must move out of this first phase of his story and into the next one—full of love and adventure, yes, but defined by a war. That transition requires him to go to Mathura, to kill King Kamsa, and to free his biological parents. Social and religious subversion first, and now, in Mathura, political subversion: the revolutionary trifecta.

That vendetta, that bloodletting, that act of redemption must serve as his grim rite of passage into manhood. Even here, though, the story brings in the spirit of play—the reckoning in Mathura takes place in a wrestling arena.

9

BROTHERS BLACK AND WHITE

You are what you remember.

I remember the kites, pink and blue and yellow, shivering aloft. At first, I wasn't skilled enough to scale the wind with one. I stood pinching the kite between thumb and index finger while a cousin, twenty feet away, read the wind and waited. The bendy cross was balsa, or some even airier wood from a tree grown in cloud loam. The kite paper was so hotel-bible thin, I feared the casual brush of a thumbnail might rend it. Roadside vendors sold them by the bundle: mayfly kites, kites built to die cheaply, not the bowtie-streamered, manta-ray-broad, thick plastic kites I had known in Ohio.

The winter solstice festival, Uttarayan, weaponized these kites. Kite vendors suspended powerline-thick stretches of string, soaked them with pink dye, and rubbed them with fine glass shards. Uttarayan was an air war, the sky packed with more loop-de-loops and derring-do than the Battle of Britain. Rival kites twitched and sidled closer to one another, jerk-fluttered skyward and watched—until the aggressor made his move, and shard-crusted kitestrings crossed like swords.

In my first kitefight, I ignored my screaming cousins and yanked hard, creating a clockwise loop and downstroke. The tension in the string let up

immediately. I watched my kite go unresponsive, then tilt unnaturally. It dropped once, as if stumbling down a step, then drifted out and away and down, down, down. Cheering from a nearby terrace and the silence of my cousins told me the foolhardy American had disgraced himself. I had been given the reins too early; I had to be taught.

When an enemy kite engaged mine, my cousins explained, the first evasive measure was slack, yards and yards of slack. This was the kitefighter's equivalent of a boxer's feint. The shard-crusted string should risk slicing open my rubber finger-sleeve. (No matter how careful I was, I always finished Uttarayan with deep red cuts on my fingers: battle wounds.) When they told me—I could never quite figure out the wind-word or kite-juke that made them scream *pull pull pull pull!*—I had to haul that string in, yard after yard, arm over arm, until it rested in loops and tangles behind me. I followed their instructions perfectly, but I never remember slitting a stranger's kite. I do remember going to the terrace edge and watching kids on the street running under my kite, each boy eager to catch it and tie it to his own string, then send it up into battle again, reborn. Garrulous and wiry, they battled us rubber-thimbled rich kids with our own kites. Spry battalions scoured the treetops for fallen paper diamonds. Attacking from street level, they overcame the eight-story disadvantage and beat us.

The centerpiece of the festival King Kamsa held in Mathura was a holy relic: the Bow of Indra. Indra was the God whose worship Krishna had subverted in the countryside, the God whose imagery and hymns centered on kingship and conquest. Just as with ancient Roman festivals, sponsored games made the festival a festival. Mathura's arena would host wrestlers. This was the kind of dance a tyrant would enjoy. Wrestling, so much like lovers grappling, turned dance into something brutal. Wrestling in a public arena was the warped, inverted mirror image of the leela hidden in a forest clearing.

The prophecy had never stopped bothering Kamsa. The assassins he sent had failed, and lashing out against a whole cohort of babies had left his citizens full of resentment. Preserving order forced his cruelty, and his cruelty forced more efforts to preserve order. The tyrant was caught in a cycle. Festivals and games like these were a way to buy some popularity.

Popularity that Kamsa needed badly; Mathura's citizens knew about Krishna and Balarama, Devaki's secret sons in the countryside. Every exploit, every near-escape found its way to Mathura. How? Every week, the gopis came in from the countryside to sell their milk and butter. They whispered the gossip—*he's out there*—and sang the ballads. *Him and his brother, just the cutest things, one white as fresh cream, the other dark as a raincloud.* There was more than just butter in those clay pots. *You know he did a jig on the hoods of Kalinaag, right?* There was hope.

Kamsa knew Krishna was out there, too, and he could not bear waiting for the showdown. If his nephew was going to kill him, or if he was going to kill his nephew, whatever the outcome—and it was still early, the outcome wasn't certain yet—just let the reckoning *happen*. Pacing his palace under threat of death was worse than kneeling for the executioner's ax. Every year that passed took strength from Kamsa and gave it to Krishna, as Krishna inched toward manhood and Kamsa's hair thinned under the crown. If they had to fight, best fight now, while King Kamsa still had the advantage. Or better yet, let someone *else* fight Krishna: trained wrestlers like Chanur and Mushtik, masters of the foot sweep and double-leg take down and (when necessary) the thumb jab to the eye.

Nanda and other village elders would be attending the festival. A chariot, if it left now, could fetch Krishna and Balarama and get them here in time for the wrestling match. Kamsa had struck at his predicted killer from a distance, over and over, through proxies. Now he would bring the pretty boy to Mathura and see for himself.

The man Kamsa chose for this errand was Akrura, a distant relative of Krishna's. In spite of what Kamsa had done to Krishna's parents and siblings, Akrura stayed in Kamsa's administration. (To be entrusted with this mission, he must have proved his loyalty, though the texts don't tell us how. Taking orders from a paranoiac like Kamsa required comfort with moral gray areas, with lacunas in the conscience. How else do you survive that close to power gone mad?) Akrura was crucial to Kamsa's plan. A stranger would have raised suspicions, luring children into his chariot with stories of a festival in the big city; a soldier in uniform would have scared them off. Kamsa's choice

played on Akrura's blood ties to Krishna's birth parents. It preyed on trust in a society where family ties, to this day, remain stronger than other kinds of affiliation.

The choice backfired. The blood tie that Kamsa tried to exploit ended up undermining the plot. Setting out to fetch Krishna and Balarama, Akrura set out to betray the king.

How tired his eyes had become of the big city! He hadn't known until he left Mathura's walls behind him and cooled his eyes on green. Distance from Kamsa, too, got him off the psychological tightrope and onto terra firma. And if Krishna and Balarama really were what the milkmaids said they were, *and* what Kamsa said they were—demon-slayers, Devaki's prophesied sons? Akrura could not believe his luck in being the one to bring these boys into Mathura.

A twilit gravel road crackled under his wheels as he pulled up to Nanda's house. Cumin's kitchen sizzle mingled with the pong of palm-sized cow dung patties drying on the wall. A few scattered bleats and whinnies announced him. At the door, Nanda greeted him warmly and invited him to dinner. In that house, Akrura was a friend of Krishna's father Vasudeva, and only secondarily a messenger of Krishna's enemy, King Kamsa. Every decent man, city- or country-dweller, shared a secret-society-like nod and eye contact, united by their decency against the regime.

Akrura explained that Kamsa had invited Nanda to Mathura for the Festival of Indra's Bow. Taxes were due, the usual tribute of cattle and butter that Nanda had to bring anyway. Seats would await him and his fellow villagers in the wrestling arena. Akrura lowered his voice. "The King has invited your boys to attend, too. He wants me to bring them in my own chariot. Will they come with me?"

Nanda shrugged. "Why don't you ask them?"

The boys were around the back, late finishing the day's work. Akrura found them seated each on a stool beside a cow, bucket under an udder, noisy with rhythmic squirts. It was hard to believe that this boy, busy at his chores, could be the focal point of prophecies, songs, royal dread, and feminine adoration. But then Krishna looked up from his work and turned to smile at Akrura, and the elderly diplomat understood, in a dark flash, what the hype had been about.

On the way to Mathura the next morning, Akrura halted the chariot beside the Yamuna. This was the same place Krishna had purged of Kalinaag a while back. Now that it had the cleanest, brightest, most lotus-lovely water for yojanas around, pious Akrura thought it the best spot to pray and bathe. He told the boys to wait a few minutes and hurried down to the water.

Akrura muttered his prayers and dunked himself. While he was underwater, his eyelids lit up orange-red, as if he had turned his chin skyward with his eyes shut. Baffled, he opened his eyes, and there he saw darkskinned Vishnu sitting under the flared awnings of a thousand-headed white sea serpent, those flared diamond-marked hoods shivering on high in the current like kites in the wind.

What was below mirrored what was above, down to the color contrast:

> The serpent was seated on a white seat, made out of the coils of his own body. . . . Vishnu [was] seated on his lap, attired in yellow garments and with an extremely dark complexion. . . .
> *Harivamsha*, ch. 70, p. 268, translated by Bibek Debroy

The serpent was

> white like the fibres of the lotus flower. He appeared like Sveta, the white mountain. . . . Vishnu, the four-armed supreme being, on the serpent's lap . . . was dark as a [rain]cloud, and wearing yellow silk garments.
> *Krishna: The Beautiful Legend of God (Srimad Bhagavata Purana Book X)*, part I, ch. 39, translated by Edwin F. Bryant

Akrura stood up and looked around to find the boys still on the chariot: dark-skinned Krishna, white-skinned Balarama. The boys grinned and looked at each other. Akrura stuck his head underwater again: dark-skinned Vishnu, white-skinned serpent. The vision thrilled him and puzzled him and elevated him and unsettled him and awed him, and made him laugh at his puzzlement and awe and unsettlement, all at the same time.

Over on the chariot, Krishna, chewing a straw, squinted at the dripping,

wide-eyed Akrura. Krishna's voice had a lilt to it. "You alright, sir? You look like you saw something that shook you, down there in the water."

Akrura joined his hands and marveled. He knew their true identities, their iconographic infinitude, but his sense of holy awe mingled with a sense he was getting ribbed by two mischief-making teenaged boys. They had given him a vision of their joint secret nature. It was a mysterious gift, but it was also, even more mysteriously, a prank.

The vision given Akrura, and the teasing, mock-innocent question that followed it up, has no precedent, to my knowledge, elsewhere in world religion. Imagine Tom Sawyer and Huck Finn, getting into scrapes, having their adventures . . . only each boy keeps a divine secret identity tucked away, like flint or an arrowhead in the pocket of his overalls. The incident collapses the dual nature of the childhood stories into one eloquent scene: the boys are avatars on a mission, the boys are tricksters having fun.

Krishna's fun-loving tricksiness gets muted in the *Mahabharata*, which deals with political intrigue and warfare, though Krishna's advice on the battlefield often involves tricks that bend and sometimes break the conventional kshatriya code.

We see this combination of mischief and divinity just as the freewheeling phase of their lives approaches its climactic end in Mathura. There, they will exit the mythological world of demon-slaying and transition to the "real-world" violence of killing soldiers.

Akrura's vision was not Krishna-as-the-Universe, as Arjuna's was, but rather Krishna-as-Vishnu. Balarama, in that vision, corresponds to Shesha, the Serpent whose name means "Remainder." The "remainder" is a reminder that the God who is everything is always something more. You never get to the bottom of him. You never encompass him. Some piece remains beyond your ken or outside your book. That is why Shesha's other name is Ananta: "Endless."

True story: I am writing this *after* having retold the *Mahabharata* in three books. I realized only after their completion that my thousand-plus pages barely touch on the story-world of Krishna's childhood. Nor have I covered

every last childhood tale. This may be why the Sanskrit *Mahabharata* is so long. Infinity is always what's left over. "Take fullness from fullness," says the *Isha Upanishad*, "and fullness remains."

What Akrura saw was a classic of Hindu iconography: Vishnu resting on Shesha, afloat on the bioluminescent Ocean of Milk. The image was widespread on the Indian subcontinent and Southeast Asia. Extant renditions of it in stone, outside India, date back to the 10th century Angkor period of Cambodian art. In India, the Bhaumakara Dynasty of Odisha produced an open-air rock relief that has survived thirteen hundred monsoons. You can visit it to this day. That Vishnu reclines, as ever, under the open sky; the Archaeological Survey of India, tasked with protecting India's monuments, has not bothered to erect so much as an awning over him. "Reclining Buddha" statues, like the third century C.E. example from Gandhara (in modern-day Afghanistan), derive from this precursor image of Vishnu.

Balarama is no less an avatar than Krishna. Shesha and Vishnu incarnate in tandem. In the *Ramayana*, Shesha showed up as Rama's loyal brother, Lakshman, who volunteered to join Rama in a fourteen-year exile. Shesha's avatar plays a smaller role in the *Mahabharata*. In that epic, Balarama sits out the war on principle, and he gets a reputation for heavy drinking. Over the centuries, thanks to the Radha story and the *Gita*, Krishna has captured the imagination of Hinduism's artists and theologians. Yet in earlier, surviving forms of worship—as at the Jagganath Temple in Puri—the focus seems more evenly split, the siblings inseparable, as they are in the tales.

In the *Mahabharata*, Balarama's true nature as Shesha comes out only at the end. In a surreal scene, Krishna witnesses Balarama give up his body:

Then he [Krishna] went straight to the forest, where he saw Balarama still standing alone in that solitary place. He was absorbed in Yoga, and Krishna saw a great serpent issuing from his mouth, white in colour; that noble-minded creature had a thousand heads with red mouths, and his hood was as high as a mountain. As Krishna watched, [Balarama] abandoned the body that had been his, and set off for the ocean. . . .
 The Mahabharata, ch. 16: The Clubs, translated by John D. Smith

There, too, he is white, in contrast with—and *one* with—Krishna's blackness. That persistent emphasis on their colors signals the unity of seeming opposites. A conversation—like, say, the *Gita*—requires speaking and listening, sounds and silences. Words without white space are gibberish. Day and night are both time.

10

HOLY HOOLIGANISM

The tradition attributes both main accounts of Krishna's youth, the *Harivamsha* and the *Bhagavata-Purana*, to the same, other "Krishna," Vyasa. Philology speculates otherwise, but it has never really pinned down dates for the anonymous author or authors of each work. The *Harivamsha* has parts that might go back to the first century B.C.E., while the *Bhagavata-Purana* was probably composed in the sixth century C.E. That's roughly the same gulf of time that separates Chaucer from a contemporary poet.

What happened to the Krishna story during those seven centuries? Growth by accretion. This colorful narrative coral reef deepened its own waters. The structure stays the same, but details and new touches tassel and spangle it. Radha appears in neither book, but in the later one, we get to meet, during the leela in the forest, one unnamed "proud woman" who gets special attention from Krishna. The other gopis get jealous and track the couple, noticing where her footprints disappear because he's swept her off her feet and carried her; his footprints deepen accordingly. A spot with two half-footprints mark where he stood on tiptoe to pluck her flowers. This kind of erotic nuance—the portrait of two lovers, through the eyes of his

other jealous girlfriends—is largely missing from the *Harivamsha*. Another five centuries, and subtlety, eroticism, and focus on passions will flourish in Jayadeva's *Gitagovindam*.

That unnamed gopi, who spent time alone with Krishna and probably evolved into the Radha we know today, did not get to stay with Krishna. It was her pride that ruined it. She gloated about her good fortune and demanded her lover carry her again. So Krishna told her to climb onto his back, but when she tried to, he vanished. The other gopis found her distraught at what she had lost. The sensual leela story sneaks a moral into the mix: no one devotee—no one religion, some might argue—enjoys an exclusive claim to the divine. To fancy yourself uniquely blessed, even at the moment of mystical union, lets selfishness creep in. Your alienation from other people alienates you from the God.

That distress at being abandoned returns on a much larger scale when Krishna leaves for Mathura—but not in the earlier *Harivamsha*, which makes no mention of the gopis lamenting Krishna's departure. Krishna and Balarama leave with Akrura, and that's that. The later *Bhagavata Purana*, by contrast, has developed the romantic aspects of the story. It plays up the rasa, or aesthetic "flavor," known as "sringara," meaning love or beauty. (That rasa's presiding deity is Vishnu, and appropriately so.) During the leela passages, the gopis remain the focus of several chapters in a row. When the time comes for Krishna to depart, the *Purana* focuses on them again:

> The faces of some of [the gopis] were pale from sighing. . . . The braids in the hair of some became slack, as did their bracelets and garments. . . .
>
> The gopis said: "*Aho!* Oh creator! You have no mercy whatsoever! After uniting embodied beings in friendship and love, you separate them for no purpose, with their desires unfulfilled. Your behavior is like that of a boy playing around." . . .
>
> The gopis followed their beloved Krishna. . . . they remained standing, in anticipation.
>
> *Krishna: The Beautiful Legend of God (Srimad Bhagavata Purana Book X)*, part 1, ch. 41, translated by Edwin F. Bryant

At this point, Krishna, seeing the gopis stumbling out of the village be-hind Akrura's chariot, sends a messenger back to give them a message: *I will return.*

It's a lie. Both source texts agree that he leaves Vraj behind for good. There are no stories of his return as a grown man, no stories of tearful re-unions with middle-aged gopis who have gray hairs and grown children. The flute does not play in Vrindavan again.

The source texts match in their accounts of how Krishna and Balarama enter the big city: as hooligans spoiling for a fight.

These are not the charming cowherds of Vraj. Krishna and Balarama, in full command of their strong and beautiful bodies, team up for a different kind of play: bruising, brawling, bullying. They want to swagger around Kamsa's city in style, so their first stop is a washerman's, where they admire the fancy clothes and realize these are royal robes sent out for cleaning. They don't of-fer to pay. They demand that the owner give them Kamsa's finery. Naturally, this nameless businessman of ancient Mathura refuses. "Who are *you*?" he asks in the *Harivamsha*, contemptuous of these dung-smelling rubes. "You seem to have no fear," he adds, puzzled. He knows what will happen to him if he loses the royal robes. The washerman finds out soon enough who they are. The brothers rough up the washerman, who ends up with his skull split open. They deck themselves out and move on to a garland seller, who realizes he's better off acquiescing.

Next they come across a hunchbacked young woman who's selling lo-tions. With her, they are gentlemanly and kind, and Kubja, who rarely gets much male attention, explains how she supplies the palace. Krishna and Balarama invite her to smear their torsos with the King's lotions. When she finishes, Krishna decides to thank her by curing her back. "As if playing," the *Harivamsha* specifies, he "gently pressed the hump with two fingers of his hand." *As if playing*: even the miraculous cure for Kubja's disability is done casually, with a light touch.

The two source texts differ with regard to this episode, though. In the *Bhagavata Purana*, Krishna straightens the woman's back by stepping on her foot and pushing up, with two fingers, on her chin. Her name, in that

version of events, is Trivakra, which means "thrice-crooked," in reference to her spine. In both books, when the woman Krishna heals stands straight, she turns out to be a beautiful woman "with large hips and breasts," and she tries to thank the young stranger by offering him her new body. That's not a detail that made it into the illustrated children's book where I first read the story.

Krishna and Balarama head downtown in royal silks and garlands, black skin and white skin tinged and aglow with Kubja's lotions. The women of Mathura come out to see these brash young celebrities, and their reaction to Krishna's arrival matches that of the gopis maddened by Krishna's flute:

> The women even climbed onto their houses in their eagerness. . . .
> Some of them wore their ornaments and their clothes back to front, while others had forgotten one of a pair of something and had put on only one ear-ornament, or one ankle-bracelet. Still others had failed to put mascara on their second eye [having done the first]. Some discarded whatever they were eating in their excitement. . . . some who were sleeping jumped up after hearing the sounds, while mothers who were breast-feeding put aside their infants.
> *Krishna: The Beautiful Legend of God (Srimad Bhagavata Purana Book X)*, part I, ch. 41, translated by Edwin F. Bryant

Krishna fever has spread, gone viral from the gopis of Vraj to the house-wives of Mathura, endemic now in Krishna's, excuse me, *Kamsa's* city.

The brothers ask directions to the famous Bow of Indra, the festival's centerpiece. The one who shielded the villagers of Mount Govardhan from Indra's monsoon-tantrum was hardly one to respect this relic. Decorative sen-tries stand guard around the immense weapon. The men are less susceptible to Krishna fever, and it takes a scuffle for Krishna to grab the Bow. Though it stands taller than he does, Krishna hops up and loops a string around the top. Burly, surly Balarama holds off the soldiers while Krishna squeezes the ends of the Bow together—and snaps it. No thundercrack of Indra's Vajra bolt sounded half so loud. The last time a sacred Bow snapped that loudly was centuries before in Mithila, when the avatar preceding Krishna, Prince Rama, also a teenager at the time, strung and broke the Bow of Shiva. There,

the bride he won was Sita. Here, it will be Mathura, her turrets and garrets, her damp alleys and spread-wide thoroughfares.

That noise echoes endlessly in Kamsa's head. It sets his ears ringing. The great king, though he has the next morning planned out, gets no sleep. Omens and paranoia torment him:

> When he saw his reflection there was no head visible, and stars appeared double. . . . Holes appeared in shadows, and the sound of his breathing became inaudible. . . . he could not see his own footprints. He was embraced by ghosts in dreams, ate poison while riding a donkey, and moved about alone, naked, smeared with oil and wearing a garland of spikenard flowers.
>
> *Krishna: The Beautiful Legend of God (Srimad Bhagavata Purana Book X)*, part I, ch. 42, translated by Edwin F. Bryant

Spikenard is a dream-signal. Ayurveda knows it as jatamansi, and it is a fragrant Himalayan herb that found its way west to funeral rites in the Old Testament and Homer. It was used to conceal the stench of the corpse. The earliest description of Hindu funeral rites, the *Asvayalayana-Grihya-Sutra*, translated by Max Muller in his ninth Gifford Lecture, describes the preparation of a body: "They anoint [the dead man] with spikenard and put on him a wreath of spikenard." King Kamsa's nightmare shows him his own, living body prepared for cremation. He is, like a criminal shuffling to the electric chair, a dead man walking. Dazed, limbs gone slack in the predator's jaw, squinting into the daylight on no sleep, Kamsa shuffles to his fatal chair, the throne set up for him on a balcony overlooking the arena. It's time.

Krishna and Balarama, according to the *Purana*, slept well the night before the wrestling match. Approaching the arena, they saw a festooned and garlanded elephant waiting outside the gate. Balarama nudged Krishna and pointed out some ominous details—what were those scars in his gray flank? Why were his tusks sanded down to spear points, why did his mahout wear armor, why did the elephant's ears have holes in them, as if they'd been shot up? Krishna and Balarama realized they were looking at a war elephant disguised as a friendly festival elephant. That's why the mahout shooed away

the local children and told them they mustn't run up and feel the elephant's skin or feed him twigs. He was on the lookout for two specific children to punish.

And here they were. No mistaking their description: one black, one white. The mahout stabbed his spike into the elephant's flank. Bazaar stalls and parked carriages went tumbling as the elephant trumpeted and charged, as ferociously as on any battlefield. Balarama skipped around and grabbed the tail while Krishna juked and somersaulted loops among the pounding gray pillars. Now he was on top of the elephant, and the mahout was on the ground. Balarama dug in his heels and stopped the juggernaut pachyderm.

Playfulness, even here: "Krishna teased the elephant," according to the *Harivamsha*, "like the wind teasing the clouds." The play turned deadly serious when Krishna leapt onto the elephant's head and uprooted the tusks. One stab of the tusk gored the elephant, who lost control of bladder and bowels, piss and dung. Balarama had to skip clear. Krishna rolled off the subsiding head, past the buckling elephant-knees and the loose firehose of the trunk. The murderous mahout got a blow of the tusk, too, which killed him instantly. With Balarama just behind him, Krishna ran into the arena with the torn-up tusk held high, and the audience, which had gotten word of the battle just outside the gates, greeted the victors with shouts of joy. Lightness, ornament, beauty marked Krishna even here: "The [elephant's] fat and blood," says the *Harivamsha*, "seemed to have created playful armlets on his arms."

King Kamsa, outraged at how his own citizens greeted his would-be killer, gave a nod to his wrestlers, and the real game began.

Their names were Chanur and Mushtik, famous wrestlers with large followings of their own. Was the cheering today for them or for their opponents? It seemed to have a different character, shriller from so many women's voices, some of which sounded panicky or fearful—no doubt out of motherly concern. Some of the veteran wrestlers debated the ethics of two champions taking on untrained country boys. Hadn't they just killed an elephant with their bare hands, though? How were these opponents unequal? Before they could declare in favor of the king's decision to let the match go forward, Chanur was grappling with Krishna, and Mushtik was grappling with Balarama.

In those days, in that part of the world, wrestlers and gymnasts powdered their hands not with chalk but with dried cow dung. The faint smell must have reminded the country boys of home, of play-wrestling in the grass while the cows grazed nearby. The foundation of the universe tested moves on the foundation of the foundation of the universe, no doubt making for seismic upheavals on farflung planets. Here, though, they tussled with men three times their size.

Chanur and Mushtik wondered what the right way to handle this might be. An instant headlock and neck twist would seem brutal and make the whole matchup seem unfair, unsportsmanlike. Should they take a fall or two, scuffle in the dust a bit, so it didn't look like they simply murdered two boys in public? These young teenagers had no peachfuzz mustaches yet, no hair under their arms; their voices hadn't even broken. Prolonging the match, though, would make the professionals lose face.

The decision wasn't up to them. Neither wrestler had the luxury of toying with the other. Boy and man hoisted and slammed each other, pinned and escaped, pressed a knee into a back, then felt the ground itself slip out from under him. Beauty and playfulness, even here. The women in the audience commented on it:

> Look at the lotus face of Krishna as he dances around his enemy. It is covered with drops of perspiration from fatigue, like water on the calyx of a lotus flower. Do you not see the face of Balarama, with its red-coloured eyes? It is flushed with anger at Mushtik, and glows from excitement and laughter.
> *Krishna: The Beautiful Legend of God (Srimad Bhagavata Purana Book X)*, part I, ch. 44, translated by Edwin F. Bryant

Fatigue and delight, the joy of a game played for mortal stakes. The brothers knew they were safe, but Nanda and the Vraj cowherds had front row seats for the unfair matchup. Their shouted demands to *Stop this now!* couldn't be heard over the crowd. They were on their feet, but so was everyone else.

Everyone except for King Kamsa, fixated on the wrestlers covered in reddish arena dust. So this was the Krishna that everyone sang about, in spite of the royal edict against ballads? The public had to see the boy's dead

Dark-skinned Krishna and his white-skinned brother, Balarama,
grapple with King Kamsa's wrestlers.

body and smell the smoke off the pyre. That would disabuse everyone of superstitions regarding Krishna's predestination.

Chanur straddled Krishna, his knees pinning the small dark forearms. Kamsa had seen Chanur win like this before, and sure enough, the champ started pummeling the boy with both fists. It should have ended there. A few well-placed blows could break the eggshell walls around his eyeballs and drive the shards into his brain.

The fight ended all right, just not as Kamsa expected. Krishna's arms escaped the weight of Chanur's knees, and his reflex-quick hands caught and halted the giant fists. Krishna tilted up and threw down his enraged adversary like a foaming cup drained to the dregs and dashed.

Balarama was just finishing off Mushtik with his fists as Krishna strode toward the king's balcony. Kamsa got to his feet and started ordering arrests. *Arrest Nanda, arrest everyone from Vraj, arrest Devaki and Vasudeva, arrest—*

Krishna, paying as little attention to these orders as Kamsa's soldiers, climbed a pillar to the royal balcony. All his practice climbing trees back home made it easy. Kamsa saw hesitation and pallor in his supposed body-guards. They thought of their king as a doomed man. Why hitchhike to the funeral ghats on someone else's bier? King Kamsa, alone now, fell back and grabbed his sword and shield. When the young dancer swung over the balcony and floated down onto his lotus feet, Kamsa feinted left and right, as he had learned over years of training. Yet these rehearsed jukes made him move as clumsily as a hoofed animal wearing lead clogs.

Krishna, unarmed, ignored that flashing sword and grabbed Kamsa by the hair under his crown. Krishna, already behind the shield somehow, seemed too close to stab. The sword clattered at Kamsa's feet as he felt himself taken control of. He felt his body ascending, and his gaze went to the clouds. He rose so quickly and weightlessly that he wondered whether heaven whooshed him skyward in his own body. (Later, it would become a matter of scholastic speculation whether Kamsa might have earned himself a spot in heaven and a lucky rebirth: after all, had anyone, even Radha, meditated as intently and continuously on Krishna as the paranoid king?) Kamsa's giant body loomed for a moment there, stormcloud-vast, suspended above the storm-dark child. Then he became lightning and struck the ground, head first.

11

CHAMELEON ME

With the broken body still bleeding, and Kamsa's wives mourning him on the arena floor, Krishna visited his parents. He had two fathers in the crowd: Vasudeva, who snuck him out of Mathura in the night, and Nanda, who raised him.

Krishna visited his birth parents, Vasudeva and Devaki, first. Bowing to them, he touched their feet, the ancient gesture of respect observed to this day. Reverence—but distant, formal reverence. He apologized for his absence all those years; they deserved better. From there, he moved on to Nanda, who, by contrast, got an embrace. Krishna told him, perhaps in a whisper, that a child's parents are the ones who nourish him. But Nanda, too, he sent away. Krishna would stay in Mathura now.

In the earlier source, the *Harivamsha*, an Heroic Age ethos surrounds Kamsa—even Kamsa—with mourners. His death is not portrayed as a cause for celebration. Krishna himself regrets the pitiable state of Kamsa's relatives. Long passages convey the grief of Kamsa's widows and Kamsa's parents, who speak in their own voices. And at Kamsa's cremation, Krishna participates in the rites.

A sense that the enemy, in defeat, stops being your enemy, that all is rec-onciled after the war (or wargame) is over—this is the heroic epic's outlook. You find it in Homer, when Achilles shows mercy toward Priam and allows Hector's body to be burned. You find it in the *Mahabharata*, too: when the el-dest Pandava gets to the heaven reserved for noble warriors, the first person he sees there is his cousin Prince Duryodhana, his nemesis on earth, leader of the side that lost the war. The simpler, starker, good-versus-evil dynamic is psychologically primitive. The enemy is an orc, Sith, devil, heathen, kafir, and must be destroyed, with no empathy and no quarter given. This frees up the conscience by sacrificing empathy. We saw that same mentality in the tales of Krishna slaying demons. The only peek into the demon's private life came when the nervous snake-wives pled with young Krishna for the life of Kalinaag. When he slew the other demons, there was no sense of a tragic end. The slain demon commanded no respect.

So when Krishna pours out water at Kamsa's funeral, the act marks a break point in Krishna's story. The forest, the gopis, the leela, herding cows, slaying beastly demons with a dancer's ease: the pastoral idyll is over. Now his story enters the morally ambiguous world in which a nephew may well have to kill his uncle for the sake of dharma. Decades later, on the battlefield of Kurukshetra, the prospect of killing family members will prompt Arjuna to throw down his bow and Krishna to impart the *Gita*.

Krishna did not kill Kamsa to usurp the kingdom. He installs Kamsa's sidelined father, Ugrasena, as king. Krishna and Balarama join an ashram to receive a formal education—the equivalent of an illiterate teenager walking into the big city and enrolling at a prestigious university. The promiscuous Krishna even takes a vow of celibacy for the duration of his studies (though not before he has one last fling with Trivakra, taking her up on the offer she made when he straightened her spine).

This is no longer the world of romance. Krishna never returns to Vraj. He has entered the grownup world of politics and dharma. The world of the epic.

I returned to Ohio as a fourth-grader.

"You're the color of my shit. Every time I look at you, I think about my shit."

The Italian-American kid who snarled about the fecal color of my skin was just as brown as I was. I could have lined my arm up next to his, and we wouldn't have been able to tell which was whose. I had seen his mother just two days before when she visited our school to help out with lice checks. Reindeer-sweatered moms ran coffee stirrers through our hair while the teacher continued talking at the front of the class. His mom, a petite divorcée, obviously visited a tanning salon; her skin was an even darker brown than mine.

Most of my memories of getting bullied about my skin color feature the descendants of Italian immigrants. No doubt their grandfathers or great-grandfathers had been insulted over their swarthy complexions, back when America's racial hierarchy placed Southern Europeans above Black Americans but below people of Anglo-Saxon stock. I was never very good at firing back at the kids who insulted my skin. Comebacks occurred to me, sharp and eloquent and devastating, just as I was falling asleep, or sometimes days later. At the time, when it happened, I always went into a physiological reaction that choked off my speech: pounding pulse, dry mouth, mild dizziness, and a queasy feeling in my stomach, like I was in a dropping elevator. At that age, nothing strikes at the core like a comment about the surface. It's paradoxical. Such a trivial insult, but I remember it, in intricate detail, over thirty years later.

Our suburb of Cleveland had resettled dozens of Jewish families from Russia, Belarus, and Ukraine after the fall of the Soviet Union. The Russians—we called them all Russians, even though the redheaded Ukrainian kid Yuri kept correcting us—had thick accents, and the ones I knew were garrulous and jolly, always full of coarse jokes and good-natured insults. The locker room before gym class hosted friendly competitions to see who could conjure the most absurd images of the other's mother in heat. (I remember examples, but I'll spare you.) Though their skins were much whiter than the other main ethnic group in our high school, they never showed any skin-color animosity. They were not yet fully American.

I remember the time our gym teacher had us line up and swing across the monkey bars, one by one. I wasn't good at much in gym, but I could take those bars two at a time, swinging so skillfully that some of the girls said *wow*. I dropped to the floor with my heart soaring. One of the boys, jealous

maybe of the impression I had made, muttered, *So what—they're closer to monkeys*. My classmates snickered; the gym teacher either didn't hear or pretended not to.

Trivial, trivial—but the memories lodge themselves, splinters under the skin of the soul. These minor insults were the worst I dealt with, and even those I still carry with me. I can only imagine the burden of flagrant injustice, serious threats to safety, or full-blown violence. I was never beaten up, never hassled or slammed to ground by the police. Our tiny community of Indian-Americans suffered no lynchings, no hakenkreuz burned into lawns, no graffiti spray painted on our garages or our local temple. The worst I got were racist insults like the ones I've shared here. I've forgiven them all. It's easy enough for me to do that. I never got a black eye or broken nose. But I have not forgotten. If I had suffered what other groups have suffered here, I doubt I could do either.

There's another reason I can forgive those insults and slights so casually, which is that, when I look objectively at my childhood and everything after, I...won. If anything, the game was rigged in *my* favor. The kid who called my skin the color of shit—he came from a broken home, and his mom styled hair for a living at the Best Cuts on Wilson Mills Road. The kid who likened me to a monkey? His dad worked in the sun for a local landscaper. No doubt, back in southern Italy, his ancestors had been peasants. They probably came to America on a boat, not speaking a word of English. My parents? They came here on Air India with medical degrees. A decade before their arrival, Black Americans had faced down attack dogs and firehoses to get the Civil Rights Amendment passed. I grew up in a big house in a safe suburb with steaming rotis all glisteny with butter, and all I had to do was ask my mom. My parents paid for college and medical school. I started practicing Radiology in a private group with zero debt. My parents could afford that because they were both physicians. Brahmins of a subtype elite even relative to *other* Brahmins, they gave me a centuries-curated genetic inheritance. If I *didn't* end up successful, *that* would be my fault. For everything else, I have my ancestors to thank, all the way back to Narsinh Mehta. Birth-luck.

I can forgive those bigots so easily because they evoke my pity, not my rancor. They had a brief interlude in their lives when they had some measure

of ascendancy over the bookish and gangly brown kid with the weird name. Their time passed quickly, and it ended with … the sight of that same gangly brown kid in a cap and gown, on stage, giving the valedictorian speech. Of course they resent me and, I imagine, any Indian-American who reminds them of me. Even the nostalgia and pity I feel for them must infuriate them. I was set up to succeed by nature and nurture in a way they weren't.

And as for America? It was the place where birth-luck could maximize its effects, and my immigrant parents knew it. That's why they came here. They tried to return to India, but after two years, they came right back home to Ohio because, even though all their siblings lived there, even though that was the country of their childhood memories, this place was better than that place. They chose this country because they saw the future in it—theirs, my sister's, mine.

You are what you remember.

I remember the books. Skinny legs stood on bike pedals, straining uphill to the Mayfield Regional Library. My blue and gray Jansport backpack bulged with sharp corners as I cruised back down that hill, bracing for the skewed sidewalk-squares, watching for cars that might back out and block my ten-speed's shirring descent.

For me, elementary school was *Encyclopedia Brown* mysteries and *Choose Your Own Adventure*; middle school was James Bond novels and Asimov's *Foundation* series. In eighth grade, when my sister was a senior, I found her copy of Dante's *Inferno* lying around. She had been assigned it for English class. I asked her what it was about, and she said it was too complicated for me to understand. I took this as a challenge and embarked on it. It so happened that I came down with the flu that very night. Whether or not those first cantos made much sense to me, I don't recall. All I recall was that I had a fever dream inspired by Dante. As for the details of it, I wish I retained them. It took place in outer space, and there was a lot of fire (in both the dream and the feverish dreamer). I was hooked after that.

Tracking Dante upstairs to the library's little-visited second floor, I discovered the literary past in the form of Loeb Classical editions: Greeks in green, Romans in red, Christmastime giftwrapped under the Tree of Knowl-

edge. By pure serendipity, that branch of the county library system was the repository of the Classical Literature collection. I read my way through Europe, Persia, and India in translation. That cluster of shelves, that sector of the Dewey Decimal System, became the Bermuda Triangle where my adolescent hours went missing without a trace. I honeybeed from shelf to shelf, astonished at how much there was to read. All the names on the spines sounded familiar to me. Was it déjà vu from a past life of reading? This was my native country. These were my people. Our skins all had the same color, black ink on white paper.

Most of the time, those two worlds, the infinite eclectic cosmos of world literature and my tiny ethnic enclave of Hindu Indian-Americans, never overlapped. In the course of time, through years of omnivorous reading, I encountered my ancient Hindu ancestors through foreign eyes. Skin color was never a uniquely American obsession; there was never a time that people "didn't see color." Outsiders had been observing—and, alas, conquering—Hindu Indians for centuries. How had we appeared to them, and how had their perceptions changed our perceptions of ourselves? How did India, which exalted black skin—the krishna skin of Vyasa, Draupadi, and Vishnu's avatar—warp into the India that sells skin-whitening creams and keeps dark-skinned beauty off its television screens? The answers lay in the books.

THE WHITE ARMS OF THE IONIANS

Hindu India's already-developed civilization showed up in the work of Greece's earliest historian, Herodotus. His fifth-century B.C. descriptions of "gymnosophists"—"naked teachers"—tracks to the ascetic yogis who strew the forests of Sanskrit literature. (Millennia later, Churchill would call Gandhi a "half-naked fakir.") After discussing the wide range of diets to be found in India—the whole spectrum from cannibalism to vegetarianism—Herodotus shared his theory of Indian bodies. He connected Indians and Ethiopians, and he believed the difference was more than just "skin deep."

> The sexual intercourse of all these Indians . . . is open like that of cattle, and they all have one color of skin, resembling that of the Ethiopians: moreover the semen which they emit is not white like that of other races, but black like their skin; and the Ethiopians also are similar in this respect.
> **HERODOTUS**, *Histories,* book III, translated by A. D. Godley

The Greek word he uses is "melanchroes," which contains the same root as the modern word "melanin."

The passage shows the earliest expression of one side of the West's di-

vided mind about India. In Herodotus, we have a vision of Indians copulating in the open. The Indians are sexually immoral or even amoral, no better than animals. It is the start of a trend. The uptight cultures that approached India from the west, first Islamic Central Asia and then Christian Europe, also perceived India as a land of excessive license. Iconoclastic ghazis hacked at the noses and breasts of shameless sandstone apsaras. Nineteenth-century Victorian missionaries, claiming Hindu temples doubled as brothels, regarded the eradication of Hinduism as a prerequisite for the imposition of basic morality. Krishna's many loves in Vrindavan (sixteen thousand, in poetic hyperbole typical of Sanskrit texts) were grounds for pious condemnation.

By the time of Pliny the Elder (first century C.E.), half a millennium after Herodotus, the classical Mediterranean world had a more detailed, level-headed sense of Indians. Pliny's place names are a mix of archaic ones and ones in current use—I wonder if "Jomanes" is really Jamuna and "Methora" Mathura. The larger observation, that Indians in the south have darker skin than Indians to the north, holds true to this day.

> The river Jomanes runs into the Ganges through the territory of the Palibothri, between the cities of Methora and Chrysobora. In the regions which lie to the south of the Ganges, the people are tinted by the heat of the sun, so much so as to be quite coloured, but yet not burnt black, like the Æthiopians. The nearer they approach the Indus, the deeper their colour, a proof of the heat of the climate.
>
> PLINY THE ELDER, *Historia Naturalis*, ch. 22: The Ganges, translated by John Bostock

This passage begs the (highly politicized) question: What's the story behind the color change from northern India to southern India? Some claim a prehistoric invasion by white people that antedates even the composition of the Vedas (circa 1500–1000 B.C.E). Not surprisingly, empire-building whites came up with this theory very recently, a theory that doesn't seem to have occurred to any actual Indian in three thousand years. Sanskrit texts can be *interpreted* as supporting it; no text actually states it. A British Christian missionary came up with the word "Dravidian," today a rallying cry of India's

southern secessionist fringe. Other scholars claim a nonviolent migration, citing how British archaeologists, like Mortimer Wheeler, exaggerated and sometimes just made up evidence of the Indus Valley Civilization coming to a bloody end. Still others refuse to admit any intermixture of peoples at all, even in the face of emerging genetic evidence.

One of the meanings of "varna," the Sanskrit word translated as "caste," is "color." In any text that refers to caste, the various varnas are always specified according to their tasks, roles, and duties—priest, warrior, merchant, laborer—and not their skin color. The textual record's earliest overt references to skin color, the *Upanishads*, rate darker skin more highly.

Who knows? The uncertainty provokes motivated guesswork from all parties. Basically, it has become a proxy for the question of whether modern Hinduism is the "indigenous" religion of modern India, or just one more invasive species.

I have my own opinion, but it's not entirely relevant to this discussion. Guesses about prehistoric India don't apply to the colorism discussion because Vyasa, Draupadi, and Krishna all came *after* whatever may or may not have happened. Krishna worship is *more* vigorous among some light-brown populations of India than it is in the deepest South, where skin is generally darker. The black-skinned Shiva and the black lingam that symbolizes him once gloried at the northernmost, lightest-skinned end of India, the snow-white heights of Kashmir. The present-day color spectrum of India has obscure and prehistoric roots. The contemporary distaste for dark skin has a later origin.

So where and when did that shift in perception arise? Did it originate with light-eyed, light-skinned ancient Europeans who invaded India?

Even before Alexander the Great, in the mists of mythic time, the God Bacchus was said to have conquered India. The first-century C.E. Roman poet Ovid, in Arthur Golding's classic Elizabethan translation, describes that God as a beautiful child:

> Thy youthfull yeares can never wast: there dwelleth ay in thee
> A childhood tender, fresh and faire: in Heaven we doe thee see
> Surmounting every other thing in beautie and in grace

And when thou standste without thy homes thou hast a Maidens face.

To thee obeyeth all the East as far as Ganges goes,

Which doth the scorched land of Inde with tawnie folke enclose.

OVID, *Metamorphoses*, book IV, translated by Arthur Golding

In A. S. Kline's less flowery translation, those last two lines read, "The Orient calls you conqueror, as far as darkest India, dipped in the remote Ganges." Youthful beauty is not all Bacchus shares with beautiful young Krishna. Consider the gopi-like behavior his female devotees exhibit when called to their God's festival:

So all obey, young wives and graver matrons,

Forget their sewing and weaving, the daily duties,

Burn incense, call the god by all his titles . . .

Son of the Thunder, the Twice-Born, the Indian,

The Offspring of Two Mothers. . . .

OVID, *Metamorphoses*, book IV, translated by Rolfe Humphries

"Twice-born" corresponds to the term dvija in Sanskrit, the physical birth first, the spiritual birth second. The "offspring of two mothers" has a different meaning in the Bacchus story: Zeus fathered him with Semele, but when Hera arranged her death (by forcing Zeus to show her his divine form), Zeus had to sew the unborn fetus into his thigh. It doesn't correspond to Devaki and Yashoda. Yet the epithets have an uncanny aptness. Bacchus began as a bearded, masculine God with a reputation for warlike conquest of the East—yet in later Roman times, as we see above, he was portrayed as androgynous and beardless, similar to many modern depictions of young Krishna.

All that is still in the realm of mythology. What about recorded history? The ancient Indians knew the Greeks as Yavanas (a corruption of "Ionians"). Philosophical crosstalk occurred even before Socrates, but Alexander's armies brought Greek culture, Greek genes, and Greek aesthetics to the subcontinent in full force.

What was the Greek ideal of beauty? The Goddess of love and beauty was Aphrodite, and Hesiod, in his fifth-century B.C.E. poem *Theogony*, refers to

This 2nd-century C.E. terracotta figure of Isis-Aphrodite
has survived with her pigments largely intact;
the color scheme preserves the whiteness of her body.

her as "golden Aphrodite." It isn't certain whether that refers to her hair or her skin color, but the poet does go on to describe how she was born from the (white) sea foam. It's a long story, but to summarize, after Cronus castrates Uranus and throws his genitals in the ocean,

> a white foam spread around them from the immortal flesh, and in it there grew a maiden. . . . Afterwards, she came to seagirt Cyprus, and came forth an awful and lovely goddess.
> HESIOD, *Theogony*, translated by H. G. Evelyn-White

In Homer, a minor sea Goddess saves the life of wave-tossed Odysseus. Her name is Leucothea—literally, White Goddess. Greek goddesses consistently have white skin: "white-armed," leucolenus, is an epithet Hesiod gives to Persephone and Homer gives to Hera.

What about Helen of Troy, the Iliad's equivalent of Draupadi? In Homer, as in Vyasa, a supremely beautiful woman becomes a cassus belli. We could get a sense of the Greek ideal from her description, but Homer does not specify Helen's skin color. Yet he does specify the skin color of a different Trojan woman, the wife of Hector, Andromache. She, too, has "white arms."

As for the male ideal of youthful beauty, unearthed classical statues of Eros (Cupid) may look like pure white marble, but time has bleached them. In their original form, classical statues wore skins of lifelike paint. Those color schemes have not survived, but Pompeii's mosaics confirm an absence of black-skinned deities. (The earliest portrayal of Eros is the third century B.C.E. Hellenistic *Sleeping Eros,* but his color matched his sculptor's medium, bronze.) We do have a description of Cupid that dates to the second century C.E. It is found in the Roman author Apuleius. Psyche observes her divine lover by lamplight:

> And when she saw and beheld the beauty of the divine visage shee was well recreated in her mind, she saw his haires of gold, that yeelded out a sweet savor, his neck more white than milk. . . .
> APULEIUS, *Golden Asse*, ch. 22, translated by William Adlington

So Cupid, like Venus, has white skin. Not surprising, since this was a white-skinned part of the world. The question is whether this aesthetic got imposed on India by the Macedonians and other Greek-speaking groups.

For a few reasons, the answer is no. First of all, Hellenistic influences antedate the rise and frenzy over the black Krishna that climaxes in Jayadeva's *Gitagovindam*, over a millennium after Alexander. Alexander's forces never pushed all the way to the Ganges, and a majority of India was never subjugated under a single Greek dynasty. Sculptors in Gandhara (modern-day Afghanistan) created a syncretic sculptural style; meditating Buddhas wore the heads of Hellenistic busts. Yet by the third century B.C.E., King Ashoka's Rock Edicts describe his sending Buddhist missionaries to Antiochus Gonatus, a king of Macedonia and a successor of Alexander. Though India traded extensively with the classical Mediterranean world, neither Greek nor Latin ever became the language of power or administration in most of India.

Did any language manage to seize that role? Did any empire, religious or political, invade and dominate many-colored India for a period long enough to cause a shift in aesthetics, a shift in self-perception? Colorism in India is a vestige of two successive periods of domination by political and religious imperialists, who regarded native Indians with contempt. That contempt was total, for the depth and the surface alike—for both their religious tradition and their skin. The imperial aesthetic, in both cases, came from the West.

13

HOW PERSIAN SPEAKS OF BEAUTY

It would be futile to pretend this chapter is apolitical. Religion—particularly the long history of Hinduism and Islam—is one of the central fault lines in South Asian politics. That line maps to India's contemporary borders with Pakistan and Bangladesh, as well as to the Line of Control in Kashmir, as of this writing.

Nothing religious is apolitical in India, not even decades-old television series based on ancient epics. The actors who played Krishna and Rama onscreen in the 1980s, Nitish Bhardwaj and Arun Govil, went on to become successful politicians with the Bharatiya Janata Party, the political party that takes the Hindu side in India's equivalent of the culture war. Roopa Ganguly, who played Draupadi, and Dipika Chikhlia, who played Sita, also became BJP politicians. As recently as 2020, during the COVID-19 lockdown, the state television channel broadcast the epics again, and fifty-one million viewers tuned in—a quarter of them children. That same year, Rama's birthplace was reconsecrated in Ayodhya, the site of a mosque built on the archaeologically verified ruins of an ancient temple.

Even my childhood memories of India hide a history of Islamic invasions and iconoclasm. For example, the Somnath Express we took to Junagadh was named after the Somnath temple, first sacked by Mahmud of Ghazni (a city

in modern-day Afghanistan) in 1026 C.E. That same temple was rebuilt—and sacked again, this time by Alauddin Khilji. This cycle of Hindu creation and Muslim destruction persisted until Somnath's complete destruction by the genocidal Mughal emperor, Aurungzeb. The site remained a ruin until an independent India, under the supervision of Sardar Patel, built the iteration that stands there today.

Ahmedabad, where my sister and I lived and went to school, was built on or near the location of an earlier city, Karnavati. A Muslim sultan, Ahmed Shah, built his own city there in 1411 and named it after himself.

My own ancestors never lived under direct British rule. The kingdom of Junagadh, over ninety-five percent Hindu by population, was ruled by a dog-loving Muslim nawab until 1947, when that autocrat chose to accede his kingdom to Pakistan, not India. My grandparents fled when they heard doors getting kicked in down the street. They escaped the purge of Hindus and wintered in another city before India took charge of that green Pakistani dot on the coast of Gujarat.

My earlier chapters elide the sectarian background of my own references. I mentioned how the Jagannath Temple houses the most ancient image of Krishna with a deliberately chosen black color. The Muslim warlord Firuz Shah Tughlaq desecrated that temple in the fourteenth century C.E., and then Aurungzeb forced its closure during his lifetime. I've mentioned Mirabai, the poet in love with Krishna, getting widowed at an early age; her husband died in a battle with Babur, the Muslim founder of the Mughal Empire. The Krishna sect that centers his childhood in Vraj, known as Pushti Marg, was founded by a holy man named Vallabha. The *Bhagavata Purana*, from which I've quoted so extensively, served as his central text. Before Vallabha was born, a Muslim sultan named Bahulul Lodi threatened an invasion of the Hindu holy city of Varanasi. Vallabha's mother, pregnant with him at the time, fled the city and gave premature birth after the journey. A temple marked Krishna's birthplace in Mathura; the Muslim emperor Aurungzeb destroyed it and built the Shahi Eidgah mosque there, which still stands. The holiest city of Hinduism, Varanasi, was also defaced by Aurungzeb. He destroyed the top of the Kashi Vishwanath temple and used the foundation as the base of the Gyanvapi mosque. The clashing structure has stood for

four hundred years, and the faithful pray inside it to this day, its dark brown Hindu temple foundation visible below, the mosque of white stone on top: the color scheme of imperialism given architectural form.

So yes, though I wrote this book as a private inquiry into memory, heritage, literature, time… everything about this is political. This colorism question has led, inevitably, to a thousand-year stretch of history that activates intense loyalties. Polite, university-based, career-cautious Indian discourse minimizes the Islamic invasions, while online Indian discourse explores and denounces them through thousands of anonymous accounts.

Skin color, though, is a question of eyes and bodies, of a group's collective sense of beauty. The Qur'an never mentions skin color, and the Prophet selected a black man, Bilal, to serve as the first muezzin. The religion nowhere advocates discrimination on the basis of skin color. If black African Muslims instead of Central Asian Muslims had conquered India, this issue would hardly have arisen. (Briefly, in the mid-fifteenth century C.E., Ethiopian eunuchs did rule Bengal; brought to India to serve as palace slaves, they revolted against their Muslim masters and became the sultans of the Habashi Dynasty.)

All we know is that adhering to Islam (or any religion) does not protect its followers—whether Arab, Turk, Mongol, Afghan, or Indian—against human failing. Consider the Shariah-sanctioned East African slave trade, which forced millions of black Africans onto auction blocks. It lasted for an entire millennium, far longer than the West African slave trade that disgraced the Americas. Victorians exploring the interior of Africa documented their encounters with Arab slave traders throughout the region. Those traders already knew every kilometer of the geography Burton and Speke were trying to map. One of the largest slave markets, run by the Sultan of Zanzibar, shuttered only when the British Royal Navy, in the nineteenth century, threatened bombardment. Slavery was outlawed in Saudi Arabia in 1962, at least on paper (ten percent of the country's population, a hidden multitude, is Afro-Saudi).

Contempt and sexual insecurity mingled in the region's attitude toward black bodies, the same toxic psychological mix that led to lynchings in the American South. The East African trade featured castration centers to preempt miscegenation. Recall what triggered King Shahriyar's nightly decapitation of a new bride in the *Arabian Nights*:

In the royal palace there were windows that overlooked Shahriyar's garden . . . a door opened and out came twenty slave girls and twenty slaves, in the middle of whom was Sharhriyar's very beautiful wife. They came to a fountain where they took off their clothes and the women sat with the men. "Mas'ud," the queen called, at which a black slave came up to her and, after they had embraced each other, he lay with her . . . and they spent their time kissing, embracing, fornicating and drinking wine until the end of the day.

 The Arabian Nights: Tales of 1001 Nights, v. I, ch. 4, translated by Malcolm C. Lyons with Ursula Lyons

The Hindus of India became victims of the slave trade as well, with a whole mountain range possibly getting its name from the slaves who died on the forced march west across it: Hindu Kush, according to the fourteenth-century traveler Ibn Battuta, meant Hindu-Killer. In the seventh century C.E., Arab Muslims penetrated as far as Sindh, in the western part of the subcontinent. A few centuries would pass before other Muslim warlords penetrated all the way east to the Ganges. Arabic never became the language of power—of court administration, of the aristocracies of force—in most of India. That language was Persian.

Or Farsi, as my paternal grandfather called it. Farsi was one of the many languages he spoke, along with Sanskrit, Urdu (at that time not completely distinct from Hindi), English, and the Gujarati he spoke in the home. I envy the range of books he could have read in the original. I never got to have those conversations with him, as he died when my father was the age my twin sons are now. The Krishna songs of Jayadeva and Narsinh Mehta, the plays of Kalidasa and Shakespeare, the epics of Vyasa and Firdowsi, the ghazals of Mirza Ghalib and Rumi—he could have sampled them all, heard their kindred and divergent music. I would trade all my radiology knowledge of anatomy and physics for those languages. Someday I will ease up on both the day job and the book writing and devote myself to nothing but ecstatic frenzies of speaking—and reading—in tongues. (I daydream about retiring from medicine, but I don't envision some golf cart in Florida. I see

myself surrounded by textbooks and foreign language dictionaries.) It will be the start of the big project of mastering my grandfather's languages and then some. Persian will be one of them.

After all, its magnetic appeal has been transcending ethnolinguistic boundaries for hundreds of years. Babur, the founder of the Mughal Empire, had Mongol ancestry and wrote his memoirs in Chagatay Turkic. Yet when he stopped to jot down the poems that occurred to him, sometimes he composed them in Persian. Turkish written poetry (distinct from the folk tradition) adopted Persian meters and countless Persian and Arabic loan words. The Ottomans often ruled Persian lands, but the Persians ruled Ottoman poetry.

What did the classics of Persian poetry tell my grandfather, back then, at the start of the twentieth century? How did they conceive of beauty?

In 1206 C.E., Qutb-ud-din Aibak founded a sultanate in Northern India. He built one of the first mosques in India from the ruins of twenty-nine demolished Hindu and Jain temples; the Prowess of Islam mosque stands to this day, preserved by the Archaeological Survey of India. The very next year, in 1207, a poet named Rumi was born to the west of that new sultanate. The slave trade that trafficked people out of South Asia made "Hindu" synonymous with "slave," and the color association runs through Rumi's poetic work:

I become black and dark, you might say I am of the infidels.
RUMI, in *Mystical Poems of Rumi*, poem 216, translated by A. J. Arberry

I have found it necessary to fall back on Arberry's older, more literal translations. Modern American translators elide Rumi's textured religious and cultural allusions to create a more palatable product for modern readers (Coleman Barks, the most famous of these translators, does not read Persian).

Rumi, as Arberry notes, uses "Hindu" throughout his poetry as a synonym for slave. When used metaphorically, "Hindu" signifies night, ignorance, and grief, while "Turk" signifies day, enlightenment, and joy. (Rumi himself was born in Balkh, in modern-day Afghanistan, and died in Konya, in modern-day Turkey.) "O dawn," runs one apostrophe, "fill the world with light, drive afar these Hindus" (Poem 230, Arberry). In another poem, Rumi uses the

Hindu and the "Zangi"—the Ethiopian—as two examples of blackness overthrown. It combines associations of night, unbelief, and the righteous conquest of people with black skin:

> Dawn has arrived and drawn his polished blade, and from heaven camphor-white morn has broken forth. . . .
> After being routed, the Rumi [Roman] of day having found the strength has dragged the Zangi [Ethiopian] of night from the royal throne.
> From that direction whence the Turk of joy and the Hindu of grief arrived there is everlasting going and coming, and the way is not to be seen. . . .
> Night is bewildered at who has blackened its face; day is bewildered at who has created it so fair.
> RUMI, in *Mystical Poems of Rumi*, poem 112, translated by A. J. Arberry

As for ideals of beauty, Rumi shows us the opposite and leaves no doubt about the color of it. Metaphorically, the "unworthy crone" might be a "savorless deception"; in the pictorial world of the poem, Rumi's epitome of ugliness is an old, black woman:

> You who let a garden go for the sake of a small fig, let slip the houri for the sake of an unworthy crone. . . .
> A stinking-mouthed crone with a hundred clutching talons and tricks, putting her head down from the roof to snare a clever one.
> Who is such a crone? A savorless deception, fold on fold like an onion, fetid as garlic. . . .
> When death opens your eyes, then you will behold her, her face like the back of a lizard, her body black as pitch.
> RUMI, in *Mystical Poems of Rumi*, poem 355, translated by A. J. Arberry

Elsewhere, too, he refers to a "drunken pitch-black Hindu," the consummation of servitude, ugliness, benightedness, and lack of moral self-discipline.

The Persian romance often compared to *Romeo and Juliet*, for its story of star-crossed love, is *Layli and Majnun*. In it, we read how Layli was able

> To teach the cypress what is meant by height,
> And wash the lily's whiteness with her white. . . .
> NIZAMI, *Layli and Majnun*, p. 50, translated by Dick Davis

Her breasts are "silvery white," and her "lovely buttocks gleam quicksilver-bright."

To reinforce the color schemes described in words, we can look to extant Persian miniatures, many of which illustrated literary classics. Safavid Persian tile panels show us beautiful women with chalk-white complexions. Illustrations of another Persian narrative poem, Jami's *Yusuf and Zuleikha*, show a seductress purchasing Yusuf in a slave market. One of the most famous Persian miniaturists, Riza-yi Abbasi (1565–1635), painted *Two Lovers* (1630) as well as the *Lovers in a Garden* with bright white skin.

The Persian ideal of heavenly beauty: Two camelback houris from
a Persian manuscript describing the Prophet's trip to Paradise.

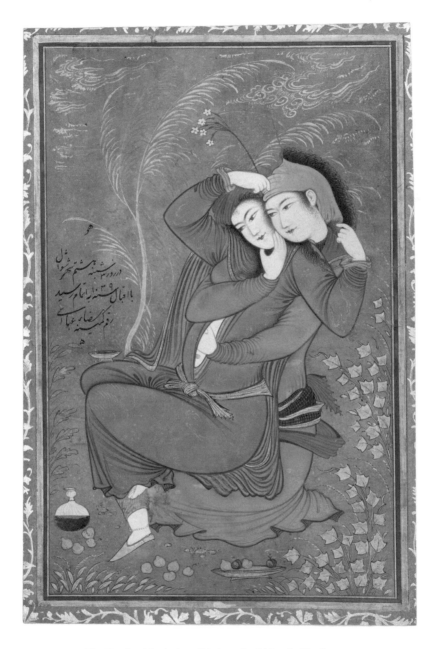

The Persian ideal of earthly beauty: Abbasi's *The Lovers*,
just as light-skinned as the houris.

It wasn't as though artists in the Persian sphere of influence painted complexions white by default, as if they hadn't seen people of any other color; Indian-Hindu and African slaves abounded in Central Asia. The painters made deliberate choices: in *Sakyamuni Announces Another Prophet*, from the *Majma al-Tavarikh*, a fifteenth-century painter from Herat portrays a scene that takes place in ancient India. The Buddha's followers are painted dark brown. The Buddha ("Sakyamuni"), because he is foretelling the Prophet Mohammed, has been painted with light skin to indicate his difference from the kafirs. The Indian visitor who introduces chess to the Persian court is also dark brown compared to the fascinated Persian observers who surround him.

The zenith of beauty, in this tradition, is the houri, the divine form of those who make it to heaven. A hadith in the *Sabih al-Bukhari* describes them as translucent or transparent, the bone marrow visible through the bones and flesh of their legs. A seventeenth-century Ottoman portrayal in the Harvard Art Museum, done in ink and opaque watercolor, keeps the houri's complexion identical to the white paper. The Bibliotheque Nationale's *Miraj Nama* contains an illustration of the Prophet's ascent to heaven on a flying horse; at the bottom, the houris on camelback have white skin.

This color preference, and its corresponding artistic expression, influenced Indians, both in their self-perception and their art. The Arab historian Ibn Khaldun (d. 1406), reflecting on Arab imperialism's conversion of much of the world, was among the first to describe the process:

> The vanquished always want to imitate the victor in his distinctive characteristics, his dress, his occupation, and all his other conditions and customs. The reason for this is that the soul always sees perfection in the person who is superior to it and to whom it is subservient. . . . The soul, then, adopts the manners of the victor. . . .
>
> IBN KHALDUN, *Muqaddimah,* part 2, section 22, translated by Franz Rosenthal

"[H]is . . . characteristics, his dress" . . . I wore a kurta at my Hindu wedding. "Kurta" is a Persian word, and the tunic came from Central Asia, perhaps with the same Ghaznavids who sacked Somnath. I did not wear paduka at

This painting imagines the Buddha announcing the future appearance
of the Prophet Mohammed. The Buddha, being enlightened, has light skin;
the Indians he enlightens are dark brown.

my wedding, those wooden sandals described in the *Ramayana*; I wore mojari, brightly decorated sandals whose distinctive style dates back to the Mughal Empire.

People who adopt the dress of the conqueror would adopt, if they could, that other outer covering, the skin. I imagine Ibn Khaldun would agree, since the psychological mechanism is the same as the one he describes. The prestige associated with power gets associated with the physical appearance of the powerful.

When contemporary Americans talk about skin color, most follow America's racial binary of "white" and "people of color." Other phrases like "Black and brown bodies" conflate Americans of non-European origins as far apart as Somalia and Japan. Though my fellow Ohioans would have trouble telling a brown Persian apart from a brown(er) Indian, groups in Central and South Asia were keenly aware of differences of shade. Contempt for darker skin merged with contempt for benighted, kafir religion.

We possess illustrations, commissioned in Rajput courts or the court of Akbar, of the *Mahabharata*, the *Ramayana*, and scenes from Krishna's life. This art, half a millennium into Persianate dominance, mimics Persian illuminations in size and style—and in the colors chosen for female beauty. The gopis match the houris. As for Krishna, his blackness seems to have fallen into disrepute. No more was he portrayed in the unapologetic black of the wood sculpture at the Jagganath Temple.

Plenty of variation persisted, of course; it's not as though a memo went out to all the artists of all the kingdoms of the subcontinent mandating that everyone switch their palettes. In fact, we see clear signs of defiance. During centuries of Islamic political dominance and the sacking of Hindu holy cities, scattered communities struggled through to a resurgence—and they did so through the worship of Krishna. Krishna's ubiquity and popularity did not begin abruptly, neither during his life nor immediately after his death. The worship spread and gathered force over hundreds of years. During the long centuries of oppression by light-skinned Central Asians, indigenous Indians foregrounded their blackest avatar. The revivalism of the Bhakti

movement centered the figure who most resembled the "pitch-black Hindu" held in contempt by Persian-speaking masters.

I remember patting my cheeks and forehead with a small mound of Pond's talcum powder. My sister and I did it side by side in the mirror. I was eight and she was twelve, and we were whitening ourselves. I thought America was the reason my face was relatively light-skinned compared to the Indians around me—wintertime in Ohio, those white Christmases, had leached into my skin and bleached it. For some reason, I never connected my skin with my mother's. But my face felt chalky with that powder on it. Sometimes it dusted my lips, and my tongue, brushing it, experienced an instant thirst. When I got back to America, I abandoned talcum powder pretty quickly. I patted my face with a towel and left it as it was, growing to love my skin gone abruptly dark brown again. Because my patriotism inverted once I got back from India. Just as I had been jingoistically U.S.A. in India, in Ohio I was all *mera Bharat mahaan*. I was insecure. I had to have a superior somewhere-else to which my peers had no access.

In a few years, as I hit my bookish adolescence, that India—thousands of miles away, its cockroaches and burning trash fading in my memory— began to grow religious, historical, imaginary. It became the landscape of the Hindu dharma rather than a real place. I could love it better that way. Naipaul called it a wounded civilization, and I knew where the knife went in. The wound has a name: the Khyber Pass. Only what you love can hurt you, and I loved and love that irretrievable India more than any other place on the page or on the planet.

Because I love it, it can hurt me. But above all, it can hurt me because it lives. The descendants of the Incans speak Spanish and worship in Catholic Churches. The descendants of African shamans and Celtic Druids and priests of Isis are Christian or Muslim and remember nothing. If they do see traces of their old Gods, they think of the old ways with a shudder, as Pakistani Sunnis do when they come across a Vishnu murti buried in the Indus clay. It is heathen, benighted. It is the jahiliyya, the time before the one truth. But I remain a Hindu; I am still here; I still know and I still remember and I still love what the others have been taught to despise. It is

a strange fate to be the holdout religion, to be the guardian poet entrusted with the world's last living ancient mythology. I know that Krishna means black and I know, too, what it is to see all the power and confidence wear a whiter skin than mine. I know how, over hundreds of years, in this or that conquered city, an artist portraying the avatar switched from Jagganath's black to nightfall's black-blue, or a bruise's blue-black—and how decades later, his student mixed a little white with that blue, and then a little more, to make that face less black, to make "stormcloud-dark" Krishna the color of a daylit cloudless sky, until centuries later, there could even be a white Krishna installed in a temple, the inversion complete.

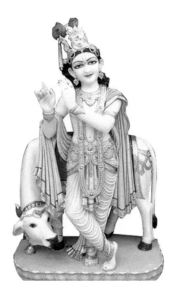

A modern-day Krishna statue in white marble.
Different parts of the statue have been painted, just not the skin.

Self-loathing had not yet driven Indians to bleaching creams, laser treatment, and chemical peeling. Another, whiter colonial power expanded its rule in India beginning in the 1700s. This group's fixation on skin color made Rumi's metaphors seem benign. Brownish-white Central Asians were displaced by white Europeans.

14

THE WHITEWASHING OF INDIAN INTERIORITY

These men aren't niggers; they're English! Look at their eyes—look at their mouths. Look at the way they stand up.
 RUDYARD KIPLING, "The Man Who Would Be King"

The white soldiers in that Kipling story have left India and gone into the mountains of modern-day Afghanistan. There, Daniel Dravot and Peachy Carnahan stumble on an isolated, polytheistic tribe. The Nuristanis have somehow escaped Buddhist and Islamic influence in the region for centuries. Their white skin will make them natural empire-builders, Dravot believes: "They only want the rifles and a little drilling."

Notice the "niggers" that Dravot refers to are not Africans. Kipling's stories and poems enshrined the living slang of common imperial soldiers, and we see how the term was applied to dark-skinned Asians as well. In one of Kipling's *Barrack-Room Ballads*, we can hear British soldiers invoking the term as far east as Burma:

Now remember when you're 'acking round a gilded Burma god
That 'is eyes is very often precious stones;

An' if you treat a nigger to a dose o' cleanin'-rod
'E's like to show you everything 'e owns.
RUDYARD KIPLING, "Loot"

This widespread usage brought the word into an 1886 glossary made for Britain's Indian empire:

> NIGGER, s. It is an old brutality of the Englishman in India to apply this title to the natives. . . . The use originated, however, doubtless in following the old Portuguese use of *negros* for "the blacks," with no malice pre-pense, without any intended confusion between Africans and Asiatics.
> HENRY YULE and A.C. BURNELL, in *Hobson-Jobson: A Glossary of Colloquial Anglo-Indian Terms and Phrases*

Britain's worldwide empire, with territories on multiple continents, col-lapsed Rumi's distinction between the implicitly light-skinned "Turk" and the implicitly black "Hindu." In the eyes and mouths of British soldiers, Indian Hindus, Indian Muslims, and even Burmese Buddhists were all, like the Africans just across the Indian Ocean, "the blacks."

Hobson-Jobson's mention of the Portuguese reminds us that the British were not the only European colonizers to enter India—they were just the most successful. The Portuguese conquered a smaller territory, but they did not leave Goa until 1961, when the Republic of India evicted them by force. The Portuguese instituted the Goan Inquisition, imposing Christianity with the help of imported torture instruments (Goa remains twenty-five percent Christian today). One of the missionaries, Francisco de Jasso y Azpilicueta, was a Basque from Navarre who wrote home about how he recruited young hooligans to ransack temples and destroy their murtis. He did this kind of thing so well he ended up getting sainted.

> For as there is so great a variety of color among men, and the Indians being black themselves, consider their own color the best, they believe that their gods are black. On this account the great majority of their idols are as black as black can be, and moreover are generally so rubbed over

with oil as to smell detestably, and seem to be as dirty as they are ugly and horrible to look at.

FRANCIS XAVIER, "Letter to the Society of Jesus at Rome, 1543," translated by Henry James Coleridge; in *The Life and Letters of St. Francis Xavier*

St. Xavier's almost became my alma mater in India. When deciding among schools in Ahmedabad, my parents knew the most prestigious one was the all-boys Catholic school. The Indian Christian priests in charge agreed to let me in, but before they gave my dad the paperwork, they took him aside and asked for an astronomically high "donation." My father expected something like this (it was India, after all, and the priests knew he was carrying US dollars), but he balked and looked around for a better deal. The administrators at Gujarat Law Society undercut the holy fathers by two hundred thousand rupees. A close call.

With Sanskrit, Greek, and Persian literature, you have to look around a bit to find mentions of skin color. With the exception of Krishna, whose name signals his blackness, those three bodies of literature do not strike me as epidermally fixated. In English literature, and European literature more generally, this is not the case. The obsession with white skin is everywhere, and not just in the literature of colonial encounter.

The English tradition's two foundational elements are the King James Bible and Shakespeare. In the Old Testament, we read, in the Song of Solomon,

I am black, but comely, O ye daughters of Jerusalem, as the tents of Kedar, as the curtains of Solomon.

Look not upon me, because I am black, because the sun hath looked upon me.

SONG OF SOLOMON, 1:5–6, King James Bible

Incidentally, two spices mentioned in verse 4:14 originated on the Indian subcontinent: spikenard, native to the Himalayas; and cinnamon, native to Ceylon, Burma, and the Malabar Coast.

Bernard of Clairvaux, in the twelfth century, preached an entire sermon on the dark color of this biblical woman. At first, his sermon seems to approximate the ancient Indian aesthetic sense that saw beauty in both Gauri and Draupadi: "'I am black but beautiful.' Is that a contradiction in terms? Certainly not.... Not everything therefore that is black is on that account ugly." Then he gives some examples of what he means by this.

> For example blackness in the pupil of the eye is not unbecoming; black gems look glamorous in ornamental settings, and black locks above a pale face enhance its beauty and charm.
> **BERNARD OF CLAIRVAUX**, sermon 25, translated anonymously in the *Cistercian Fathers* series

This saint cannot conceive of dark *skin* as being compatible with beauty; it's a white face that gains from a frame of black hair. The woman in the Song of Solomon was not even racially African or Asian; her "blackness," as the second verse makes clear, was just a tan from working in the fields.

Shakespeare, whose global reputation has benefited from Britain's global empire, had Romeo praise Juliet's skin by contrasting it with its opposite:

> It seems she hangs upon the cheek of night
> Like a rich jewel in an Ethiop's ear;
> Beauty too rich for use, for earth too dear!
> So shows a snowy dove trooping with crows
> As yonder lady o'er her fellows shows.
> **WILLIAM SHAKESPEARE**, *Romeo and Juliet*, Act I, Scene 5

Elsewhere, Shakespeare did refer to India specifically, and though he did not know the word "Hindu," much less any hymns to Surya in the Rig Veda, he did know that India contained a preponderance of benighted heathens. When Helena describes her unrequited love, she compares herself to someone who worships something incapable of awareness.

Thus, Indian-like,
Religious in mine error, I adore
The sun that looks upon his worshipper,
But knows of him no more.

WILLIAM SHAKESPEARE, *All's Well That Ends Well*, Act I, Scene 3

The East India Company was incorporated in 1606, the same year as *King Lear*'s first performance. The EIC Board of Directors shared Shakespeare's notion of India as a place of immense wealth; the same greed that motivated the warlords of Ghazni and Samarkand motivated the economic predators of London. Consider how a Shakespeare character describes the meeting of the French and English royal entourages:

Today the French,
All clinquant, all in gold, like heathen gods,
Shone down the English; and tomorrow they
Made Britain India: every man that stood
Show'd like a mine.

WILLIAM SHAKESPEARE, *King Henry VIII*, Act I, Scene 1

"Made Britain India"—and, over time, made India Britain. Ibn Khaldun's insight about the imitation of power applies here as well. An educated Indian became a "babu," Anglicized and estranged. Muslims were not immune to the phenomenon; the founder of Pakistan, the London-educated lawyer Mohammed Ali Jinnah, dressed in three-piece suits, wore a monocle, and was fluent only in English.

The distaste for dark skin in the Persianate world was replaced with the English-speaking world's aggressive loathing for it. The white-skinned ideal of beauty is so pervasive in English poetry and art that examples of it could fill a separate book. The word "fair," in reference to hair, skin, or general appearance, conflates whiteness and beauty in the same word. That British usage persists to this day in India, whose most popular skin lightening cream is called Fair & Lovely, and "fair" is a common feature of Indian matrimonial advertisements:

SM4 Brahmin, 27, 5'2", Btech, Fair, Beautiful Girl, Family settled in Chandigarh. Only Govt. employees preferred.
Times of India, 22 March 2020

In English literature, we find Milton describing Eve as "so lovly faire" in *Paradise Lost,* Keats in *Endymion* hymning a "white Queen of Beauty" with "fair eyes," and Edmund Spenser's *The Faerie Queene* deploying all three conventional images of white skin in its litany of sea nymphs, with "Phao lilly white.... And snowy neckd Doris, and milkewhite Galathaea." All that's missing is a swan. No matter, Lord Tennyson can supply one, when a Knight of the Round Table offers some jewelry to a queen:

> Take, what I had not won except for you,
> These jewels, and make me happy, making them
> An armlet for the roundest arm on earth,
> Or necklace for a neck to which the swan's
> Is tawnier than her cygnet's. . . .
> LORD ALFRED TENNYSON, "Launcelot and Elaine," in *Idylls of the King*

The British brought with them, at a high cultural level, the ideal of white beauty; at a political level, subjugation to Victoria, the "White Queen over the Seas," in Kipling's phrase; and at the street level, the interpersonal "brutality" of "nigger" and obsequious salaams before the white sahib. Central Asian imperialists brought the same combination of a monochromatic ideal of beauty and a loathing for black skin, all linked to a sense of religious superiority. Their successors, the European imperialists and the missionaries they brought with them, possessed all those traits. Though the British were just as contemptuous of the "Hindoo" religion, temple destruction and physical torture were mostly the specialty of Portuguese colonists. The British perpetrated no equivalent of the quarter-millennium Goan Inquisition, instead doing most of their killing through conventional war and famine. The Portuguese imported thumbscrews and the strappado from the mother country to enlighten the natives. (They also imported black slaves from

Africa, a whole community of whom went on to settle in Junagadh, at the foot of Girnar Mountain.) British colonial identity fixated on skin color, and unlike religion, skin was not an identity marker that could be changed to match the master's.

Cumulatively, then, over one thousand years of psychological pressure have taught dark-skinned Indians to hate themselves as well as their dark-skinned Gods and Goddesses, their black epic heroine, and their emphatically black avatar. Is it any wonder, then, that Ravi Varma's paintings of Draupadi bleached her? His paintbrush did to Draupadi's skin what an entire generation of Indian women are doing to theirs when they use skin-lightening creams. Is it any wonder that Krishna's iconographic color has transformed from the Jagganath Temple's black to the illustrated picture-book's light blue? In fact, the alteration has gone even further: today's online marketplace abounds with Krishna murtis fashioned out of white marble, white terracotta, white porcelain. His clothes, hair, flute, garlands all get painted—just not his face and arms. Those are left white.

EPILOGUE

THE I OF THE BEHOLDER

The *Mahabharata* and the *Ramayana* are sometimes taught in Indian public schools, but the original poems are too vast to read in their detailed entirety. As stories, they don't require institutional support to keep people familiar with them. Even young children in India knows these stories, and popular culture remakes them endlessly, in movies, cartoons, children's books, comic books—not out of blind reverence for tradition but because there's money in it.

Still, there's a downside to failing to engage with the actual lines and passages. It entrusts the epics to entities like the Bollywood film industry. The *Iliad* and *Odyssey*, even in Homer's time, were not primarily experienced through reading. Performers called rhapsodes took the epics on tour in a series of live performances, tragedians used them as raw material for drama festivals, and mosaic artists pieced together scenes and characters on the walls of villas and bathhouses. You can't rely on the actual book getting read, not even in a society with literacy rates as high as America's: as every author who's done a television or radio interview knows, it's hit or miss whether your interlocutor has done more than skim the back cover.

So that is one possible solution to a problem over one thousand years in the making: the epics, in some version that holds scrupulously true to the

authentic original, must be required reading. Not just for Indian students, but for the people who create the art that's based on them. India needs its modern expressions of these living epics to track to the originals. Both the audience and the industry should find it jarring if, say, an actor playing Krishna or Draupadi isn't extremely dark-skinned.

A return to the source texts may change Indian self-perception by changing what Indians see on screen. Male and female beauty standards, as we see them on Indian screens, are a holdover from India's Persianate millennium, not the two centuries of English rule. White men and women with blue or green eyes and blond hair are not the ideal of beauty. Hindi cinema prefers a slightly browner complexion—people who look like they hail from far to the north and west, without quite crossing the Caucasus mountains. This is why Hindi film stars look more like Afghans or Iranians than Indians; the most famous early twenty-first century actor is partly of Pathan origin. Bollywood's skin color ideal tracks to India's former colonial masters: Turkic, Afghan, Mongol. For decades, all three of the most famous male actors in Bollywood had the last name Khan. This psychological colonization occurred in a top-down fashion; the decolonization, too, must occur in the same way.

The endgame is not to simply replace the current ideal with an inverted one that places darker skin at the top of a beauty hierarchy. That is not how classical India saw beauty. Draupadi was black, Gauri was white, Sita was golden. Krishna was black, Balarama was white, Buddha was golden. Classical Indian notions of beauty, human and divine, male and female, covered the whole spectrum of human skin tones. Indians, then as now, varied so much in color, even within the same family sometimes, that a starkly graded "whiter, prettier; blacker, uglier" hierarchy—most notoriously present in Europe—could not emerge organically. The current attitude is a psychological deformation, and it has resulted from centuries of subjugation by whiter racial groups. Enduring history has done this to Indian self-perception. Understanding that history will help India overcome this imperial legacy. The beholders must change their eyes to behold their own beauty again. The beauty has always been here. The beauty is everywhere.

*　*　*

You are what you remember.

I remember the Grundig videorecorder that we took with us to India. Its sleek gunmetal case opened noiselessly on black styrofoam niches where the technology rested, efficient even in its stillness, commanding my fascination even while powered off. I knelt before it, afraid that the oils of my fingers would smear it, interfere with its workings somehow. To me it symbolized the West, the superior civilization. I would have fought off my cousins if they had tried to slide a rude hand into its velcro strap or jab its mystical buttons or violate the side panel that, pressed in, followed the finger away to open the cassette slot. In the VHS footage of our Ahmedabad apartment, I dance and sing before the lens. My eyes search its solitary black eye, desperate to enter it and become permanent. It is a kind of worship.

I remember the stash of frozen chocolate we tucked away in our White-Westinghouse refrigerator, giant by Indian standards. A single bag of fun-sized Snickers, left over from what we believed was our final Halloween, had to be protected from the Indian heat. On our first Halloween in that country where no one had heard of Halloween, we chipped it free of its ice crust and unwrapped a single, precious memory. Frozen hard, almost a year old, brown ice cubes sat in our mouths. Even after mine melted, it tasted of nothing at all. The taste, like the past, like our lives in Ohio, seemed irre-coverable. We tucked the bag back in its crystal-fuzzy corner behind the ice trays. It became a symbol of Halloween candy for us, not the candy itself. We never disturbed it again.

I remember the epic game of Holi, squirt-gun assault and tag and paint-ball in one, that exhilarating suspension of propriety and deference that allowed an eight-year-old like me to grab a fistful of bright pink powder and fling it at someone five times as old with no consequences, laughter all around. Festivals, however briefly, replaced society's norms with their own to make the whole society realize the absurdity of its quotidian rules, to get the pent-up Dionysian wildness out for an afternoon. The festival suspended the old rules, so you got some insight into the game-nature of social life. You could return, willingly and wisely, to the rest of the year. The powder burst out of my hand into a color cloud. Pump-action squirt guns sipped from buckets full of dark water that spat blue or green onto white kameezes.

The dye felt gritty on my cheek when an aunt snuck up and marked me. How could the festivals back home compete? Gifts under a tree were nice, and candy and costumes were nice, but this, like Uttarayan's kite battles and Navratri's mass dances, was something of an entirely different nature. This was fun.

I remember the first time I read the *Upanishads*. I had come back a few years earlier from India. This was something at a different level than poetry, "philosophy," or essays. This was the truth, sent through time by my ancestors to me, or maybe even from myself in a past life to me now. I had never read it before, and yet, I had read it before—literary déjà vu. The ideas settled into their black styrofoam niches, and the gunmetal-gray case of my mind shutting noiselessly on them, on obscure verses I couldn't possibly have understood at that age, and yet, in some nonverbal way, *got*:

> Pushan, Ekarsi, Yama, Surya, son of Prajapati,
> Draw apart your rays and draw them together.
> I see the light that is your most beautiful form.
> That very person—I am he.
>> *Isha Upanishad*, 16, in *The Upanishads*, translated by Valerie J. Roebuck

"I am he": the solitary blazing eye overhead was watching me, and everything I did and said and wrote was permanent in its recording. *You are that.* What did that eye see, that solar eye? It saw me for who and what I was, which was something else. Certainly not my skin, "dark" on this continent, "fair" on that one, a trick of the light as it touched the retinas of strangers, a deception: what encased me was *maya*, a mix of dyes on the surface of me, melanocytes and skin cells just so many powders exploding off my writer's hand into a cloud, whoosh, gone. My self was my atman, and my atman was not this shade of brown—not an Ohioan, not a Nagir from Saurashtra, not an eight-year-old or even a future forty-two-year-old writing what he is by writing what he remembers. That Upanishadic I became the pillar at the center of me. On top of that pillar I build my memory, that is, my identity: which is not what is unique to me, but what is idem, the same, between me

and you and what is beyond us both, shining over us, through us. We have one imperative on this side of history, as we strive to recover our selves from the ruins. We hear it in the last line of the *Isha Upanishad*—where "isha" means both the self and the one who governs the self. The goal is to collapse these two into one I, into self-rule, the dream of the colonized. In my own translation:

> Aum. Resolve to remember what has been done.
> Remember it. Resolve, and remember.
> What has been done: *Remember it!*

THE *RAMAYANA* AND THE
BIRTH OF POETRY

Consider Punch. He wears jester's red and carries a stick the size of his body, a stick he uses to hit everyone around him. He runs amok until the hangman finally catches up with him—but it's the hangman, not Punch, who ends up with his neck in the noose.

Now consider Jesus. Wearing a plain robe, he carries two sticks in the form of a cross the size of his body. He walks slowly up a mountain until he arrives at the place of his execution. The Roman soldiers, after casting lots for his clothes, carry out their task. Jesus does not find a way to stop them or switch places with his executioners. He ends up nailed to the cross in the sun.

Everything in literature falls somewhere on the spectrum between these two forms of storytelling: slapstick and scripture. The mouth opens, and a sound erupts from somewhere deep in the chest, almost reflexively. With slapstick, it is laughter; with scripture, a hosannah.

Slapstick and scripture demarcate the two extremes of the literary spectrum. Where a work falls on that spectrum depends on the reality of the suffering portrayed in it. Bones don't break in a Punch and Judy show. There are no scenes in the hospital, no leg casts, no months of rehab. Today, the descendants of slapstick are children's cartoons. Wile E. Coyote realizes he is running on air; he turns to you, waves goodbye, and plummets thousands of feet to a puff of dust at the bottom of a canyon. But he isn't falling to his

death. We know that even before he shows up perfectly intact in the next scene. We laugh because that suffering is absolutely unreal.

The four Gospel writers, by contrast, believed they were writing nonfiction. Most of their readers believe they are reading nonfiction, in spite of manifestly supernatural story elements. These four writers weren't exactly the Nabokovs of their day; their Koine Greek was not an extravaganza of finely crafted sentences, lush descriptions of scene, and snappy, unexpected metaphors. This is the Plain Style, appropriate to a simple account of events. Not only did the Crucifixion really happen, that really is the Son of God on the cross, and he really is dying for *your* sins. Sentimental sniffles are out of place here. You are implicated in that suffering. And that suffering is absolutely real.

These two elements—a plain or transparent style, and the air of nonfiction—are critical when it comes to conveying absolute suffering. The few twentieth century works that come closest to conveying absolute suffering are nonfiction stories: Elie Wiesel's *Night* and John Hersey's *Hiroshima*. We read these books differently. They hit us differently than the finest examples of narrative invention. Novels like Toni Morrison's *Beloved* or Günter Grass's *The Tin Drum* derive their power, in part, from historical settings (slavery, Nazism) that we know to be real. The novelist's magic transfers the absolute suffering of the nonfictional dead to the fictionally alive.

Our stories and poems portray suffering with varying degrees of reality. Sometimes the suffering is just real enough to add excitement or a sense of danger. Most "romances" (in the archaic sense of the word) and adventure novels need this kind of suffering to achieve their overall effect, which is to keep a plot going without opening any abysses along the way. It isn't meant to move you. If a detective gets grazed by a bullet in a noir novel, he barrels on after the crook. If a child were to get grazed by a bullet in a work of literary fiction, perhaps in a school shooting, the aftermath could take up the rest of the book.

Many literary forms blunt a character's vulnerability to make the suffering less real. The mechanisms for a character's superhuman indifference to pain are innumerable: vampirism, lycanthropy, and zombie infection are

only the most obvious. The Batman suit—or any form of body armor that serves as a bulletproof exoskeleton—is a lineal descendant of the magical suit of armor found in chivalric romances, which itself goes back to the "vulcanized" Shield of Achilles in Homer. Even when these outward shields against pain aren't brought in, there may be some internal toughening that allows a hero to deliver the phrase *It's just a flesh wound!* with perfect equanimity. The noir detective is "hardboiled" because other people are eggs that crack easily. The hardboiled detective looks like a regular human being, but he can take punishment in book after book and never "crack," either psychologically (as in having a breakdown) or physically (as in breaking a bone).

Some perfunctory explanation is usually given for this superior tolerance to pain and suffering. Bulldog Drummond, whom Ian Fleming cited as the literary precursor of James Bond, was a World War I veteran; he had survived the most intense suffering known to that audience, and now anything was possible. Comic book superheroes wear their superpowers on their sleeves (or on their capes). The semidivine warrior in a heroic epic (say, Achilles) does what others do, like throw a javelin, only way better. The "highly trained" agent of a contemporary thriller can shoot bad guys five hundred feet away while sliding on his back across the floor of a warehouse with his nondominant arm bleeding because *It's just a flesh wound.* A superior tolerance to pain is often paired with a superior ability to inflict it. This is why it's so thrilling to identify with these heroes. From classical epics to modern-day thrillers and screenplays, storytellers seem to know that even the godless like to feel godlike.

The Gospels, by contrast, pursued the exact opposite tactic. They accessed unprecedented storytelling power by making the divine figure vulnerable. The violenced God had some forerunners in the cutup bodies of Osiris or Dionysus. That cutting and resurrection mimicked the cutting and regeneration of the harvest or the vine. The emphasis there was on regeneration.

In Christianity, the resurrection inspired far less art than the crucifixion. Jesus's body was portrayed on the cross to command contemplation. The Gospels had inverted the customary Homeric device of having a God or Goddess fight alongside a warrior, making the human superhuman and impervious to javelins and sword-thrusts. (*Enthusiasm*, in its Greek etymol-

ogy, means "entered by a God.") The new religion's artists sensed, perhaps instinctively, the source of the story's uncanny power: this moment in which the superhuman, having become human, endured human pain. The suffering was absolute because the Absolute was suffering it.

So this is the spectrum of suffering: slapstick on one end, scripture on the other, with fiction and poetry ("high" or "low," "genre" or "literary") in the vastness between them.

Portrayals of suffering are perennially interesting. Suffering itself, of course, is not. The Buddha designed an entire religion to escape it. No one wants to endure suffering themselves, but everyone is eager to watch or read about someone else enduring it, whether it's Christ, King Lear, Harry Potter, or Punch's wife. What is it we crave? Why seek out portrayals of suffering to read or watch? Why write them? Why suffer vicariously and move on, over and over?

No matter how much people claim to want heaven, the *Paradiso* remains stubbornly less popular than the *Inferno*. It seems human beings prefer shipwrecks, corpses discovered in the woods, soldiers burning villages, mysteriously poisoned millionaires, and the occasional apocalypse. With the latest technological form of fantasy fulfillment, people consistently opt for battlefield violence that would have them waking up screaming with PTSD in real life. Their lives and deaths are innumerable, and they pick up where they left off, endlessly reincarnated. If the fantasy they shell out for is set on a beach, it's Normandy in 1945. What happens after the game's last level is beaten? Nothing much: winner's circle, mission accomplished, the pose with the trophy.

Because that was never where these games' creators focused their attention. Heaven, the fulfillment of desire, has little intrinsic drama. Nirvana is a flatline. *And they all lived happily ever after* is how storytellers dismiss years of fulfilled desire; the bulk of any fairy tale is the riddle at the bridge, the imprisonment in the tower, the dragon-slaying, the rescue. We don't like literary environments with no conflict. Politics springs eternal. We want to be happy, but we want to struggle and suffer for it.

* * *

Desire, the ancient yogis believed, is infinite. Its infinite appetite likes infinite variety.

Happiness, safety, peace, prosperity: do such things grow stale? Does freedom? A lukewarm monotony might be just as intolerable as hellfire.

Imagine a society, the safest and most prosperous in history, whose people madden themselves daily with lurid images and tales of trauma and atrocity beamed to a device they carry in their pockets. The next alert, the next ginned-up emergency gets their attention with a ping. This is what people do when they are born into comfort. They make themselves a *little* uncomfortable in some way—morally, politically, spiritually.

Literature might do the same thing the news does: stir the pot of the mind for the sake of stirring it. That clockwise sweep of the ladle is just enough agitation. The latest heartbreaking picture that makes the rounds of social media may well be on a spectrum with transient bestselling tearjerkers and half-a-millennium-old high tragedies. It is, all of it, storytelling, suffering aestheticized, a manageable dose of suffering that leaves no mark. We give this account of suffering five stars. We share it. The only way we could *enjoy* these portrayals of suffering is if they retained a measure of unreality. Slapstick is not something we outgrow. It merely puts on more sophisticated masks.

The giveaway is the unreal violence—a corollary, in storytelling, of unreal suffering—that thrills us onscreen or on the page. A paperback tearjerker, too, gets us shedding tears for a character in the "world" of the novel; that is why the crying stops a few moments later, and a new unreal story finds its way onto the nightstand, another "world" is conjured, another character goes through three hundred or so pages of suffering for our entertainment.

Only rarely does literature push toward absolute suffering and pierce the membrane between art and reality. When it strives to do so, we have poetry. The second most popular story on earth, after the Gospels, is an ancient Hindu epic that disseminated throughout Asia, the *Ramayana*.

In the *Ramayana* we, too, have an incarnation of the divine. Here, too, we see Rama suffering like any human being, going temporarily insane with grief when his beloved wife, Sita, is kidnapped by the king of Lanka. Hindus experience this story, talking monkeys and all, as true history and

poetic fantasy at the same time; the footprints on the rock where Hanuman landed, after jumping eight hundred miles from the tip of India, is a tourist destination in modern-day Sri Lanka. Hinduism is the last living mythological religion; Hindus experience their epics the way the Ancient Greeks experienced Homer, which would explain Homer's Bible-like role as a source of quotations and wisdom in Plato's dialogues.

Many poems gain their power from our sense of their actually being nonfiction—specifically, autobiographical. Sylvia Plath's final poems benefit from this effect. Byron routinely capitalized on the confusion between Byron and the Byronic hero; Europe's sense of Byron's life–art interchangeability inflated his fame for a century. To this day, no reading of Keats is entirely unaware of his tuberculosis. His most beautiful poems are at once what they are—an ode on a Grecian urn, or an ode to a nightingale—and dramatic monologues in a play about a poet dying young.

In the ancient Indian story of how poetry came to be, the first poet, Valmiki, who has not invented the art form yet, is just another holy man walking in the forest. He is thinking about the great tragic love story of his time, the story of Rama and Sita: two lovers kept apart. First, by the demon-king Ravana, who kidnapped Sita and held her in his island fortress-city of Lanka. Second, by the utterly senseless separation that came when Rama exiled Sita again while she was pregnant with twins, essentially to secure his reputation against the calumny of her rumored infidelity. She ended up at Valmiki's own ashram, and he heard the Queen's suffering firsthand.

Valmiki wants some way to express this story of suffering and struggle and resilience, but there is nothing in language that will do ... yet. To his surprise, he stumbles on two herons mating in the forest. The male has spread his wings, as though for privacy's sake, and has aligned himself with the female. The shuffle and rustle of feathers tells Valmiki, celibate ascetic though he is, what he is witnessing.

Just then, an arrow whistles through the trees from one side. The two mating birds, seemingly as lightweight as butterflies, are pinned together by the single arrow, efficiently gored, killed in the act of procreation. A tribal hunter, oblivious to the horror of what he has done, runs to his spoils. He,

too, will have a story to tell: two kills with a single shot, marvelous. But Valmiki, who has seen this moment whole, feels a pain deep in his heart. It is referred pain, pain felt somewhere other than the site of injury; Valmiki feels it in his throat.

The cry that erupts from him is the first metrical speech. The exact words, in Sanskrit, comprise a curse on the hunter for killing the mating birds. All of poetry is there in embryo, an understanding of suffering unwitnessed even by those seeing it. Those herons are Rama and Sita, interrupted in their union, pierced and destroyed by time's arrow, paradoxically reunited by love in death. The first verse was a curse because poetry has a role in the world, however disregarded, to condemn violence and call out injustice. It was an elegy for the two birds and all the birds who might have come from their completed union. It was a beginning.

FIVE FAMOUS
ASIAN WAR PHOTOGRAPHS

THAT NAMELESS AFGHAN GIRL
ON THE COVER OF *NATIONAL GEOGRAPHIC*

Her eyes are green because they had to be green for the photograph to mean anything to us. Her eyes' intensity, and their hunted look, depend on their greenness (and, admittedly, a slightly disproportionate size relative to the rest of her face). Recessive eye colors are associated by people of European origin with people of European origin, and hence with a fully developed personality. Her face loses the onesidedness so often ascribed to the Asian person by both SEAL teams and college admissions committees: the default Asian, depending again on the eyes, "looks like" either a religious fanatic or an uncreative overachiever. But not an Asian with green eyes; such an individual is set apart. Green eyes add mystery and a sense of recognition simultaneously. Green eyes, in the setting of this otherwise standard refugee-face, create instant empathy, forcing us to imagine, in this most unexpected place, Someone Like You or Me.

Of course, her green eyes are themselves a recessive trait. They penetrated that far east of Europe, or south of Russia, in the forced injections of genetic material brought about by the British Army's invasion in the 1800s or the Red Army's in the 1900s. Or the Macedonian Army's circa 300 B.C.E., or the United States Army's a couple of millennia later. The girl is nameless—she does not exist, she *represents*. So there is a possibility our empathy for the Afghan

Female in Wartime is being aroused, when we look at this photograph, by the genetic trace of the ancient rape of an Afghan female in wartime.

THAT GUY IN SAIGON
WHO IS ABOUT TO GET HIS BRAINS BLOWN OUT

This is a photograph that has a clear precedent in painting: Goya's *The Third of May 1808*, in which a row of Napoleonic soldiers have lined up firing squad–style in front of a group of Spanish resisters. The center of the group is that unforgettable man in the white shirt with his arms up. The left sleeve (the right is obstructed by the head of a fellow Spaniard) is the second brightest spot in the painting, slightly brighter than its own light source, the small box that the soldiers have set down to illuminate their targets. The brightest white in the painting belongs to the tiny sliver of white in his eyes. Because his eyes are open, and his head is tilted, as if he were pleading, or about to plead. This is a man who might be shot in the next instant—but then again, he might simply be arrested.

The guy in Saigon who is about to have his brains blown out has no arms at all; the twisted front of his shirt would suggest they are bound behind him, but in the photograph, his shoulders taper abruptly into nothingness. He cannot throw his arms up in surrender, and he cannot throw his arms across his face in futile defense against the blast. He is, *literally*, an unarmed man getting shot.

This is only one way in which the photograph improves on Goya's painting. The second aspect is the intimacy. Firing squads *had* to be five to eight strong; military leaders knew that a few of the soldiers always shot wide on purpose, and that close-quarters executions were psychologically sustainable only if the soldiers could offload the guilt onto their neighbors in the squad—*his* bullet made the actual kill, not *mine*. Even this pseudo-anonymity takes a toll on soldiers; hard as it may be to believe, the nervous breakdowns of SS men in Polish forests prompted Himmler's shift from conventional bullet-based massacres to the gas chambers. The Saigon picture is much more intimate, with two men foregrounded.

Goya does not show us the executioners' faces; the Saigon photograph shows us the shooter in profile, and his chin is unexpectedly weak. This weak chin has a clear relationship to the smallness of his pistol. The guy about to get shot is unarmed, but the guy shooting him is unmanned. These details articulate visually a very basic, widely held truth about a soldier who kills a civilian: it is an act of weakness. It marks an inadequate man, who did not deserve to be granted the strength and dominance of the soldier. His weapon has shrunk in his hand, just as he is about to shoot. He is, in a sense, impotent.

The photograph also benefits from the surreal fast-forward effect of the civilian's face. Parts of his face are a few seconds in advance of the rest of the photograph. There seems to be blood about his mouth, and his right eye, closest to the pistol, is already shut.

DOUGLAS MACARTHUR
WADES ASHORE IN THE PHILIPPINES

Several photographs were taken of this apparently staged procession, various angles showing various water levels along the pants and boots, which must have been terribly soggy afterwards. The one that is most widely circulated, however, shows the General and several cronies from the right, facing away from the camera. They are still close enough to the boats for the boats to be seen in the background; and the water is roughly knee level. Most importantly, however, the shore is not included in the frame. MacArthur, the white male, is actually *wading through the Pacific itself*, with the mighty tread of an aroused giant.

The brim of his hat parallels the upward angle of the prow immediately behind him. He is at once the white American avenger and the flagship of the Pacific fleet, the instrument of American vengeance. (The atomic bomb hasn't been built yet.)

To these Americans, treading the ocean floor, the Japanese home islands will be less than sandbars. In the photograph, MacArthur's pants seem dark to the hips, but later photographs of him on the sand prove that he

was never more than knee deep. He was set down very close to this quiet Leyte beach, on an island secured much earlier, by Marines who waded through water navel-level or higher, their rifles over their heads, taking fire.

THAT BUDDHIST MONK
WHO HAS SET HIMSELF ON FIRE

Thich Quang Duc in the fire, like MacArthur in the water, is another photograph that records an act of self-dramatization. The monk is one shade closer to death than the Saigon civilian with the gun at his head. He has crossed even further, but every viewer "knows" the photographed monk is still alive in the fire; a photograph of a burning corpse would fail to have this effect. It would become a grotesque or obscene photograph—imagine the Saigon civilian, photographed *after* his head was blown off. The photograph would become something unfit for widespread replication. The moment *before* death is dramatic, and the closer the image can get us to its threshold, the better; too far, and the image instantly hemorrhages all its drama. This is why none of the truly famous photographs of war, Asian or otherwise, are photographs of corpses. Corpses leave us cold.

So the monk freshly burning commands our gaze, while no photograph of the charred, humanish mound is available. Nor are there any easily procured photographs of the people sweeping up the monk's remains. Did locals pour buckets of water over the blotch? Did they scrub at it? Assuming they didn't get it completely clean, who pedaled the first bicycle over the black stain?

THE DETAINEE AT ABU GHRAIB
HOODED AND DRAPED IN BLACK

Of the roughly 2,742 photographs that emerged from Abu Ghraib, 689 involved pornography or simulated sex acts, 540 were of corpses, 37 involved dogs, and 20 involved a swastika between the eyes of an American soldier.

So a considerably smaller number of images were actually fit for potential widespread replication in the media. If we subtract images of detainees either naked or near-naked (though admittedly, the Pyramid of Naked Arabs did gain some dissemination), it stands to reason that the cover of the *Economist*, and countless other websites, should have replicated the image of the prisoner standing on the crate in the black hood and black poncho-like drape, with what appear to be wires leading to his fingers.

Paradoxically, an excessively covered-up figure became emblematic of a torture facility that, in a clear majority of cases, stripped people naked. The arms, held out, fall just short of the 90-degree angle required for a parallel with the Crucifixion. The hint is unmistakably there, however—the image that provokes sympathy for The Muslim dovetails with the central image of Christianity. Notice also that the face, and indeed the entire head, is *covered*. Instead of hinting with the device of green eyes, the photograph creates a black box (or bag) inside which we can imagine Someone Like You or Me. Even the smallest visual hint of sweaty black hair or overlong beard or large nose would estrange the viewer instantly; the image's power resides in its multivalence.

The torture scandal, represented most frequently by this photograph, managed to remain a self-examination regarding the *methods*, not the enterprise. Our pity for the enemy could rise to the surface without diminishing our sense of the cause's righteousness. The detainee's black hood and loose-fitted black drape resemble the veil and robe worn by women under the rule of orthodox Muslim males; the black hood, with its cone shape, resembles the white hood worn by members of the Ku Klux Klan. These are the cues that reinforce the detainee's guilt, subconsciously reminding the Western viewer of Arab Muslim misogyny and intolerance. The two photographs represent two ways of approaching Islam. To move the West to empathy, one Muslim had to be photographed as a female child with green eyes; the other had to be photographed without a face at all.

MEDITATIONS ON
THE LINGAM

1

Incense sticks lit to a river spirit antedate, by centuries, abstract Vedantic musings. The sacred grove antedates the soaring temple of marble. The earliest religion seems to have had a local quality to it, bound to the landscape. Pantheistic modes of worship were the first iteration of environmentalism. Do not cut down these trees. Revere this river. Stand in awe of that mountain. That suspicion of ubiquitous sentience must have evolved its own ethics. The sky is watching.

Hinduism is so old, so autochthonous, so grounded in India and its neighboring modern-day countries—whose borders, in the end, are the doodles of an arbitrary Englishman named Sir Cyril Radcliffe—that its very geography is sacred. What's more, all its layers are exposed at the same time. You can visit the monastic centers of a later, abstraction-enamored, philosophical age, centers of learning founded by the theologian-poet Adi Shankara around the ninth century C.E. As for its Heroic Age epics, the Himalayan Queen Express stops at Kurukshetra Junction Station—the battlefield of the *Mahabharata*. Future Hindus will worship, as their ancestors did for centuries, at the physical birthplace of the Ramayana's epic hero.

The strata of sacred geology go all the way down to the earliest stirrings of what we now know as Hinduism (and what people of Rama's time and Shankara's knew simply, and more encompassingly, as Dharma). The Ganges

is not the only sacred river. Krishna played on the banks of the Yamuna, and the Brahmaputra translates to "son of Brahma." Google Earth does not reveal Shiva meditating at the summit of Mount Kailash, but mysteriously, the mountain has yet to be scaled. Mountaineers indifferent to religion have attempted the climb and died. I stare at pictures of its peak sometimes; angular, geometric, the snow on its oddly horizontal ridges mimicking the bright horizontal stripes drawn across the Shaivite sadhu's forehead. I try to resist, but something in me gets pulled back to primordial awe. Shiva may well be the oldest element of Indic Dharma to survive to this day. The Pashupati seal, discovered at Mohenjo-daro, shows a deity in Shiva's familiar yogic pose, surrounded, as the lord of the animals, by a menagerie.

The Dharma foregrounds poets and musicians—the *Gita* is metrical verse, and it is sung—but, above all, it cherishes sculptors. The sacred sculpture, or murti, pulses at the center of every temple. The Gods and Goddesses, in their physical representations, are made of the stones of the place. So are the temples, and not just out of bricks and blocks. Kailasa Temple in Maharashtra is the world's largest monolithic sculpture, a whole building hollowed out of a mountainside. The temple *is* the land.

One of the earthiest manifestations of the spirit are Jyotirlingams, the lingams of light, usually smooth, cylindrical natural masses that were discovered where they now stand and that mark places where Shiva interpenetrated the geography as a pillar of light. There are sixty-four of them, of which twelve remain, in temples as far south as Rameshwaram at the tapered tip of India, as far north as Kedarnath in Himalayas, as far west as Nageshwara on the coast of the Indian Ocean, and as far east as Baidyanath in Jharkhand.

<div align="center">

2

</div>

In other temples, lingams are man-made, often but not always of stone. Each one serves as the focal point of worship. With a few meaningful exceptions, the lingam, unlike a conventional murti, is not a work of representational art. It is a smooth black pillar with a rounded top.

Shiva is said to be primordial, and that's in keeping with the archaeology, which shows his iconography already developed at the time of the Indus Valley Civilization. One of his epithets is Swayambhu, "self-become." Dharmic time is cyclic, with phases of existence succeeding one another. Each one suffers a total dissolution; even the pantheon is destroyed. Shiva alone bridges them, dancing the Tandava, the dance of universal destruction, in a sphere of fire.

Shiva's lingam, or *sign*, comes from a phase of iconography before the chisel gets to work. In many versions, the distinguishing topography of a face or body is missing. Rarely, faces rise out of the smooth surface, caught at the moment of their emergence into form, like Michelangelo's *Prisoners* from the block. This signifies an event outside time itself: undifferentiated Brahman ("God" is the wrong word) differentiating itself into the Gods and Goddesses of civilizations around the world.

In the Dharma, there are two states of one underlying divine principle. There's the state you can see, touch, light incense to, pray to, know, and, above all, name. That is the vyakta form—literally, in Sanskrit, the spoken form. There are as many of these forms as there are languages, pantheons, peoples. Prior to this state, giving rise to this state, is the avyakta, the unspoken.

The Hebrews, too, remain reticent about the exact name of their feature-less, unsculptable YHWH. Brahman (a concept, not a name) is ultimately unsculptable as well. Unlike YHWH, however, Brahman takes on a vast multitude of representations. It is on this theological nuance that the iconoclastic religions differ from the last (thriving) iconopoetic one.

The lingam's form speaks to us from this threshold between unknowability and knowability, the unspoken from the spoken divine. The smoothness is on the verge of becoming a bas-relief. The pillar stands, though not—or, at least, not yet—on legs.

3

Sanskrit is polysemic. "Sign" is not the only meaning of "lingam." That is the abstract and philosophical meaning. There is also a concrete or earthy meaning. And that meaning is "penis."

The phallic aspect of the lingam is rarely expressed by modern-day sculptors. The iconographic tradition has elided it for at least a thousand years. For an example, we must go back to one of the earliest known Shiva lingams in existence, in the contemporary Indian state of Andhra Pradesh. The Gudimallam Lingam dates back, at a conservative estimate, to the time of Alexander the Great. With its glans-like top, it leaves little doubt that Indians of distant antiquity understood the phallic nature of the sign, the meaning-rich nature of the phallus. Shiva himself emerges, in bas-relief in the garb of a hunter, from the shaft of the lingam. He is standing on a dwarf, Apasmara, believed to represent ignorance. This is the same dwarf that Shiva, in his later form as the apocalyptic Nataraja, tramples underfoot while dancing the Tandava. The Gudimallam Lingam stands five feet tall; if it indeed represents a penis, it is an erect one.

Why put a phallus in a temple? Why connect a phallus with a deity? Mahatma Gandhi once remarked that he had no idea the Shiva lingam had anything to do with a penis until British scholars claimed it was the case. Even today, many practicing Hindus consider the phallic connection to be an attempt by anti-Hindu academics and monotheistic missionaries to degrade or render obscene a sacred object. Practicing Hindus do not have a phallic metaphor in mind while they worship before the lingam, just as Catholics do not view the Mass as cannibalism. Still, the Gudimallam Lingam might prompt modern-day Hindus to reconsider what they deem sacred and what they deem obscene—and why.

Let us unlearn, for a moment, everything we have been programmed to think about sex being dirty or shameful. In the Abrahamic religions that predominate in the world, Eve is the temptress. Adam's sexual partner forces his descent (and hers) into sin and death. Genesis emphasizes not the happiness of motherhood but the punishment of labor. The glorification of motherhood involves a woman who, we are meant to believe, gave birth without copulating with her husband. That son grew up to die a virgin on the Cross (though one of his closest associates, present at his death beside his mother, had been a sex worker). Early Christian priests converted the wealthy ladies of late Rome while remaining celibate, and this self-restraint set them apart, exempt from the soiling physicality of reproduction.

The Qur'an briefly allowed the worship of three Arabian goddesses, al-Lat, Manat, and al-Uzza, before the notorious "Satanic Verses" related to these goddesses were eliminated. Allah is conceived as transcending gender, but Arabic is a grammatically gendered language, and all ninety-nine Most Beautiful Names are male. The "Eternal Feminine" is either demonized, desexualized, or deleted. Other than a few vestiges like the Song of Solomon (albeit quite prudish relative to the erotic descriptions of Kalidasa) and mostly sexless references to "the beloved" in the ghazals of Sufism, there is very little that sanctifies sexual union. Unlike in Kalidasa's Sanskrit poetry about Shiva, sex is not sublime.

4

In Kalidasa's poetry, Shiva sits atop a Himalayan mountain. Ashes smear the divine ascetic's limbs, and his appearance is fearsome, grotesque. Nevertheless, a beautiful daughter of the mountain, Parvati, sees this ascetic and falls in love with him. For she, unknown to herself, is the Goddess Shakti, born in a mortal body. That physical body has grown capable of desire—and capable of inspiring it:

> The lotus-eyed girl's pale breasts,
> pressing against each other,
> so grew
> that between them,
> with their black nipples,
> there was not room
> even for a lotus fiber.
>> Kalidasa, *The Birth of Kumara*, canto 1, stanza 40, translated by David Smith

She tries to impress the ascetic by mimicking his asceticism. But her austerity is ingenuine, in the service of desire. In her desperation, she appeals to Kama, the God of eros. As in ancient Greece and Rome, India's Love-God is an archer. Kama agrees to shoot Shiva with an arrow made of flowers.

He sees Parvati, and her true nature breaks down his resistance instantly. Yet he realizes his awakening has squandered his hard work—the Sanskrit word is "tapas" and means, literally, "heat," as though the yogi's body is a nuclear reactor. In a rage, he looks around to see who has shot him with the arrow.

Shiva's third eye opens, a flamethrower that burns Kama's body away. Immortal eros cannot die, so only Kama's physicality is destroyed. (After this, he is known as Ananga, "Limbless," in keeping with the nature of love, which can linger in the absence of the beloved's physical form.)

The happy lapse, the pleasurable damage, is done. Shiva, surrounded by his wild menagerie, goes to ask Parvati's hand in marriage. Kalidasa's poem ends with an extended description of the God and the Goddess making love, rendered in intricate and earthy detail:

> When his darling beloved
> was fastening her garment,
> which had become loose,
> Shiva the Destroyer
> prevented her—
> his eyes had at that moment
> been drawn to the series
> of scratches at the top
> of her inner thighs.
>
> KALIDASA, *The Birth of Kumara*, canto 8, stanza 87, translated by David Smith

The poem is unfinished. It never does get to the birth of Kumara, the son born of their union. The last lines, the ninety-first stanza of their lovemaking, offer an image of Shiva's insatiable sexual desire, "the submarine fire / under the ocean's waters."

Kalidasa produced the most sublime sex writing in all literature, by the grace of his freedom from shame and prurience alike. That eighth and final canto gives us a sense of the spiritual milieu that saw sanctity in how our species perpetuates itself.

Dating Sanskrit texts is often a game of guesses. Scholars assume that Kalidasa wrote his plays and poems around the fourth to fifth centuries C.E. His *Birth of the War-God* comes well after the Gudimallam Lingam—and well before imperialist monotheism invaded India and smashed the scandalous apsaras and bare-breasted goddesses of India's temple statuary. The Dharma's (paradoxically innocent) sense of sex as sublime, even holy, still held. After all, the climax of yoga—literally, "yoking together"—is uniting the individual self, atman, and the divine collective, Brahman. Sexual climax is the physical, short-lived equivalent of nirvana.

5

Notice, in that story, how Parvati's lover starts out as the ascetic, restraining his desires. Before he is the athletic and mystical lover of Kalidasa's epic poem, Shiva is the supreme celibate, cocooned in samadhi, awaiting the end of time. So the Gudimallam Lingam's erect phallus is not necessarily a symbol of procreation. The lingam, like Shiva, encompasses asceticism. The Gudimallam Lingam shows Shiva with his foot on Ignorance. Its pillar is the heavenward thrust of self-restraint and celibacy, desire contained and the contents under pressure.

Yet the Gudimallam Lingam is not a typical example. The symbol welcomes the opposite interpretation: as something that bespeaks the generative force in nature, the desire of male for female (and female for male), seeking to couple and continue the species. The conventional structure, found in temples from Kedarnath to Kauai, involves more than just a pillar. The lingam sits on a disk-shaped, elongated platform called the yoni.

"Yoni," too, has more than one meaning. As a concept it signifies "source" or "abode," while the word's literal meaning is "womb," and its form also represents, in a stylized way, the vulva. So male and female, in the lingam and yoni, are joined, "yoked," equally sacred. The ritual worship of the lingam and yoni involves abhisheka, a purificatory washing—not with water but with milk. The choice of milk is eloquent, not arbitrary. What purifies the coupling of these divine newlyweds, Shiva and Parvati—what makes

sex sacred, what keeps it from being "dirty"—is motherhood symbolized by mother's milk, the perpetuation and sustenance of the species.

In the story of Shiva and Parvati, Parvati tempts Shiva. Like Eve, she is a temptress, but unlike Eve, she is not demonized for it. She suffers no resentment from Shiva for breaking his samadhi. Shiva loves her, and the Dharma reveres her, making her his coequal in the sanctum, his "other half," the yoni paired with his lingam. Their union has been sculpted as the Ardhanarishwar, literally "Halfmangod": a single body that divides down the midline, part Shiva, part Shakti, part male, part female, but no less bilaterally symmetrical for that—if anything, at last made whole.

6

Kalidasa's poem cuts off at the sexual union of Shiva and Parvati, but the title suggests that its aim was to show how their son came into the world. The rhythms of history commence with the stirring of their desire. Kumara has more than one name; he is better known as Skanda or Kartikeya, the God of war. Their other son, tellingly, is Ganesha, the God of lucky beginnings.

Nowhere in antiquity was war considered the absolute or unmitigated evil that it is today. War gods, such as Ares, Odin, and Huitzilopochtli, are everywhere in ancient civilizations. The Bronze Age origin of "Yahweh" may lie in a warrior or war God. Religions born later, during recorded history, found a way to see wars as holy, whether waged in the name of the New Testament's loving God or of the Qur'an's God of a peace synonymous with submission.

"Eradicate" implies, etymologically, a rooting out. During the long centuries of rapacious Afghan imperialism in South Asia, the indigenous religion's richly endowed temples attracted iconoclastic zeal. Destroying a lingam was a way of both destroying the sacred object and emasculating the conquered, indigenous population. In 1025 C.E., the Turkic invader Mahmud of Ghazni destroyed Somnath's Shiva lingam with his own hands; he sent its pieces to be incorporated into the steps of the Jama Mosque, so believers might defile the infidel "idol" in perpetuity.

After a centuries-long series of Muslim imperialists came the British Empire. The British brought to India their combination of capitalist exploitation and evangelical Christianity. Monotheistic imperialism in India had two different approaches to eradication: one shattered the sacred object; the other kept it intact but neutralized its numinous nature. The British carried off murtis and quarantined them in museums thousands of miles away.

A pedestal or case reduces the murti or lingam of a living religion to an art object for aesthetic contemplation, a spoil of conquest to fascinate residents of the home island. The British Museum's collection includes no fewer than thirty-four lingams or related objects. An early lingam dated 800 C.E. takes the transitional form of a pillar with faces emerging from it. The description implies the story of Kalidasa's poem; the climactic unity of male and female, God and Goddess, is proven in how one of Shiva's faces is his wife's:

Four-faced Siva 'linga.' At each of the cardinal points a face of the god is carved: Siva as incarnate terror (Bhairava), as withdrawn and serene ascetic (note the rosary beads around his neck and the crescent moon in his hair) and as feminine power (Parvati). Made of schist.

The caption for an eighteenth-century lingam and yoni in the British Museum's collection makes no secret of its being extracted from a holy site:

Linga. Black sandstone linga on a circular base with a long tapering spout. A serpent partly coils round the linga and has its head resting on the top. The lower portion of the base is unfinished indicating that the piece was originally set in the floor of a temple or shrine.

7

Made of schist. Made of black sandstone. Made of brass, made of wood, made of clay, made of the hard bones of the earth. Made to endure in spite of the hater's hammer or the looter's crowbar. People made the earth divine by making sculpture and story and sign. The Ganges flows down from the

sky and into and out of Shiva's wild hair, they said. Shiva adorns his hair with the crescent moon. That mountain is where he meditates. This spot is where he pierced the earth with a shaft of light that said *Aum*, that said *Home,* that said *Here is my birthplace and temple and sign.* The sign of Shiva is both iconic and aniconic, both imagery and not. The sign of Shiva is a phallic symbol resting on a symbol of the feminine, not just contiguous but continuous with it, male and female self-becoming from a single piece of schist, of black sandstone, of brass, bathed in milk and Sanskrit. Shiva has more than one face, and one of those faces is the face of the woman he loves, the woman he simultaneously is—Ardhanarishwar, duality as one. Shiva is the one continuity between Mohenjo-daro and Ohio. Though Shiva was born of no one, self-become, Shiv was the name my wife and I chose for our firstborn son. Shiva is the God of many guises: ascetic, hunter, and dancer; loner, husband, and wife. Shiva is so ancient that he antedates time. He is Somnath, God of soma, the liquid entheogen brewed in the Vedas, its recipe lost for centuries. Shiva is remote and immanent, dark-skinned and luminous, dish of stone and shaft of symbol, the light, the love, the lingam.

THE TALKING
MONKEY PROBLEM

A chain of limestone shoals stretches underwater between an island off the coast of Sri Lanka and another island off the coast of Tamil Nadu. You can see this pale thread of spider silk connecting India and the teardrop-shaped island to its southeast in satellite photographs. The sunken land bridge, if we can call it that, stretches thirty miles, deviating southward smoothly and subtly before creeping back up to the closest point. A ferry between the two countries runs to the north of it, taking a straighter, shorter course.

The Sri Lankan island is Mannar Island. The bridge connects it to the Indian island of Rameshwaram. This name is an eponym of Shiva. In Sanskrit, it means "Rama's Lord." The island got its name because Prince Rama, in the *Ramayana*, prayed to Shiva there after his war in Lanka, which he fought to rescue his abducted wife, Sita. Rama felt guilt at the killing he had done there and wanted to expiate the sinful karma. A temple stands at the spot, and the island's name transubstantiates Rama's name into the name of the God he worshipped there. That string of limestone shoals is called Rama setu. Rama's bridge.

What do we believe when we believe, and how do we believe it? In Valmiki's *Ramayana,* the earliest account of Rama's life, the bridge was built by an army of talking monkeys. Once inscribed with his name, the stones floated. Across that bridge, divinity-made-flesh walked on water. If India's Hindus believe the land connection between India and Sri Lanka to be a deliberately

constructed bridge, don't they also believe, implicitly, the part about talking monkeys being its construction crew? The bridge is a suspension bridge, relying on the suspension of disbelief.

The question is not just limited to Hinduism, with its poetic and mythological tradition. Do modern Muslims really believe that a winged horse named Buraq flew the Prophet to heaven after the archangel Gabriel took the Prophet's heart out of his chest and "washed" it? How many Christians believe that the Holy Grail provided infinite food and drink, or that Saint George killed a "dragon"? Every faith loves its geographical proofs: Rama's Bridge is also known as Adam's Bridge, thanks to medieval Islamic sources, which speculated that Adam fell from heaven onto Sri Lanka, then walked across that bridge to India. A single mountain in Sri Lanka, Sri Pada (also known as Adam's Peak), holds the distinction of preserving footprints made by either Hanuman, Shiva, the Buddha, Adam, or St. Thomas.

It is almost a point of honor for some believers to claim, in the face of skepticism, that *yes*, their ancient stories are literally true, and the more literally you believe what seems impossible to believe, the stronger your faith is. *I believe because it is absurd*, went the old Latin saying. But there may be a disconnect between the public-facing assertion and the way people think about the world. Few if any Hindus believe a monkey can talk, few if any Christians believe in dragons, and few if any Muslims believe in winged horses.

There are, of course, different ways to reconcile the world of the story and the world of experience. The story can be said to relate a state of exception: a female cannot conceive without the involvement of a male, *except* in the one case of the immaculate conception. The story can be said to take place in a time so long ago that such things were possible: Methuselah really *did* live to be 969 years old because life spans were longer in distant antiquity and got shorter as time went on.

When it comes to unabashedly poetic myths like the one about Brahma emerging from Vishnu's navel to create the universe, the commonest reconciliation is to interpret the story symbolically or metaphorically. The navel, which represents the fetal connection to the mother (and hence prior generations), is the source of the creative "flowering." That is, tradition stimulates and sustains the new. The poet's imagination is translated into the philoso-

pher's discourse, and the abstract concept, the "moral of the story," is easier to *really believe* than a tale about a four-armed God relaxing on a sea of milk with a lotus sprouting from his belly button to reveal, seated in that lotus, a four-headed God, who proceeds to create the cosmos.

Really believe, of course, here means *believe literally*, as opposed to figuratively. Is the *Ramayana* a historical chronicle, or a made-up story, or a hybridization of the two forms? If so, what parts should be extracted as having "really happened"—Rama's bridge, for example—and what parts are mere embellishment and tall tale, like those Sanskrit-speaking simians? Maybe what the poet called "monkeys" were really just primitive tribesmen; maybe Ravana's ten heads symbolized his changeable and conflicted nature.

This tension between literal and poetic "belief" has exercised thinkers for quite a while. Goethe, in 1817, described "Stages of Man's Mind." In the beginning, poets express themselves imaginatively; then, theologians speak in terms of abstractions and ideals, favoring reason where the poets favored story and fantasy. Then, before the final dissolution, comes an era of "intellectual doubting," in which sensible interpretations take over. The talking monkeys start out as just that, monkeys who talk; then they become symbols of Rama's ability to commune with the natural world in his sacred quest to rescue Sita; finally they become a primitive forest tribe transfigured, by poetic fancy, into animal forms.

Goethe's essay conceives of these mindsets sequentially, but in our own time, a "believer" may well fluctuate among them, depending on the situation. I myself, among non-Hindus, readily reframe our myths in abstract language to make them palatable and reveal their depths. When I retell the epics, isolated in the creative moment, those explanations feel superfluous, forgotten, the blathering of a killjoy. The exhilaration of the story takes over, and the monkeys regain speech.

One direct investigation of this issue came from the twentieth-century French philosopher, Paul Veyne. In *Did the Greeks Believe in Their Myths?* Veyne studied the ways in which the Greeks experienced their religion. He, like Goethe, saw an evolution over time, culminating in the travelogue of Pausanias, who visited the real-world sites of mythological occurrences.

Veyne confessed some uncertainty about the nature of Pausanias's belief. The Greek writer "admitted that myths sometimes told the truth by allegory and riddle and that sometimes they told the truth literally," but he also expressed a belief in the divinities of the pantheon. When visiting Charonaea, Pausanias was shown a Homeric relic—Agamemnon's scepter, fashioned by Hephaestus in *The Iliad*. Veyne marvels how Pausanias discusses other works attributed to the same God and dismisses them "on stylistic criteria," finally concluding in *favor* of the attribution of this one.

Veyne realizes Pausanias's internal contradictions are part of the nature of belief itself. The evolution described by Goethe is not necessarily a succession that eliminates the forms of belief in the preceding stages. Literal, poetic, metaphorical forms of belief can coexist with each other—and with disbelief, too. Veyne offers a telling anecdote about a group of Ethiopian Christians, the Dorzé: they believe every leopard observes the Coptic Church's fast days, but they still don't leave their flocks unguarded on Wednesdays and Fridays.

Writing the title of Veyne's book, I briefly mistyped it as "Did the Greeks Believe Their Myths?" The preposition is crucial: in English, believing something is not quite the same as believing *in* something. The difference is subtle, but the first implies credulous literality, and the second, a thought-out giving of credence. (This is why, in English, God is believed in while conspiracy theories are simply believed.) French multiplies the possible prepositions that accompany "croyer": You can tack on "que," "à," "en," and "dans," shifting the implications each time. "Croyer en" is to believe in, based on emotion or irrationality. But Veyne does not use this preposition in the original French title of his book. He uses "croyer à," which implies intellectuality and reason underlying the belief—the kind of mindset Pausanias might bring to the question, or someone in Goethe's last stage of evolution. The answer to his question is not a simple yes or no. Nor should it be.

Do the Hindus believe their myths? Do the Hindus believe *in* their myths? That question is best answered, and best asked, by focusing on the monkeys themselves. What was the nature of their speech? It was not just gestural communication or signing. The monkeys, or Vanaras, conversed with Rama,

but not in some special, simian language. Rama does not have the ability to interpret animal speech like Saint Francis or Dr. Doolittle. Animals (including a vulture and a bear) speak to him in human language. In the *Iliad*, a horse belonging to Achilles, Xanthus, speaks Greek—but only briefly, by the permission of Hera, which the Erinyes immediately revoke.

The monkeys of the *Ramayana* speak Sanskrit from start to finish. The first time Rama and his brother Lakshman encounter Hanuman, in the fourth book of the *Ramayana,* the monkey has disguised himself as a wandering holy man. He greets the princes, who are searching for the abducted Sita, in the same metrical Sanskrit spoken by human characters in the epic. If anything, Hanuman's praise of the two princes is more fulsome, formal, and elaborate than anything Rama says in answer:

> With your fair complexions, you ascetics strict in your vows resemble gods or royal sages. Why have you come to this place, frightening the herds of deer and other forest dwellers, and examining on all sides the trees growing on the banks of the Pampa?
>
> VALMIKI, *The Ramayana of Valmiki*, book IV: *Kishkindhakanda*, sarga 3, verses 4–8, translated by Robert P. Goldman

His praise goes on for several verses. The princes are almost certainly taken aback, since Hanuman, part way through, asks, "Why do you not speak to me when I address you this way?"

Hanuman's being a monkey does not cause the princes to hesitate. Only *after* he reveals his simian nature do Rama and Lakshman respond, and they do so without expressing any shock that a monkey has spoken. They admire his speech for its own sake. The first descriptor Rama uses in reference to Hanuman has nothing to do with his strength or his ability to change size. The epithet is "skilled in speech"—and it is used twice in quick succession, once by Rama and the second time, three verses later, by Valmiki. Later, Hanuman speaks with Sita and with Ravana, among others. No one in the story reacts with shock to a talking monkey; characters experience the marvelous as commonplace, as they do in the magic realism of Gabriel García Márquez.

Maybe, goes one line of reasoning, the characters don't experience sur-

prise because Hanuman and his fellow monkeys are in fact human beings. But the claim that the Vanaras were simply tribesmen fails to account for the other Sanskrit-speaking animals in the epic, among them a vulture and a bear. In any case, the epic insists that Hanuman and his comrades are monkeys. Hanuman, joining the search for Sita, eventually does a long jump to Lanka—Rama's Bridge had yet to be built, so he couldn't walk across. When Hanuman finds a woman he mistakes for Sita, his reaction is telltale:

> He clapped his upper arms and kissed his tail. He rejoiced, he frolicked, he sang, he capered about. He bounded up the columns and leapt back to the ground, all the while clearly showing his monkey nature.
>
> VALMIKI, *The Ramayana of Valmiki*, book V: *Sundarakanda*, sarga 8, verses 46–50

The poet *emphasizes* that Hanuman is a monkey. Valmiki wanted there to be no confusion.

Hanuman's monkey tail, it turns out, is central to the epic. When the Lankans set it alight to humiliate him, he escapes and scampers through the city, spreading flames as he goes—the most famous act of arson in literature. So the term "monkey" is hardly metaphorical. It is a word of wonder, spoken and meant to be understood literally. It is poetry.

Is suspension of disbelief the same as faith? The two states of mind converge. Faith need not be forced, the result of a conscious effort to overcome doubt. Mythological religion seeks to remove, through poetry and storytelling, the basis of doubt itself. It builds faith through literature. As the Classical authors quoted Homer, so theologians quote their Book. The Bible has scenes no less fantastic than the *Ramayana* or *Iliad*. The sun halts in the sky, a voice emerges from a burning bush, corpses rise from their graves and walk about Roman-occupied Jerusalem. These are all works of literature that foster faith by suspending disbelief and foster contemplation by fostering faith. But disbelief remains, too. The world of the words, through immersive beauty, overlaps with the world in which the believer reads or listens. So the place where long-jumping Hanuman landed, a crater in a rock, remains a famous

tourist site in modern-day Sri Lanka. Other footprints of Hanuman have been enshrined in Thailand, Malaysia, and Andhra Pradesh. All of them await their Hindu Pausanias.

And so we approach a solution to the Talking Monkey Problem. The solution to contradiction is not fanatical adherence to *one* attitude—whether literal belief, or a belief that it's all metaphorical, or disbelief. All these states coexist, and the mind naturally toggles among them. It is accustomed to role playing, to forgetting one "self" and taking on another. Literature takes advantage of this natural flux, allowing readers to be captivated by characters unlike them, often enjoying superhuman abilities—for example, a monkey who can speak, change his size, and leap from India to Lanka.

Questions about the nature of belief segue naturally to questions about the self that's doing the believing, or the believing-in. Do you have a single, fixed personality, or a sum of personae that change on the basis of context? My speech patterns and active vocabulary differ depending on whether I'm interacting with my mother, my best friend, or a patient, and so do my patterns of thought. My belief, in nature and degree, never lacks context. I become a rational materialist while I read radiology studies for my day job. I do not pray for Hanuman to aid me in finding an appendicitis; I search for the inflamed structure systematically, coldly, godlessly. When my shift ends, I revert—or advance, depending on your point of view—into irrational and magical modes of thought, into degrees of belief that embrace the theological, the metaphorical, the poetic. I experience a transient but intense certainty in divine intervention and the power of prayer. These states of mind, too, have instrumentality, depending on whether I write a poem or an essay. I am not alone in embracing this flux, containing these contradictions. The Dorzé believe two opposite things about their carnivorous Coptic leopard. In them, as in me, there is no tension.

So the *Ramayana*'s monkeys do, in fact, speak Sanskrit to Rama. Valmiki's epic says so. Monkeys don't speak Sanskrit and can't be taught it. I don't have to be a trained zoologist to know that much. Rama himself was a historical figure from the modern-day state of Uttar Pradesh in India. Rama was also an avatar of the God Vishnu, and the main character in an epic poem. Rama died many centuries ago by walking into the Sarayu River. Hanuman has

since gone on to live forever, sustained as long as the *Ramayana* continues to be told. The average life span of India's most common species of monkey is about twenty-five years; the monkey Hanuman (skilled in speech) is a living deity to whom I can pray and be answered in this life, in this world, now. All of these assertions are true at the same time, even the ones that contradict each other.

More than one religion claims to be founded by a prophet, but the real faithmakers have always been poets; even the Prophet Muhammad, reciting the prose of the Qur'an, made sure to internally rhyme. In Plato's era, Homer was thrilling entertainment, but no less authoritative for that—as if, today, a single art form were to give us what we get separately from screens and scripture. In modern India, the epics still have this role. We can understand the Greek experience of Homer, rapt delight and reverence, only through comparison with the Indian experience of the *Ramayana*'s still-living epic poem.

No matter how literal-minded our belief, the monkeys in Ayodhya do not speak to us. The disappointment lasts until we recognize we are in the wrong Ayodhya. Returning to the epic, to its perfectly overlapping world, which is not the real world yet not *not* a real world, we meet the mundane commingled with the marvelous. The story is symbolic, and also, it actually happened. The prince is human and divine, heroic and fallible at the same time.

And yes, in case you are wondering, the monkeys talk.

IDOLATRY ROCKS

1

My wife does classical Indian dance. I love to watch her practice because she turns her body into the ancient Chola bronzes I admire—the same angles of hips and waist, the same gestures of the hand. Every configuration of the fingers has a meaning to it. She walks me through the meanings sometimes, but I forget them, partly because I get lost in admiring her elegantly cocked, pinched, and flared fingers. It's sign language.

Her cherished art, Bharatanatyam, is partly closed off to me. I know the stories and characters, I can read the expressions on her face and a few of the movements, but her body speaks a language too complex for me. Her dance is to me what my poetry is to her. She loves to read, but she chooses to read prose, never poetry, much less contemporary poetry. So some of the stylized things I do with otherwise familiar language seem complex and strange. Expressive, but not to her. Maybe it is best we keep these semiprivate worlds to ourselves, separate, supporting each other from a distance. We are enmeshed in every other way. Any more and we would collapse into a single self, like Ardhanarishwar, the half-male, half-female deity who is Shiva and Shakti in one. Even our names risk confusion, elision: "Ami" is always three-fourths of the way to "Amit," and "Amit" can't be written without "Ami."

"This one is really simple," she told me once, matching the upraised hand of the Shiva Nataraja—patron God of dancers, enshrined in bronze at the

corner of every stage—with her own. "It's the end times, and he's dancing to destroy the world—so he's gesturing to his foot, showing you what's going to stomp everything. Under that foot, the one he's standing on, that's the dwarf who symbolizes ignorance. But even as Shiva's doing all this, trampling ignorance and burning up the world, he's saying—with this other hand—*Do not fear.*"

2

"And I will destroy your high places, and cut down your images, and cast your carcases upon the carcases of your idols, and my soul shall abhor you."
LEVITICUS 26:30, King James Bible

I learned about statuary from the living, moving statue of Ami. Everything means something. The name of the dwarf under Shiva Nataraja's foot is Apasmara, a Sanskrit word that means *memory loss.* I know, I have witnessed all too closely, the amnesia of money and modernity that makes people forget their traditions, the unfashionable Gods of their forefathers. Why is Apasmara a dwarf? You get smaller the more of the past you forget.

Everything means something. When Ami's hands rise in a certain way—thumb to lip, pinky to thumb, off to the right—it's Krishna's flute. She herself becomes Krishna. Why a flute? Because, like birds and poets, a flute makes music as long as breath is passing through it. Krishna is Vishnu is the sustainer of things: that flute is the breathing body, full of the prana, the Sanskrit word that means both "breath" and "life." (The language of Leviticus knows it, too, as the nishmat chayim, the breath of life.)

Goethe once reflected how Gothic architecture was frozen music. Ami's ancient Indian dance, with its origins in the *Natya Shastra* from circa 300 B.C.E., is sculpture in motion. The stage becomes the temple, and the body becomes deity after deity, avatar after avatar. Fingers raised in a flute, one foot crossed in front of the other in a leisurely stance: Krishna. Elbow back and

thumb raised, to symbolize the archer's resting bow: Rama. One leg raised and swung across the body, and one hand raised to say *Do not fear*: Shiva.

3

The Prophet entered Mecca and (at that time) there were three-hundred-and-sixty idols around the Ka'ba. He started stabbing the idols with a stick he had in his hand and reciting: "Truth (Islam) has come and False-hood (disbelief) has vanished."
Sahih al-Bukhari, Hadith 2478, translated by Dr. M. Muhsin Khan

To *say* a God reassures you is acceptable to the iconoclast, but to *sculpt* a God reassuring you is not. There are some reasons offered for this in the religions that honor the commandment against graven images. The most common is that God is formless, and that giving God's formlessness form is wrong. The Hindu tradition splits the difference, as it were: it does the abstract "God" one better in Brahman, which Vedanta formulates entirely through the negation of opposites: "Not this, not that." Is the God of Abraham formless? Brahman is not a form, nor a formlessness. And so there is not a single temple with a sculpture of Brahman.

Yet that same not-this-not-that Brahman manifests in infinitely different forms. The many-armed and many-deitied pantheon is populated with the forms Brahman has taken on. These invite the chisel and paintbrush just as Yahweh and Allah invite the pen and tongue. The chisel and paintbrush are in *addition* to the pen and tongue, and they do the same thing. In the Near East, the Word was in the beginning; in India, it was a Syllable, Aum. The Sanskrit word often translated as "manifest"—as in, the unmanifest and manifest Brahman—is actually a word that relates to speech, vyakta, "spoken," and avyakta, "unspoken."

Iconoclasm, the breaking of worshipped idols, is only a part of the picture. The commandment, in Exodus itself, is an injunction against all representational art. "Thou shalt not make unto thee any graven image, or any

likeness of any thing that is in heaven above, or that is in the earth beneath, or that is in the water under the earth." Of the three Abrahamic religions, some have taken that more literally than others. Christianity, which over-wrote the advanced sculptural traditions of Classical Greece and Rome, decorated its churches with statues and frescoes. Islam directed its artists to the dazzling tessellations of mosque ceilings and calligraphy.

Among the ninety-nine most beautiful names of Allah is al-Musawwir, "the Shaper of Beauty." The artist, portraying a living being, enters into an unholy competition with that original Shaper; it is a usurpation, and the Shaper, affronted by it, will challenge the inferior human artist to bring his representations to life. Another Hadith from al-Bukhari (3224) preserves the testimony of the young Aisha:

> I stuffed for the Prophet a pillow decorated with pictures (of animals). . . . He came and stood between the two doors and his face began to change. I said, "O Allah's Messenger! What did we do wrong?" He said, "What is this pillow?" I said, "I have prepared this pillow for you, so that you may recline on it." He said, "Don't you know that angels do not enter a house wherein there are pictures; and whoever makes a picture will be punished on the Day of Resurrection and will be asked to give life to (what he has created)?"

4

Ami, when she dances, brings the sculptures to life. The chisels of generations of temple stonemasons guide her fingers into the gesture that means *speech*. She echoes the pose of the eleventh century *Hanuman Conversing* we saw at the Met, which was yet another picture of an animal. Abominable or adorable, depending on your tradition. The kind of mind that takes a hammer to a sacred sculpture is unlikely to appreciate a sacred dance.

Why take on a form at all? Why would Brahman "speak" itself into Gods and Goddesses, susceptible to sculpting, vulnerable to the hammer?

In the beginning was the word—a Proto-Indo-European word root that

explains a lot. That root, that syllable, is "weid-." The root dives from modern English all the way down to ancient Sanskrit. "Vidya" and "video" have this root in common because the Sanskrit word for "wisdom" locates knowing in the eyes. With "weid-," the primary and literal meaning is "to see." Knowing is the metaphorical, abstract, secondary aspect. This root word flowered with the title of India's earliest, most sacred body of scriptures: the Vedas.

"Weid-" gave rise to "wit," too. In Old English, "wit" did not have the sense of a trivial, amusing play with words; it indicated a broader, deeper understanding. Because that sense of "wit" went back to the second syllable in "Druid," literally "tree-knower." "Tree" and "truth" share the same root, too, the Proto-Indo-European "deru-": steadfast wood, the same connection that linked "baum," tree, and "beam," the ray of our enlightening.

5

"He heweth him down cedars, and taketh the cypress and the oak," says the Book of Isaiah:

> Then shall it be for a man to burn: for he will take thereof, and warm himself; yea, he kindleth it, and baketh bread; yea, he maketh a god, and worshippeth it; he maketh it a graven image, and falleth down thereto. He burneth part thereof in the fire; with part thereof he eateth flesh; he roasteth roast, and is satisfied: yea, he warmeth himself, and saith, Aha, I am warm, I have seen the fire: And the residue thereof he maketh a god, even his graven image: he falleth down unto it, and worshippeth it, and prayeth unto it, and saith, Deliver me; for thou art my god. . . . He feedeth on ashes: a deceived heart hath turned him aside, that he cannot deliver his soul, nor say, Is there not a lie in my right hand?

Shiva Nataraja, like many a Hindu deity, has *two* right hands. One is making the gesture of reassurance, which is almost identical to the gesture of blessing. The other is shaking a small drum, a damaru, traditionally made of acacia wood, though Tibetan Buddhists used to make theirs with skulls.

Idols are most commonly carved out of stone or cast in bronze, but it is also fitting to sculpt a deity out of the same natural material that gives your family warmth and helps you cook your food. Wood decays faster than stone erodes, and that relative transience reflects the transience of all things, not just the sculptures that portray Gods but the Gods themselves. After all, the cyclicity of time implies a dissolution to come. Shiva Nataraja's sphere of fire will incinerate whatever is left of our woodlands.

The doomsday dancer is only one portrayal of Shiva. An "aniconic" version is the lingam, featureless and phallic, a rounded pillar that symbolizes life's lust to beget more life—generative power, not destructive power. Leviticus 26:1 reads: "Neither a carved image nor a sacred pillar will you raise up for yourselves." One of the most important Shiva temples in India was sacked seventeen times, rebuilt, at last, as recently as 1951. Yeats: "All things fall and are built again, / And those that build them again are gay." Fall, or are toppled.

6

"Idol," too, comes from the Proto-Indo-European root word "weid-." It gave rise to the Greek word for form, "eidos." A related word is "eidolon," the image of a dead person, a ghost. Not form itself, but the appearance—the apparition—of form. So there is a meaningful paradox in the word "idol." The idol is all too solid, while the eidolon is an emptiness that deceives the eye. So the "false idol" is a solidity—of carved stone, of carved wood—that is actually empty of God. And hence not to be worshipped.

Another word that comes from the same root as "idol" is "idea." The two words are more than just etymologically connected. Philosophical repudiations of "idol-worship" frequently render the idol abstract—that is, it isn't just a physical murti that ought to be rejected, but the misguided worship of wealth, status, beauty, worldly power.

Sir Francis Bacon, describing the limitations of the human mind, wrote of its susceptibility to four "idols": those of the Tribe, the Cave, the Marketplace, and the Theater. Roughly these correspond to preconceived ideas,

personal preferences, mishandling of language, and philosophical dogma, all of which bedevil a clear understanding of the world. But none of Bacon's idols are sculptures bedded in a temple's garbagriha, its "womb-house." At the highest levels of monotheistic thought, idols and ideas are interchangeable. The commandment that forbids the worship of false idols forbids the worship of false ideas—instead of the one, true idea of God.

There are false ideas. There are true ideas. There are false idols. Is there such a thing as a *true* idol? What would it look like?

7

The Venus of Willendorf predates both Venus and the city of Willendorf by at least twenty-five thousand years. Limestone stained with red ochre, the statuette's function and significance are all speculation. Enormous breasts hang alongside rolls of fat. In Paleolithic Europe, the caloric excesses of modern diets were unimaginable. They had the opposite problem. This female figurine may have been a fantasy of what a body could look like in a world less miserly with meat and drink. Maybe it is a male sculptor's fantasy of a fertile, childbearing woman. Or else a "fertility Goddess" to quicken the fields back then, at the beginnings of agriculture, when people first took this mad bold risk of staying in one place and burying seeds and hoping the sky worked its capricious magic. Or perhaps a woman sculpted that body, daydreaming her idealized self, her happiest self, well-fed and ready to nourish her young.

The figurine has a smooth, featureless surface where the face should be. It's unlikely the details have simply eroded. Her headdress, its appearance resembling cornrows, retains its intricacy. Goddess or woman, she is faceless.

Tens of thousands of years in the past, hands and eyes were already shaping recalcitrant stone to something recognizably human, or divine: representational art. Already, this early in the history of the species, sculpture outspeaks scripture. The stone says something more than its mere shape, hybridizes the abstract and the concrete, teases us into meditation, into

thought.

Is Christ on a cross at the front of a church an idol or a guide to the mind? Is the aniconic Black Stone inside the Ka'aba, kissed by thousands of pilgrims, any less adored than the aniconic Shiva lingam of Somnath? Mere matter finds a way to be infused with holiness and beauty and aspiration and life, now as in Paleolithic times. The wood that disgusted Isaiah is the same material that makes the pages of a modern Book—Greek, "Biblion"; Arabic, "Qur'an"—even if that book exalts the word over the wood, the truth over the tree.

The senses, in Hindu thought, are horses pulling a chariot. Those horses can be out of control or in control. The form—murti—focuses the sense of sight, and the eyes, enraptured, understand by seeing. The incense focuses the sense of smell, and olfaction has a direct neural connection to memory. Sandalwood never fails to return me to a devotion that antedates my childhood. Bells, instruments, singing focus the sense of hearing; one hand pressed to the other in prayer focuses the sense of touch; the almonds or sugar crystals or coconut pieces handed out as prasad focus the sense of taste. All five horses, guided, gallop in the same direction: inward, upward. The right hand of Shiva says *Do not fear* and my wife's right hand matches it and I raise mine to match hers and there is no "lie in my right hand." At the temple, during the puja, a tray covered in small candles floats between my hands. It circles clockwise before the murti of the black avatar who sang the *Bhagavad Gita*, the classical Indian dancer of Vrindavan. The shadows angle and stretch and shift on the wall behind it, as if the murti were moving, alive. *Aha, I am warm, I have seen the fire.* I see a graven image gravid with faith. It is a true idol. It is a true idea. *What have we done wrong?*

THE *GITA* ACCORDING TO MARCUS AURELIUS

1

"Among the Quadi, on the river Gran." Both Marcus Aurelius's *Meditations* and the *Gita* offer a statement of place. In the case of the former, this comes at the start of Book II. In the case of the latter, it's the very first line: "On that field of Dharma, Kurukshetra," where the two branches of the warring Kuru family have "mustered, wanting war."

Neither Arjuna nor Marcus wanted to fight the wars that duty bound them to fight. Kurukshetra is literally "Kuru Field," and "Kuru" is the ancestral family name of both sides in the *Mahabharata* war. Marcus Aurelius found himself far afield "among the Quadi," fighting them in the Marcomannic Wars, one of many engagements on the bloody borders of the empire he inherited. The heading places him in Slovakia, near the river Hron, a tributary of the Danube.

The *Gita* and the *Meditations* are both books of religious philosophy (in the past, these individual fields were not sharply distinguished) created in wartime. Both books are flecked with blood reluctantly shed. Both offer the mind a sanctuary from violence that reconciles the mind to violence.

2

The first book of the *Meditations* is a litany of the people for whom Marcus Aurelius is thankful:

> From my grandfather Verus, nobility of character and evenness of temper.
>
> MARCUS AURELIUS, *Meditations*, book I, section 1, translated by Christopher Gill

He goes on to mention his biological and adoptive fathers, his mother, his great-grandfather, his friends, his tutors. He thinks back to what each person taught him.

The *Gita* sets the scene in its first book with a similar litany. Arjuna, after having his friend and charioteer Krishna park his chariot between the opposing armies, surveys them. The eponym used to refer to Arjuna—Partha, literally "Pritha's son"—makes a point of referring to his mother:

> Pritha's son could see them there:
> Fathers and grandfathers,
> Teachers, uncles, brothers,
> Sons, grandsons, friends as well,
>
> Fathers-in-law, kindhearted
> Friends in both the armies,
> All his relatives in close order.
>
> *Bhagavad Gita*, 1:26–27, translated by Amit Majmudar

The mood of each litany is different—Aurelius's reverent and loving, Arjuna's loving but full of despair at having to fight them.

The parallels between the two works are uncanny, but it makes sense that both military contemplatives should focus on family, since it's the yearning for home and family that afflicts soldiers most poignantly, from the *Mahabharata* war to today. Remembering loved ones on the eve of battle has made soldiers, for centuries, wonder at the absurdity, and the absurd necessity, of what they were about to do.

In ancient Rome, that emotion gave rise to the imperial *Meditations*; in ancient India, to the raja guhya, the "royal secret," of the *Gita*.

3

The school of philosophy that strengthened Marcus Aurelius has become a word in fairly common use today. Someone who is "stoic," according to Merriam-Webster, "accepts what happens without complaining or showing emotion." Notice this definition emphasizes an exterior display of equanimity. The dictionary adds, "apparently or professedly indifferent to pleasure or pain."

Yet the ancient Stoic school did not focus on helping its adherents keep a stiff upper lip. The point of Stoicism, as Marcus Aurelius practiced it, was to learn to overcome the response to "what happens." The lack of display was to be secondary, a side effect. So he does not exhort himself to conceal his reactions to misfortune; his self-exhortation is for a deeper resilience:

> Be like the headland, with wave after wave breaking against it, which yet stands firm and sees the boiling waters around it fall to rest. "Unfortunate am I that this has befallen me." No, quite the contrary: "Fortunate am I, that when such a thing has befallen me, I remain undisturbed, neither crushed by the present nor afraid of what is to come." For such a thing could have happened to anyone, but not everyone would have remained undisturbed in the face of such a blow.
>
> MARCUS AURELIUS, *Meditations*, book iv, section 49, translated by Christopher Gill

In the *Gita*, Krishna describes for Arjuna an image of the warrior-yogi, an ideal toward which to aspire. He calls this the stitha-prajna, the "steady mystic." This is a portrait Marcus Aurelius would recognize:

> In unhappiness, his mind unworried,
> In happiness, his longings gone,

His passion, fear, and anger vanished,
Vision steady: He is called a sage.

Unattached on all sides, neither
Celebrating what he gets nor hating it,
This or that, lucky or unlucky:
His mysticism stands fast.

When he draws the senses
In from what they're sensing,
All together, just like tortoise limbs,
His mysticism stands fast.
 Bhagavad Gita, 2:56–58, translated by Amit Majmudar

Marcus Aurelius exhorted himself to attain that desireless state. "Blot out imagination," he wrote, presumably referring to idle fantasies of sex or fame or victory. "Put a curb on impulse; quench desire; ensure that your ruling centre remains under its own control." The "ruling centre" corresponds to the *Gita*'s "self" or atman:

Wherever it may wander off
(This skittery, unsteady mind!)
From there he ought to draw it back
And lead it to the master atman.
 Bhagavad Gita, 6:26, translated by Amit Majmudar

The indifference to pain and pleasure—and indeed all pairs of opposites—is another quality of the yogi. It is not an "apparent or professed indifference" but an indifference that results from inward transformation. Krishna holds such a transcendent stoic dear:

The same in honor and dishonor,
In heat and cold and pain and pleasure
The same, free of attachment,

Alike when praised or censured, silent,
Content with anything at all, at home
Anywhere, steady-minded: Such a man,
Full of devotion, is dear to me.
 Bhagavad Gita, 12:18–19, translated by Amit Majmudar

Aurelius, as an emperor no doubt surrounded by flatterers, knew the importance of being "alike when praised or censured." A passage in Book IV of the *Meditations* could be glossing that line of the *Gita*:

Everything that is in any way beautiful is beautiful of itself and complete in itself, and praise has no part in it; for nothing comes to be better or worse for being praised. . . . As for what is truly beautiful, has it need of anything beyond? Surely not, any more than law does, or truth, or benevolence, or modesty. Which of these is beautiful because it is praised, or becomes any less so if it is criticized? Does an emerald become any worse if nobody praises it? Or gold, ivory, purple, a lyre, a sword, a blossom, or a bush?
 MARCUS AURELIUS, *Meditations*, book iv, section 20, translated by Christopher Gill

4

In his litany of beautiful things, Marcus Aurelius mentions a sword in the same breath as a blossom.

"Among the Quadi, on the river Gran" is the only reference to the barbarian tribes that Marcus Aurelius fought. Nowhere do we find assertions that the barbarians are despicable and deserve to have their way of life destroyed. There are no rants against the Quadi, no lurid accounts of Quadi evil that justify their subjugation. Aurelius fought the Quadi without demonizing them.

The *Mahabharata* war centered on two rival sets of cousins, the five Pandavas and the hundred Kauravas. Arjuna is a Pandava, while Krishna is his mentor and, though neutral, serves as his charioteer. In the *Gita*, Krishna never launches into a tirade against the Kauravas. He never says a word

against them. Infidels, pagans, heathen, savages: the *Gita* is missing these words, a rare scripture without an outgroup. Arjuna fought the Kauravas and their allies without demonizing them.

How did Marcus Aurelius end up by a tributary of the Danube, anyway? What was he doing out there? He was not fighting a war of expansion. He had inherited an empire with far-flung limits, and the Quadi invaded across the eastern border, the first of many breaches. He considered it his duty—his dharma as emperor—to preserve the empire and preserve the area under Roman law. Judging from the *Meditations*, he harbored no hatred toward the barbarians. Nor did he have to gin up hatred or experience bloodlust to carry out his martial duty. Marcus himself was fully aware of his dual nature, his dual allegiance:

> As Antoninus, my city and fatherland is Rome; as a human being, it is the universe; so what brings benefits to these is the sole good for me.
> **MARCUS AURELIUS**, *Meditations*, book iv, section 44, translated by Christopher Gill

There was no room in his mind for mere hatred. Defending the empire entrusted to him had nothing to do with wanting to destroy the Quadi. Wishing to do the former did not mean he wished to do the latter. Long after he passed away, the Quadi would triumph, crossing the Gran along with the Huns. The Quadi even became kings, far to the west, in a post-Roman Iberia they could never have imagined.

After the *Mahabharata*'s war, Vyasa, the poet who would go on to compose the epic, arrives to comfort the survivors. He wades into the river beside which the soldiers are performing the funeral rites. Submerging himself, he projects, in the mist above the river, a moving image of all the dead. Enemies who killed each other mingle and reconcile:

> Now all . . . met together, free from their anger and jealousy and sin . . . they were all now as cheerful-hearted as the gods in heaven. Son met with father and mother, wife with husband, brother with brother and friend with friend. . . . through the seer's [Vyasa's] grace other kshatriyas

too, their anger gone for ever, gave up their enmities and made friends.

Mahabharata, 15:41, "The Vision of the Sons," translated by John D. Smith

<div align="center">

5

</div>

The *Meditations*, though illuminating, are not "original." Marcus Aurelius thanks his tutors and elders early on and repeats well-established Stoic ideas that he almost certainly learned from those tutors and elders. His work is not the source code for Stoic philosophy but rather a distillation of it.

That description holds true of the *Gita* as well, though few commentators emphasize this aspect. Krishna doesn't just paraphrase the *Upanishads*; he quotes them. By some estimates, the *Upanishads* antedate the *Gita's* composition by about five or six hundred years—the same number of centuries that separate Marcus Aurelius from Stoicism's founder, Zeno of Citium.

A full-scale concordance between the *Gita* and its predecessors in the Sanskrit tradition would require a separate essay, if not an entire book. But a few striking examples stand out. The text's most surreal philosophical image comes in the twelfth chapter, which describes a massive, sacred fig tree, inverted so that its roots are in the sky and its branches touch the ground below. This tree also appears in the *Katha Upanishad*.

That same *Upanishad* informs Krishna's "stoic" approach to killing in battle:

Someone who imagines this [the self] a killer,
Someone who believes that this is killed—
Neither of them knows
This cannot kill and cannot *be* killed.

Bhagavad Gita, 2:19, translated by Amit Majmudar

Compare this to the *Katha Upanishad*, in which the God of death, Yama, teaches a young boy what it means, and does not mean, to die and kill:

If the slayer thinks it [the self] slays;
If the one who is slain thinks *it* is slain:

Neither of them understands.

It does not slay, nor is it slain.

Katha Upanishad, 2:19, in *The Upanishads*, translated by Valerie Roebuck

We are dealing with two different translators here—myself in the case of the *Gita*, and Valerie Roebuck for the *Katha Upanishad*. The second halves of each quatrain, in the original texts, are identical.

Krishna quotes one of the earliest *Upanishads*, the *Isha Upanishad*, for his idea on the unity of all life: "The self in every creature, / Every creature in the self." The *Isha Upanishad*: "All beings in the self / And the self in all beings." This idea—the interpenetration of being—leads naturally to the reconciliation with war, the idea that "This cannot kill and cannot *be* killed." Both armies partake in one indestructible Being.

The serenely embattled Marcus Aurelius describes this idea in Book VII, and his Greek prose could serve as a commentary on the Sanskrit verses quoted above:

All things are interwoven, and the bond that unites them is sacred, and hardly anything is alien to any other thing, for they have been ranged together and jointly ordered to form a common universe. For there is one universe made up of all that is, and one god who pervades all things. . . .

MARCUS AURELIUS, *Meditations*, book vii, section 9, translated by Christopher Gill

"One god who pervades all things." Krishna, in the *Gita*, speaks in its voice: "I am seated in the hearts of everyone."

6

The *Gita*, over the centuries, has come to dominate the crowded field of Hindu scriptures. That is why the *Gita*'s quotations from the *Upanishads* are better known, today, as quotes from the *Gita*.

There are many reasons for this: its musical nature ("gita" means "song"), its setting within a civilization-defining epic, and its association with the figure of Krishna, who in turn dominates the crowded field of Hindu divinity. The *Gita*'s dramatic, human emotions have made its philosophy more palatable. Krishna's teaching of equanimity responds to Arjuna's messy anxiety. Above all, the teaching feels intimate. It is not a sermon to a crowd, and it is not the advice of a distant guru. For all Krishna's talk of detachment, his tête-à-tête with Arjuna is emotional. Krishna refers to his wisdom as a "secret," and he does so again toward his last verses in the last chapter. He leaves Arjuna to do what he wants to:

> I've explained to you a knowledge
> More secret than the Secret.
> Mull this over, the whole of it.
> Do what you want to do. . . .
>
> Hear me out again. My highest word,
> The secret of all secrets:
> I love you. Fiercely. That is why
> I speak, to do you good.
> *Bhagavad Gita*, 18:63–64, translated by Amit Majmudar

This is a dialogue between two best friends. We get to listen in.

Just as the *Gita* is the best known expression of Hindu philosophy, Marcus Aurelius's book is perhaps the best known articulation of ancient Stoic thought. The reasons for its success are similar, too—among them, dramatic moment and force of personality. The *Gita* starts with the iconic image of Arjuna having a nervous breakdown on the battlefield. In the background of the *Meditations*, we see an Emperor forced by his duty—his dharma—out of the philosopher's quietude and into the clash of arms. *Written at Carnuntum* reads the subheading of Book III. Carnuntum was a Roman legionary fortress in modern-day Austria. Two hundred years after Marcus Aurelius lived there, the Quadi finally destroyed it.

His book, like the *Gita*, gains from a feeling of intimacy. Yet the *Gita*—a work of verse, with occasional stretches in which Arjuna's question sets up Krishna's answer—has a composed, public-facing aspect. With Marcus Aurelius, we get the sense his *Meditations* really are notes to himself, not meant for other people. Unlike Seneca's *Letters to a Stoic*, written for public circulation, Marcus's meditations are sometimes cryptic, elliptical, and scattered. This seems to prove their private nature. If he wanted the world to see them, he never got around to preparing them for publication. "Upright, not set upright," runs the entirety of one entry. In a short stretch in Book VII, he just jots down stray lines from Euripides that he has in his head.

Arjuna has a therapist, military adviser, best friend, and guru in Krishna. In Aurelius's life, he plays all those roles himself. His "ruling centre" talks him through his reluctance to enter the fray. We get to listen in:

> The idle pageantry of a procession, plays on a stage, flocks and herds, the clashing of spears, a bone tossed to puppies, a scrap of bread cast into a fishpond, the wretched labours of overladen ants, the scurrying of startled mice, puppets pulled about on their strings. You must take your place, then, in the midst of all this, with a good grace and without assuming a scornful air; and yet, at the same time, keep in mind that a person's worth is measured by the worth of what he has set his heart on.
> **MARCUS AURELIUS**, *Meditations*, book vii, section 8, translated by Christopher Gill

The *Gita* shares this imperative, urging the warrior yogi to focus on his war-work, but always with his heart set on a higher devotion, and on the highest goal, nirvana: "So, unattached forever, / Do the work that must be done."

<div align="center">

7

</div>

Inevitably, a battlefield philosophy devalues the body. The body is precious to common men and cowards, not to warriors and men of wisdom. Krishna

exhorts Arjuna toward yogic transcendence of heat and cold, of pleasure and pain. They are merely physical stimuli:

> Casting off his worn-out clothes,
> A man takes hold of others. That
> Is how the self, embodied, casts off worn-out
> Bodies, moving on with new ones.
>
> This is what the weapons do not cut.
> This is what the fire does not burn.
> This is what the water does not wet,
> Nor does the storm wind make it wither.
> *Bhagavad Gita*, 2:22–23, translated by Amit Majmudar

Marcus Aurelius constructs an entire meditation out of a single image. The image combines religion, reverence, and physical transience all in one, while the cremation pyres of Homeric heroes and Roman emperors burn in the background:

> Many grains of incense cast on the same altar; one falls earlier, another later, it makes no difference at all.
> MARCUS AURELIUS, *Meditations*, book iv, section 15, translated by Christopher Gill

It is easy to imagine that insight coming to him after a close call, maybe after witnessing an adjutant knocked off his horse. Those falling grains of incense, needless to say, are men falling in battle.

8

Did Marcus Aurelius read the *Gita*? Thomas McEvilley, in *The Shape of Ancient Thought*, maps the diffusion of ideas from east to west and west to east, often through the intermediary of the Persian court, other times through

merchants, soldiers, and vagabond thinkers. An account exists of Socrates encountering a wandering Indian wise man; Upanishadic ideas have left traces in Plato, and Neoplatonism is sometimes indistinguishable from Vedanta. The *Ramayana* is even older than the *Mahabharata*, but both epics contain references to "Yavanas," a corruption of "Ionians." Ancient Eurasia was thoroughly interconnected, particularly after Alexander reached India; sure enough, Stoicism was a Hellenistic school of thought, founded almost immediately after contact with India increased.

The evidence of interchange is not just textual. Profiles of Nero and Caligula show up on coins excavated in Tamil Nadu; excavations at Pompeii revealed a statuette of Lakshmi. The mythologies harmonize, too. Kama and Eros, both gods of love, are winged youths who carry bows. Achilles and Arjuna, before the wars that made them famous, both spent time in hiding, dressed as women in foreign courts. Coincidence is the least satisfying explanation.

Even though the *Gita* was around for a few centuries before Aurelius's day, it is almost certain he never read it or learned of what was in it. The *Gita* attained its modern-day fame over time; unlike the Qur'an or the Gospels, it was not foundational, but rather part of a dynasty of texts. The *Gita's* global reputation in the second century C.E. was not nearly what it is today.

The poet of the *Gita* and the author of the *Meditations* likely never read each other, but that only makes the harmonic between these works more significant. Faced with the same problem, they reached the same solution. The two wartime philosophies are identical for the same reason independent geometers arrive at the same value for pi.

9

A martial code, by shaping conduct, shapes the mind. Self-restraint, so important to both Sanskrit and Stoic thought, brought peace to the mind through a perpetual war footing, desires and attachments strictly rationed. The *Gita* and the *Meditations* are books in which that "war footing" ceased

to be an abstraction. Violence and transcendence were forced into the same place and time.

They are not the only examples. Samurai codes like the *Bushido Shosh-insu* included directives about keeping death in mind. Mishima's *Sun and Steel* laid out the philosophy that culminated in his attempt at a coup d'etat; he wore a military tunic on the day he committed seppuku. Elsewhere, such ascetic ideas did not take literary expression. What set apart Sparta was an idea of citizenship. Sparta was a poem, and every male Spartan adhered to its meter. In the Higgins boats that landed at Normandy rode philosophers who never wrote a word; self-sacrifice was their hypothesis and risk their proof. 9,386 crosses mark the American cemetery at Colleville-sur-Mer: *Quod erat demonstrandum.*

Understanding the transience of things need not render us passive or otherworldly. In the *Gita* as in the *Meditations*, that understanding is the basis of worldly action. The two books force us to expand our mental image of the contemplative. It is not always a bespectacled professor in a university office, not always a shaven-headed monk in a robe. A philosopher can be a charioteer on a dusty plain, whispering to a sobbing archer the way he whispers to his horses. A philosopher can be an emperor, his fingers stained with fresh ink, buckling on his armor in a far-flung hostile forest, among the Quadi, on the river Gran.

NATURE/WORSHIP

Dharmic Environmentalism in a Time of Climate Change

1

A garland of flowers on a murti of stone: a common sight in Hindu temples. We adorn permanence with something impermanent. Doesn't life itself adorn this rock floating in space the same way? Life basks in the sun a while, then withers away. So it is for the marigolds hanging from the neck of a murti.

Of course, the stone, too, is impermanent. Every cycle of existence ends with dissolution. Stones, even the hardest ones, will die, pulverized under the feet of Shiva Nataraja, dancing the dance of destruction in a sphere of fire. Maybe the flowers are there to remind the sacred stone that it, too, is impermanent. Or else to remind us that we, in meditation, are flowers scattered at the feet of the murti.

But the flowers are no less precious for being impermanent. If anything, that makes them more precious. They add beauty, fragrance, color.

Sacred art and poetry adorn the divine. We hang our creativity on the neck of what we worship, and what we worship adores what we adorn it with. To glorify it is our glory.

Yet it is we who have been given the gift of the flowers. We are simply treasuring them up and giving them back.

2

In the *Katha Upanishad,* Death teaches a brave young boy about the asvattha tree—the *ficus religiosa,* or sacred fig tree—"with its roots above and its branches below." What could that possibly mean?

The many-branched complexity of the world has its origins in the heavens. Leaves may shiver in the wind, but roots are immune to storms and shifting gusts. Perfectly still, they seek out water among the rainclouds, at the source. The singing of birds, the hum of beehives can be found in the busy branches, but up there, among the roots of the asvattha tree, all is quiet and dark.

Arjuna is encouraged to climb that tree, but in the opposite direction, starting at the branches and climbing his way skyward to the base, to the roots, to the source. Up there he will see the green branches below him, a mirror image of the root network in heaven. What Death says of that upside-down tree, in Valerie Roebuck's translation, is this:

> It is the bright; it is brahman;
> It is called the immortal.
> On it all the worlds depend:
> No one goes beyond it.

3

The lotus is the flower dearest to Sanskrit. Saraswati, Goddess of art and literature, sits in a lotus. Krishna has charan kamal, "lotus feet." Brahma emerged in a lotus from Vishnu's navel and created the universe.

The love of the lotus comes from an insight into beauty and purity: that they are born from the muck and murk of the world. The flower sprouts from a hazy pond, but when it blooms, its petals are perfectly pink and clean. What is best in us must rise first from base beginnings in the filth of fleshly desire. We flourish when we transcend. *Om mani padme hum,* goes the Buddhist saying. We must seek to attain the jewel inside the lotus.

In the Indian epics, devotees long to wash the lotus feet of the avatar. The dust of exile's trek, the dust of the battlefield rinses away, revealing the divinity that was always there. When we scrub our air of pollution, when we clean our streams and rivers, we are washing the lotus feet of the planet.

<div align="center">

4

</div>

In the ninth chapter of the *Gita*, Krishna speaks of offerings:

> A leaf, a flower, fruit, or water
> Offered, with devotion,
> By a striving atman: That
> Devoted offering I eat.

All four of those offerings have something in common: they are sustainable. Water is part of the water cycle. A leaf, flower, or fruit, plucked, does not kill the parent plant.

Two chapters later, Krishna shows Arjuna his universal form, everything at once. Why would the universe need a pomegranate? Why would a being whose veins are rivers want some water?

This is the basis of nature worship. Devotion knows that it does not give these things. It gives them *back*. The offering is a way of saying, "I found this. It is yours."

Or, rather, "I found this. It is You."

<div align="center">

5

</div>

The earliest Western account of India is found in the Greek historian, Herodotus. He speaks of "gymnosophists," what we would call yogis, undertaking austerities and discussing philosophy in the forest. And in fact one of the earliest *Upanishads* is the *Brihadaranyaka Upanishad*, literally the *Great Forest Upanishad*.

What is it about a forest that teases the human mind into philosophy and theology? The trees model stillness for the yogis. Their height reminds us of how small we are. Their quietude models mauna, the ascetic vow of silence.

In the *Ramayana,* Rama, Sita, and Lakshman are exiled to the Dandaka forest. They spend years in meditation and wear clothes made out of bark—morphing, in dress and essence, into trees.

6

The Vedic hymns speak of—and in some cases personify and address—Soma. Soma was an entheogen, a drink that induced a heightened state of consciousness. The hymns describe the stalk of a plant pressed to extract a sap or juice, but the name of the plant and the recipe have been lost.

Soma was beloved because it offered a shortcut to divinity. The Vedic rishis could feel unity, bliss, and visionary expansion without having to work for it. Now, with Soma lost, we have to put in the work through knowledge, good karma, and devotion—the three original kinds of yoga, so much more difficult than the postures and stretches of merely physical yoga.

What did the Soma plant look like? No one knows anymore. But we do know what it tasted like: transcendence.

7

Aushadi: the Sanskrit word for "plant" is simultaneously the word for "medicine" and "bearer of light."

A plant absorbs the light of Surya, the sun. The God's energy dwells in the herb or leaf and takes on the power to heal.

The sun has long been known to heal us. Tuberculosis sanatoriums used to wheel their patients out into the sunlight for treatment. European doctors in colder climates prescribed visits to the sunnier south (John Keats died "taking the cure" in Italy). Science tells us that vitamin B12 is inert in the body until sunlight chemically converts it into a useable form.

Leaves and saps derived from flora in the Amazon continue to be studied as cures for cancer, HIV, and other diseases. As these rainforests fall to buzzsaws and bulldozers, nature's pharmacy depletes. We lose, with every square kilometer of deforestation, aushadi after aushadi.

8

The most famous example of an aushadi is the Sanjeevani, an herb required to revive Rama's brother Lakshman on the field of battle. Hanuman leapt from Lanka all the way to the Himalayan Mount Drona, but once he got there, he was unsure. Did the plant have five leaves? Or four, or three? Were its leaves serrated or smooth? Did it have a flower, and if so, what color? Hanuman did not know (and neither do we). So Hanuman uprooted the whole mountain and carried it through the sky to Lanka.

The herb is said to be "mythical," but the myth itself says something real about the Dharma's belief in the miraculous healing power of plant life. Our grandmothers believed it too, professing the cure-all nature of turmeric and ginger. A certain cast of mind needs scientific studies praising the antiseptic effects of cucurmin and the anti-inflammatory effects of gingerol. The rest of us jump, Hanuman-like, to the correct conclusion—by trusting our epic poets, or our grandmothers, or both.

9

The *ficus religiosa* has many names, many avatars. In the *Katha Upanishad* and the *Gita,* it is the asvattha tree suspended upside-down in the sky. Sitting under the Bodhi tree at Bodh Gaya, a Bihari prince became the Buddha. These are all the same tree.

A more common name for it is the pipal tree. The pipal's leaves are cordate, meaning, literally, "heart-shaped." It is interconnected with the rest of nature. A specific wasp lays its eggs exclusively on the leaves of this tree and

serves as its pollinator: no fig wasp, no sacred fig. It lets down aerial prop roots that take on the look of pillars in a temple. It lives long enough that it must have seemed, to generation after human generation, as permanent as any deity. The Bodhi tree, at least two and a half millennia old, can be visited to this day.

10

By watering a plant, one makes it a promise: *I will be your personal daily raincloud.* Many households keep a tulsi plant. The tulsi's holiness in Hinduism dovetails with the plant's English name: holy basil.

The tulsi, with its tiny pink flowers, is particularly sacred in the Vaishnava tradition. Often the tulsi plant contributes the "leaf" that Krishna welcomes in the *Gita* as an offering. The poet of the greatest Hindi *Ramayana* retelling, the *Sacred Lake of Rama's Deeds*, was named Tulsidasa, "servant of the tulsi plant."

And there is no worthier master to serve than this humble, holy plant, potted outside the door of a home—where a grandmother can make her daily offering of water, then, taking a single leaf, make her daily offering to her God.

11

In the *Mahabharata*, when the Pandavas ask for their rightful portion of the kingdom, they are given the Khandava Forest. That is where their uncle the king, with feigned innocence, advises them to build their city. Krishna and Arjuna clear the forest—not with axes, but with fire.

Why fire? It is the one form of destruction that replenishes a forest. It happens in the course of nature. Ashes nourish. This became the site of Indraprastha, and, in the far future, of Delhi.

Civilization makes room for itself. Build anything, and you smother the earth beneath. The surest way to decrease carbon emissions would be to

deindustrialize the world, retire all our cars and planes and freighters, and return to the Bronze Age. But we cannot simply rewind our civilization to the days of Rama or Krishna. The story of the Khandava Forest is a story of realistic approach to environmental problems—a matter of tradeoffs, concessions, ways of making things work. The city of Indraprastha grew in the area they had cleared. Around the city, the forest grew back, too, thicker and taller than before.

12

Ancient epic poets wrote their works on leaves or on the inner layer of bark. Though organic, many manuscripts have survived for centuries without decaying. Permanent verses rest on an impermanent medium. On that dead surface, letters live.

The earliest birch bark manuscripts date back to northwest India in the first century C.E. They are so old that the words on them are in Brahmi script, the ancestor of Devanagri, the script of modern-day Hindi. Palm leaf manuscripts date back even further in their earliest use, as early as 500 B.C.E.

The earliest palm leaf manuscript, also the earliest example of written Sanskrit, was discovered in a cave in China, close to the Silk Road. The Spitzer Manuscript is a combination of Hindu and Buddhist texts. Among its contents: the earliest list of the chapters of the *Mahabharata*.

13

Winston Churchill called this Dharma a "beastly religion," and while he meant *cruel, nasty, vile*, the word also literally means, simply, "animal-like." I think if animals had a religion of their own, it would top my list of religions to study. I imagine they might have a notion of reality unclouded by human cruelty and human nastiness and human vileness. In fact, those meanings of "beastly" are better represented by our own species. Churchill, abandoning

India to famine, did a *cruel* thing. His dismissal of this Dharma—without studying it for a day in his life—might be construed as *nasty*, if not *vile*.

Beastly? A religion animals would love is a religion that loves animals back. One that says they were not given to us purely for domination. We are on a spectrum with them: the spectrum of Brahman.

The Dharma, like Shintoism, encompasses flora and fauna in its vision of divinity. Every God and Goddess has a mount. The God of love flies on the back of a parrot. Durga sits astride a tiger. Vishnu rides an eagle and rests on a serpent. Vishnu did not scorn the forms of fish, tortoise, boar, and man-lion when picking his avatars. On more than one occasion, according to the Ten Avatars of Vishnu, the salvation of the world has depended on a "beastly" intervention. Shiva is Pashupati, "Lord of the Beasts."

In the religion of the beasts, you would pray to an elephant-headed God for good luck. You would regard a sacred fig tree with the awe and gratitude of a bird in its branches, alighting, at last, after a lifelong migration.

14

In the epics, when an event delights the Gods and Goddesses, they gather and shower petals from the sky. It implies that there are flowers growing in heaven, and that the Gods and Goddesses have gone around picking them in the event that the young prince really slays the Rakshasa, or wins the princess's hand in marriage.

Of course, all these events have occurred before, given the cyclicity of Dharmic time, so heaven knows the exact moment that the glorious event will take place and the flowers will be required. So they tread the surface tension of the ponds and pick the lotus petals one by one until they fill the baskets in the crooks of their arms. They rush to the peephole in the clouds and watch until what has happened before happens again.

And then all heaven becomes a city, come out to the balconies to cheer the parade. The hero has arrived home after his exile! The good princes have won the war! The deities grab handfuls of still-wet petals and fling them into

the sky, making it rain pink, divine confetti, a shower of praise in the form of a shower of petals.

15

Another cordate leaf is the betel leaf. Its heart shape is particularly appropriate, given its role in wedding ceremonies.

A fresh leaf finds its way to the day when two people unite for life. Why a leaf? Because the leaf is a hand splayed palm up to absorb the superabundant sunlight. It can barely catch even a fraction of it, but what it does it gives to the tree. The leaf, though connected by nothing but a fragile stem to the branch, has no selfishness. It keeps no share of the sun for itself. This is one reason why a leaf should be a part of a wedding.

The other reason is botanical. The betel is dioecious, which means that it produces male and female plants—either male stamens producing pollen, or female carpels producing flowers. The Greek word root of *dioecious* means "two households," which join in a marriage. Most importantly, the betel, like the ideal of married love, is perennial and evergreen.

16

Another way that nature attends a Hindu wedding: the betel nut. This nut (technically a small fruit) doesn't come from the same tree as the betel leaf, but rather the areca palm.

Marriage comprises more than just love. The *Kama Sutra* refers to this breath-freshener, mild stimulant, and supposed aphrodisiac in more than one passage. A man is advised to keep some always at the bedside, to give it as a gift—and, during foreplay, to slip a sliver of betel nut directly from his mouth to his lover's.

Royalty makes a gift of betel nuts in *The Ankle Bracelet* by Prince Ilango Adigal, and Kalidasa's *Description of the Seasons* tells of women taking them into the bedroom. Betel-reddened lips find their way into ancient love poetry,

both Tamil and Sanskrit. Antiquity's joyous lovers kiss the stain off each other's lips.

<div align="center">

17

</div>

Sandalwood is the wood that signifies the earth itself. Damage sandalwood with sandpaper or flame, and what it gives us is a fragrance. Damage the earth with plough and spade, and what it gives us is a wheatfield, a cornfield, a jute field, a harvest.

Sandalwood signifies yoga, too, as well as the long process of self-transfiguration. A sandalwood tree cultivates its fragrance- and oil-rich body over fifteen years.

The Indian sandalwood tree is an endangered, protected species. It is the second costliest wood in the world, as of this writing. Low-cost oils marketed as sandalwood oil often come from related species, including the "bastard sandalwood." Unlike oil from the true tree, the impostor oil loses its fragrance in a few years.

Sandalwood remains a tree beloved across the religions indigenous to India. Hindus use it to worship Shiva; Jains use it in their worship of the Tirthankaras. Sandalwood has a major role in Buddhism as well: powdered sandalwood fell from the sky at the moment Buddha entered nirvana. It is thought to optimize the mind for meditation.

<div align="center">

18

</div>

Sandalwood is one of the many natural varieties of incense used in worship. A brief glance at the stock of an Ayurvedic incense store reveals a botanical garden, including jasmine, champaka (frangipani), Indian cedar, and musk. Incense dates as far back as the Rig Veda—at least.

Why make a cloud of pleasing fragrance while you worship? Partly, this is based on the same principle as putting fresh flowers on a painted silk-clothed murti and singing kirtan during worship. Many scriptures, including

the *Gita*, advise restraining and transcending the senses—but the *Gita* also understands that this is difficult for most people. Great ascetics can indulge in cross-legged meditation and the withdrawal from things that delight the senses. But for the rest of us, worship uses the senses to overcome the senses. Cluster all the sensuous beauty at the temple's focal point, and your senses, instead of distracting you, *focus* you.

Incense is part of this approach, and possibly the most effective one. Our olfactory sense encounters the world as directly as possible. Aromatic compounds directly stimulate the olfactory nerve. (Sounds make little bones shirr in the inner ear and tickle the eardrum; light stimulates the retina and goes through all sorts of processing in the brain before it becomes an image.) Scent is yoked, neurologically, to memory. A whiff of incense will take you back instantly, inexorably, to the mood and moment of worship.

19

In their temples, some Jains wear fine cloths over their faces to avoid killing even the smallest microbes. This is ahimsa, nonviolence, taken literally.

Besides avoiding meat and fish in their diet, they also avoid eating root vegetables, such as onions, tubers, potatoes, and beets. Digging up such vegetables kills insects and worms. A root is the sustenance-seeking umbilical cord that connects offspring plant and mothering earth. Eating the root kills the plant in a way eating the fruit or leaf does not. Ahimsa, the principle of doing no harm, is sustainable.

It is also the basis of the Hippocratic Oath that doctors take upon graduating from medical school: "Above all, do no harm." This is the central principle of healing—not just the individual's body, but the planet's.

20

In the Dharma, natural things—not a lamp and a genie, nor even science and technology—grant wishes. The cow and the tree, specifically.

Gods and demons churned up the ocean in search of the nectar of immortality, and among the treasures that swirled up out of the vortex were a wish-fulfilling cow, Kamadhenu, and a magical tree, the Kalpavriksha. Indra's heaven has five wish-fulfilling trees, of which the Kalpavriksha is one. You sit under it and wish, and what you wish you receive by the grace of the tree.

The Dharma has faith that the natural world can give us all we require or wish for, and this is why it reveres so many species out of the natural world. In fact, there are no anathema species—not the serpent, not the pig. The *Gita* says that a dog, over the course of its rebirths, can achieve transcendence. Every species has an atman, and that atman is the same across species. All creatures are engaged in the same mission to merge with their source, Brahman.

This ancient theological idea can empower modern environmentalism. The Dharmic outlook, far from treating specific animals as unclean, reveres them instead. Hence the ancient sacredness of cows and India's increasingly widespread disenchantment with meat-eating. Even the wordless, immobile trees take on a spiritual life in our stories. The mystical tree's generosity, like the mystical heifer's, is infinite.

21

Eventually, the Nectar of Immortality swirls up from the churned ocean. The celestial physician, Dhanvantari, emerges from the water holding the coveted chalice. Not just the healer but immortality itself comes out of the natural world. All we have to do is seek it.

Yet before the nectar, something else emerges: poison. After all, not every herb or flower is lifegiving. Yellow oleander can kill you. Betel nut, chewed in excess, has been known to cause head and neck cancer.

When the poison spills and spreads, the Gods and demons, choking on the fumes, appeal to Shiva. Shiva scoops up the tainted water and drinks the poison. His wife Uma, worried about his safety, touches his neck to stop the poison from going down to his stomach.

Suspended there, the poison discolors his throat—the blue, perhaps, of the poisonous blue dart frog, or toxic delphinium flowers.

22

The rudraksha tree, like the sandalwood tree and asvattha tree, is indigenous to India. Its small blue fruits contain a stone at its center. Strung along a thread, these can be worn as a garland or used as a rosary. Shiva wears rudraksha beads, and so do holy men devoted to Shiva.

"Rudraksha" comes from a name of Shiva—Rudra, or "roarer"—and the Sanskrit word for "eye." So each bead is an eye of the roaring God. Yet Rudra is also the name of a Vedic storm God, and the eye of a hurricane is stillness—compare to Shiva, meditating on Mount Kailasa.

A rudraksha bead resembles a stone. Yet its hardness hides, in small internal chambers, the promise of futurity: the seeds of another tree, another generation of blue fruits, another mala of rudraksha beads.

23

Environmentalism comes naturally to the Dharma because the Dharma evolved from the geography of the earth itself. Its mythology overlays the features of the landscape. The Ganga, the Godavari, the Yamuna all have stories to tell. The Ganga's celestial origin story—pouring down from heaven into Shiva's topknot first, and from there into the world—is told in the *Ramayana*.

Mountains, too, have stories behind them. Dronagiri is the mountain Hanuman transported to Lanka and back. The Himalayas, the "abode of snows," are also the abode of Himalay, the father of Shiva's consort Parvati—literally, "mountain-daughter."

Among the Himalayas, Mount Kailasa is Shiva's seat. No one has ever scaled this mountain's strangely angular summit. Its peak can be seen from

the shore of a lake called Manasarovar: the "lake of the mind," a sarovar being deep enough, according to the ancient poems, for a lotus to grow.

24

A stone, unearthed and shaped to the seer's vision, becomes a murti. Or it may become a Shiva lingam, an aniconic pillar no less charged with divinity.

Some lingams are made of metal, but more often they are made of stone, clay, or wood. The materials closest to hand serve best: the Gods and Goddesses, like the materials that represent them, draw from the land itself.

Part of the lingam's worship involves pouring milk over it. Drawn from the heifer sacred to Hinduism, milk is the gift only a mother is able to give. Breastfeeding accounts for the name of the biological class of our species—*Mammalia*, from the Latin word for breast. Shiva is said to be Swayambhu—self-become, no father and no mother. We give him, as we worship, a taste of the drink of infancy, soothing the throat that long ago endured the poison for our sake.

25

Another of Shiva's iconic signs is the trident, an image that has found its way into flora as well. The Indian bael tree—whose conservation status is listed, as of this writing, as "near threatened"—is sacred to Shiva by virtue of its triple leaf.

The earliest written mention of the bael or bilva leaf is found in an appendix to the Rig Veda. In the "Shri Suktam," the hymn to the Goddess of prosperity and luck, we read an invocation to Vishnu's beloved, Lakshmi. She is the color of the sun, and her tapas, or spiritual heat, resembles "a giant bael tree." The hymn's speaker asks to taste the fruit of that metaphorical bael tree; its fruit will drive away ignorance, misfortune, and poverty.

The bael tree's fruit, in this Vedic hymn, is the opposite of the fruit of the

Tree of Knowledge in Genesis. Eve's fruit, tasted, brought only misfortune. The Goddess's tree bears a fruit that resembles, as the Goddess does, the sun. Another name for the bael is the golden apple.

26

Goddess iconography often shows her holding a conch shell. The conch shell's female symbolism is due to its vertical aperture and the infinite ocean it contains—there to be heard, but only if you bow close and listen.

Yet conch shells, in the epics, served as war trumpets, too. Like war horses, war elephants, and bows, conch shells were given names. The *Gita* records some: Jewelflower, Godgiven, Endless Victory.

The conch shell comes from a sea snail, *Turbinella pyrum*, found only in the Indian Ocean. The mountains, the rivers, the very shells on the shore have been drawn into the Dharma's storytelling. The mythic heritage is the geographical heritage; the geographical heritage is the mythic heritage. To preserve one we must preserve the other. Holding both sacred is the surest way to accomplish this.

27

Krishna, too, speaks of ahimsa in the thirteenth chapter of the *Gita*. He lists it among the traits of someone who "knows the Field" ("kshetra," with its triple meaning of farm, battleground, and "field" of knowledge):

No pride, no affectation,
Ahimsa, patience, honesty,
Service to your teacher, purity,
Steadiness and self-restraint. . . .

Some of these are traits suited to a good steward of the environment. As individuals and as a society, we would do well to approach the natural

world without the pride that imagines the animals were given to us for us to dominate. Self-restraint would limit our consumption and our production of waste. Honesty would mean studying, with scientific detachment as rigorous as yogic detachment, the upshot of our activity so far: deforestation, weather changes, global temperatures, sea levels, air quality, water pollution. We are polluting what our children will drink and breathe. For their sake as for ours, we must *do no harm*.

28

Krishna grew up in Vrindavana, known for its groves of vrinda, another name for tulsi. We read, among the childhood stories of Krishna, how he fights a serpent named Kaliya.

Kaliya pollutes a stretch of the Yamuna river. The poison overflowing from his venom sacs kills all the fish and trees in his vicinity and any birds that overfly him. Under the pretense of retrieving a ball, Krishna dives into the poisoned waters and wrestles the monstrous serpent. Krishna ends up on top of Kaliya's hundred heads, dancing his triumph.

The tale is an example of the conquest of nature—but it's in the service of cleaning up a river, of protecting life, of restoring nature. Human ingenuity has sought profit above all else and polluted the environment in the process. That same ingenuity must now seek ways to end pollution. To do so, we must rethink what profits us. Redefine "profit" and redefine "us." The hundred-headed snake of greed can be exiled. But what it has taken from us is lost forever.

29

In visual depictions, Krishna often wears a peacock feather. Why would Krishna choose this iridescent teal feather to tuck in his hair?

The peacock is ostentatious, and so is the universe. Consider the sky, doing what it does at dawn and dusk. Now imagine that happened only once

every ten years. We would see dawn and dusk for the light shows they are. We would set out picnic chairs and watch it and capture it on our phones. Tourism websites would list the Top 10 Places to Catch the Sky.

What a finale! What a combination of oranges, pinks, and saffrons, giving way to phantasmagorical purples and blues! Nothing like the dusk your uncle saw forty years ago, he would assure you—the dusks were more spectacular back then, when he was a boy....

Nature is ostentatious. It is a peacock fanning itself. We must overcome our desensitization and see it for the glory it is. When we do, we will trek into the cold just to admire it, as we do for the Northern Lights. We will make the whole earth a single nature preserve.

30

Young Krishna's musical instrument of choice was the flute. A cross flute, held horizontally, it was made of the same thick-stemmed grass from which ancient pens were made: bamboo.

The lips do not touch the flute; the music comes about through action at a distance. The holes and the hollowness make a flute what it is. So it is with our bodies. Hollowness makes our bones stronger than if they were solid. The holes of the ears receive the music, the holes of the nose take in the breath, the hole of the mouth prays or sings—or blows into the holy hollow of a flute.

31

In the *Gita*'s tenth chapter, Krishna shares a litany of the pinnacles of things. In a euphoric, anaphoric stretch of images, he locates himself in the natural world. Yet he begins by locating himself in every living thing:

I am the atman, Arjuna,
In every creature, my seat the heart.

Though he goes on to distinguish himself as the best or most awe-inspiring of each category—"Of mountain peaks, I am Meru"—when it comes to living things, he is inside all of them. "Of wise men, I am Vyasa," he says, but he is also all other people. "Among the birds, Garuda": he is also the sparrows, the robins, the pigeons on the street, quickening each of their swiftly-beating hearts.

"Of all trees, I am the Sacred Fig," he says. "Of cows, the wish-fulfilling Kamadhenu." So a sacred tree and a sacred animal show up again. Krishna is part of the landscape, too—he speaks of being the Ganga and the Himalayas, familiar features of the Dharma's geography.

32

In one of his most charming childhood stories, the mountain dearest to Krishna is a small, local one, not a massive Himalaya. When his fellow villagers make offerings to the distant Vedic God Indra, the boy Krishna redirects their attention to Mount Govardhan. In its shadow, they graze their cows; on its slopes, they gather fruits. Why not worship that?

That localism is a lesson worth keeping in mind today: the forms that nature has taken here, up close, in our own immediate environment, deserve attention. Sweeping, abstract, global solutions sound good but are never implemented. The only "global" solution consists of thousands of small, local solutions. If each small community focused on its vicinity and strove to preserve and improve it, all would add up to planetwide environmentalism, just as tens of thousands of local shrines and modes of worship add up to one Dharma.

33

We must contract our appetites. The *Upanishads* and the *Gita* say it, the Buddhist sutras say it—but in our era, the statement has taken on a new meaning.

The early Europeans sought spices in the East; from India, known for the "spice islands" of Kerala, they carried home pepper, nutmeg, cinnamon, and cloves. These early ships were wind-powered. Now the freighters that cross the ocean, importing and exporting, burn fossil fuels. Elsewhere, factory farms torture and kill millions of Kamadhenus a year to feed an historically unprecedented appetite for beef. The calf is immobilized from birth to produce the more tender texture of veal.

Desire—of the tongue for spices, of the belly for meat—is the source of suffering: this is the root wisdom of the Dharma. The sages meant the source of *human* suffering, the individual condemned to birth after birth. But it is not just human beings suffering anymore. Our appetites spread suffering to the species around us. Our appetites poison our vicinity with suffering, like the odor around a slaughterhouse.

34

People strive to transcend desire through meditation. Self-restraint, according to the *Gita*, generates tapas, or spiritual heat—the same tapas that made the Goddess, in the "Shri Sukta," take on a solar blaze. The yogis' ascetic austerities, the Buddha's monastic life and beggar's bowl, the Jains' dietary restrictions all had this in common.

To deliver the wordless "flower sermon," the Buddha held up a single flower. Not even a colorful flower, a simple white one. The entirety of the Dharma's teachings coalesced into the contemplation of a single effulgent example of life continuing life. A single disciple, Mahakashyapa, understood it; his recognition made him smile.

35

Nature has given the Dharma its symbolic language for millennia. Flowers have been flowers of speech. Streams have been streams of consciousness. The natural environment is the sacred language of the sacred.

If a single white flower could encode the Buddha's teaching, imagine how much wisdom lies encrypted in a whole field of Himalayan wildflowers. Imagine how much truth flows in the many aortic root-vines that coalesce into a sacred fig tree, in the many rivulets that coalesce into a sacred river.

36

In the Ganga's origin myth, the river falls from the sky, and only Shiva's head and topknot are strong enough to bear the thunderous downpour. That origin in the heavens is an origin in the sky. We say the water that flows between these specific banks, from this source to that delta, is holy. The water itself comes from the recycling rains, brought there from far away by transmigrant clouds. All water is Ganga water. Every drop has been part, at some time, of a sacred animal or tree. We can hear water's long collective history in the conch shell. If the ocean had a mind, that would be the voice with which it thought.

In the long collective history of humanity, every person has been every other species. The metaphysicians estimate hundreds of thousands of rebirths between nascence and nirvana. There is no class—social or taxonomic—of which you have not been a member, at some point in your karmic peregrinations. Your atman, your self, can announce with Krishna, "In every creature, my seat the heart" when asked its domicile. We can be environmentalists out of selfishness, too. The habitat you preserve has been your own, and may be once again.

37

Traditionally, being cremated on the banks of the Ganga meant instant nirvana—a shortcut. The body's ashes mixed into the sacred river; the atman mixed into Brahman.

What this has meant in practice: dead bodies, sometimes incompletely burned because of the cost of pyre wood, find their way into the Ganga. Tens of thousands of them a year.

Nothing is sacred to the greed of industry. Factories spew chemical waste, tanneries and mass slaughterhouses dump animal hides and offal into the Ganga and its tributaries. Every sample swarms with fecal microbes, and several stretches of the Ganga have become ecological dead zones.

Crowds at religious festivals bathe in this water anyway, seeking spiritual benefits at the risk of contracting waterborne illnesses. As of this writing, the world's most sacred river also ranks as its most polluted.

38

One of the plants mentioned in the *Asvalayana-Grihya-Sutra*, the earliest description of Hindu funerary rites, is spikenard. The dead body was anointed and garlanded with it. Also known as muskroot, spikenard covered decay's stench with its fragrance. So the corpse was given two shrouds: the first made of cloth, the second made of scent.

Spikenard, part of the honeysuckle family, grows in the Himalayas. The rite fetches this flower from a sacred mountain range to adorn the body on its way to the pyre. There, cremation returns the body to the air as smoke and to the earth as ashes. Karma recycles the atman, sending it into another womb. Agni recycles the body, elemental fire dismantling it into its elements.

39

Today, many opt for modern electric- or gas-fueled cremation, but traditionally, the pyre was made of wood—in some cases, cheap and lightweight corkwood; in others, bamboo, the same material as Krishna's flute.

Agarwood, along with sandalwood or camphor, might render the cremation fragrant. India's evergreen agarwood tree faces extinction, so agarwood is even more expensive than sandalwood. As of this writing, a kilogram of sandalwood sells for roughly $2000; a kilogram of agarwood, $100,000. Agarwood's name derives from the Sanskrit word agaru, literally "not-floating." The Chinese and Japanese names translate the Sanskrit literally and mean

"sinking incense." The sinking incense accompanies the body's going un-der. The Sanskrit word for all incense, agarbhatti, derives from this specific scented wood. "Agaru wood" was so famous in the premodern world that it passed through Greek and Latin to eventually resurface in English as "eagle-wood," rising with the atman that wings its way, Garuda-like, into the sky.

40

Energy cannot be destroyed. It only changes form. The atman cannot be destroyed. It only changes form. Physics and metaphysics conceive these laws of conservation.

No such law holds for the precious, once-and-once-only life of a body. Extinction goes away for good. It begins with plant-insensitivity, in which our eyes cease to register the varieties of flora around us, and eventually the very presence of flora at all. Modern life isolates us from animal life, too, except for pets or a rare visit to the zoo. Onscreen, nature documentaries and animated, anthropomorphized versions create varying degrees of remove and unreality. Our insensitivity permits extinctions all around us. We do not mourn the passing of lives we never saw to begin with.

Our two conventional eyes only *think* they see. Their retinas have dead-ened to the natural world. To see creation all over again, we must open our collective third eye, the eye of Dharma. Only then will the natural world, like the pattern in a Magic Eye illusion, float out of the background and into immediacy. We will see how the Dharma has sanctified the trees and the beasts and the shells on the shore.

The environment will become a temple. The future will sit at the center of that temple, like a murti wearing a garland of flowers.

And we will be that temple's keepers.

ACKNOWLEDGMENTS

"Five Famous Asian War Photographs" first appeared in *Chicago Review* and was reprinted in *Best American Essays 2018*.

"The *Gita* According to Marcus Aurelius," "Idolatry Rocks," and "The *Ramayana* and the Birth of Poetry" first appeared in *Marginalia/Los Angeles Review of Books*.

IMAGE CREDITS

1: Decomissioned logo for Wagh Bakri Tea, launched by Gujarat Tea Depot in 1934.

2: Nitish Bhardwaj in Kolkata during Atul Satya Koushik's play "Chakravyuh" (20 September 2016; photo courtesy Nilabhverma).

3: Poster for the DVD of 2013's series *Mahabharat*.

4: *Janmastami*, Lithograph, 1883, Metropolitan Museum of Art (Purchase, William Spielman Bequest, in memory of William and Bette-Ann Spielman, 2014).

5: *Yashoda Adorning Krishna*, oil painting by Raja Ravi Varma, date unknown.

6: Jagannath Mahaprabhu (festival of Ratha Jatra; photo courtesy Government of Odisha).

7: *Krishna subduing the Naga Kaliya*, 17th century, gilt copper repoussé, Metropolitan Museum of Art (Zimmerman Family Collection, Gift of the Zimmerman Family, in celebration of the Museum's 150th Anniversary, 2019).

8: Linga with face of Shiva (Ekamukhalinga), 7th century, stone, Metropolitan Museum of Art (Purchase, Friends of Asian Art Gifts, 1989).

9: *Krishna Revels with the Gopis*; page from a dispersed *Gita Govinda* (Song of the Cowherds), ca. 1630–40, opaque watercolor and silver on paper, Metropolitan Museum of Art (Cynthia Hazen Polsky and Leon B. Polsky Fund, 2003).

10: *Radha, the Beloved of Krishna*, ca. 1750, ink and opaque watercolor on paper, Metropolitan Museum of Art (Cynthia Hazen Polsky and Leon B. Polsky Fund, 2005).

11: *Krishna Holds Up Mount Govardhan to Shelter the Villagers of Braj*; folio from a *Harivamsa* (The Legend of Hari (Krishna)), ca. 1590–95, ink, opaque watercolor, and gold on paper, Metropolitan Museum of Art (Purchase, Edward C. Moore Jr. Gift, 1928).

12: *Krishna and Balarama Fight the Evil King Kamsa's Wrestlers*; page from a dispersed *Bhagavata Purana*, ca. 1650, ink and opaque watercolor on paper, Metropolitan Museum of Art (Gift of Mr. and Mrs. Alvin N. Haas, 1973).

13: Figure of Isis-Aphrodite, 2nd century A.D., painted terracotta, Metropolitan Museum of Art (Purchase, Lila Acheson Wallace Gift, 1991).

14: *Houris on Camelback*, 15th-century painting, from a manuscript titled *Miraj Nama*, in the Bibliotheque Nationale, Paris.

15: *The Lovers*, painting by Riza-yi 'Abbasi, A.H. 1039 / A.D. 1630, opaque watercolor, ink, and gold on paper, Metropolitan Museum of Art (Purchase, Francis M. Weld Gift, 1950).

16: *Sakyamuni (Buddha) Announces Another Prophet*; folio from a *Majma al-Tavarikh* (Compendium of Histories) by Hafiz-i Abru, ca. 1425, opaque watercolor, silver, and gold on paper, Metropolitan Museum of Art (Cora Timken Burnett Collection of Persian Miniatures and Other Persian Art Objects, Bequest of Cora Timken Burnett, 1956).

17: Krishna marble statue, Nihaleshwar Moorti Art, Jaipur, Rajasthan.